To Scott Newkirk
— thank you

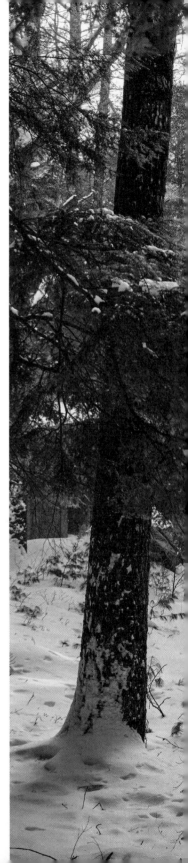

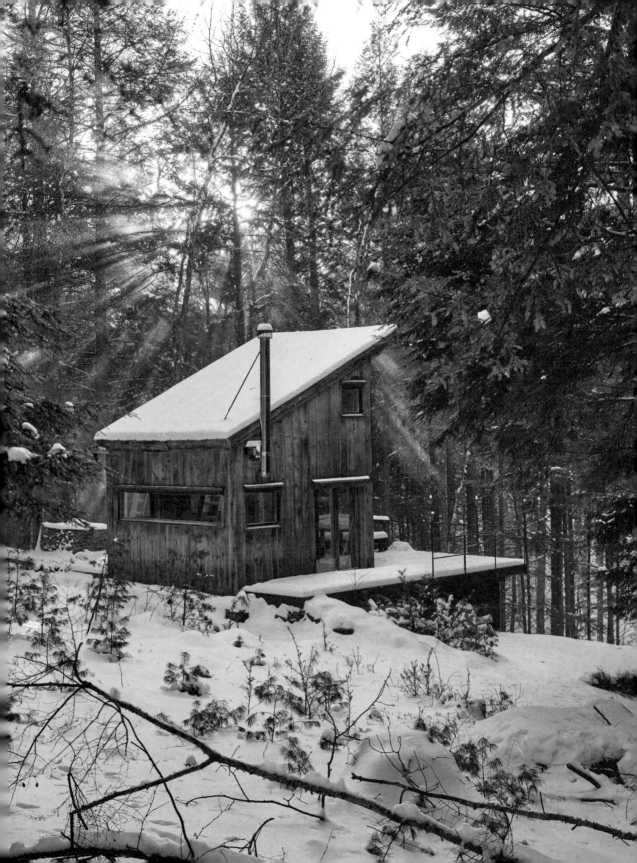

Voracious
Little, Brown and Company
Hachette Book Group
1290 Avenue of the Americas
New York, NY 10104
littlebrown.com

First Edition: October 2019

Voracious is an imprint of Little, Brown and Company, a division of Hachette Book Group, Inc.

The Voracious name and logo are trademarks of Hachette Book Group, Inc.

The publisher is not responsible for websites (or their content) that are not owned by the publisher.

The Hachette Speakers Bureau provides a wide range of authors for speaking events. To find out more, go to hachettespeakersbureau.com or call (866) 376-6591.

ISBN 978-0-316-42309-0
LCCN 2019937626
10 9 8 7 6 5 4 3 2 1
IMAGO
PRINTED IN CHINA

COVER, PREVIOUS

Scott's Cabin, a 300-square-foot structure at Beaver Brook in Barryville, New York.

PHOTOGRAPHS BY Noah Kalina

Cabin Porn
Inside

EDITED BY
Zach Klein

FEATURE STORIES BY
Freda Moon

LAYOUT & DESIGN BY
Matt Cassity

VORACIOUS
Little, Brown and Company
New York Boston London

Places

Dozens of cabins, shelters, and retreats from all over the world are included in this volume.

Each is warm, simple, and made by a Cabin Porn reader like you.

4
Cornish Cabin

Cornwall, England

34
Shantyboat

The Rivers of North America

68
Naohiro's Escapes

Naganuma, Japan

134
Bothy Project

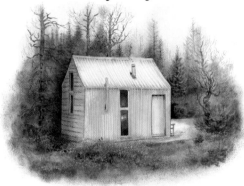

Scotland

102
Beavers Lodge

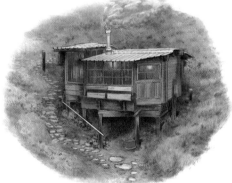

Santa Monica Mountains, California

166
Tragata

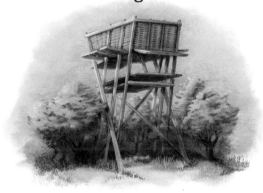

Kefalonia Island, Greece

196
Hillside Homestead

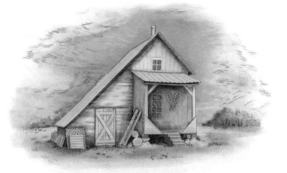

Kimball, South Dakota

256
Casa Tiny

Puerto Escondido, Mexico

226
Bird Box

Hadeland, Norway

290
Fire Lookout

Fernwood, Idaho

Each one of us wants
to be able to bring a building
to life like this.

"It is a fundamental human instinct, as much a
part of our desire as the desire for children. It is,
quite simply, the desire to make a part of nature,
to complete a world which is already made of
mountains, streams, snowdrops, and stones, with
something made by us, as much a part of nature,
and a part of our immediate surroundings."

— Christopher Alexander,
The Timeless Way of Building

Inside a Community

More than a decade ago, I began collecting stories of cabin life on a simple blog. I met generous builders who shared photos of the land they had saved up to buy, sketches of the retreats they hoped to create, and stories of friends who chipped in to make them happen.

The collection initially served only as inspiration for my own family's camp in upstate New York. Making that place we call Beaver Brook was the best time of my life. I could spend every day that way: outside with my family and friends in a gorgeous pine forest, building out the spaces that would shelter us and working to the point of feeling all used up before drenching ourselves in the brook. It is the most complete experience I have ever known, and it never ceases to delight me to share it with someone new.

Those full days at the brook and the inspiration I gathered led to an unexpected opportunity: the chance to publish a book featuring the most cherished cabins from more than twenty thousand submissions shared by the Cabin Porn community. The first volume was published in 2015, has been translated into seven languages, and continues to encourage people everywhere to make their own homes. I'm proud to include some of them in this new volume.

The book's appeal demonstrates the seemingly universal desire to bring a simple building to life in harmony with the land around it. Indeed, that collection almost entirely focuses on the exteriors of cabins amid the natural splendor that often accompanies them. Many of you have rightly asked, "But what does it look like inside?"

I've returned to many of these cabins and peeked inside for a look.

This second volume, *Inside,* serves as a reference for both the cabin builder and anyone seeking perspective on how to create spaces that just work— the ones that spellbind us with their warmth and ingenious simplicity. Here you will find hundreds of examples of what makes a cabin: the small details that enable their dwellers to live pleasantly and efficiently, as well as the mistakes and adaptations that reveal how builders must learn while creating their cabins or making their own homes. Perhaps most touching to you, too, will be the evidence that these cabins have hosted some of the most charming and memorable evenings for the people who worked together to build them.

In that spirit, I thank you for supporting this labor of love, and for sharing the cabins you've built and treasured. You have inspired so many to make their own quiet place somewhere—including me.

—Zach Klein

Timber-frame porch under way at Beaver Brook.

Zach Klein and his family and friends spend a long weekend every year bucking logs to make a winter firewood supply.

PHOTO BY Wesley Verhoeve

Cornwall, England

Cornish Cabin

Contributed by **Richard Stewart**

Photographs by
Richard Stewart, Alistair Sopp

The dramatic coastline of Cornwall's Lizard penin-
sula, the southernmost place on the British mainland,
features meadows and forests that extend right to the
edge of the sea. For photographer Richard Stewart, it
seemed like the ideal place to raise a family.

Richard was born in northern England and moved
around constantly as a kid, uprooted by his dad's
corporate job. He wanted a more settled life for his
own kids. "We wanted to bring our children up close
to nature," he says, "and in a small community where
people would recognize them and know their name."
It didn't hurt that the peninsula has clear, blue water
where Richard, a surfer, could play in the waves.

When he and his then wife, Anna, bought seven
acres of meadowland in Lizard, they didn't initially
plan to build a house. Richard and Anna were wildlife
filmmakers who had met while on assignment, fellow
travelers and adventurers who were comfortable in
unconventional living situations. So they bought a
Victorian-era train carriage—an ornate wooden train
car that, Richard would later learn, was one of the old-
est of its kind in the world. They placed the carriage at
the edge of their meadow, where they lived and grew
their family from one child to three, all girls: Lila, Sky,
and Rilke.

The train car, with its vintage brass and wood
fittings, was at once rustic and showy. Because it was

Large windows on the west-facing side allow sunlight to warm
an internal log wall, which acts as thermal mass. The green
roof insulates the cabin in both summer and winter.

4

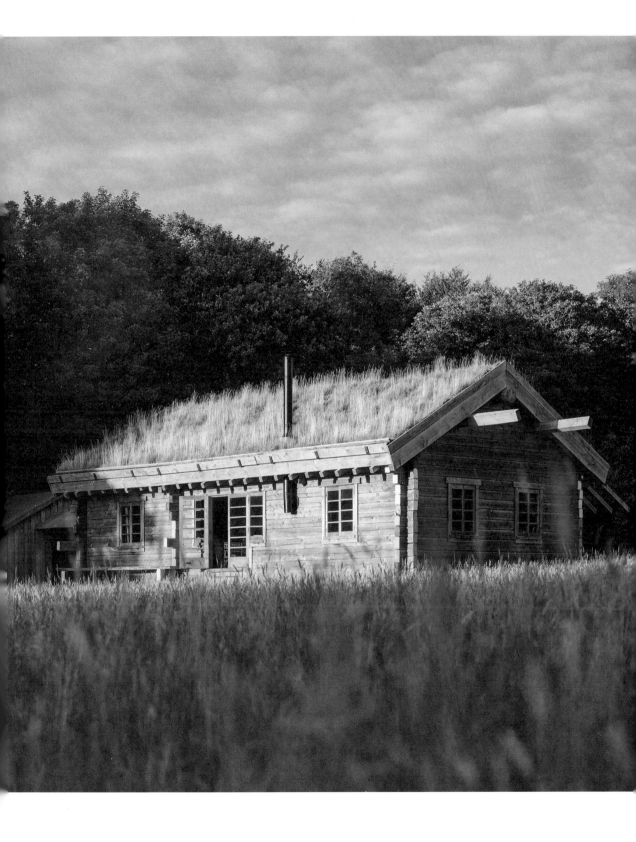

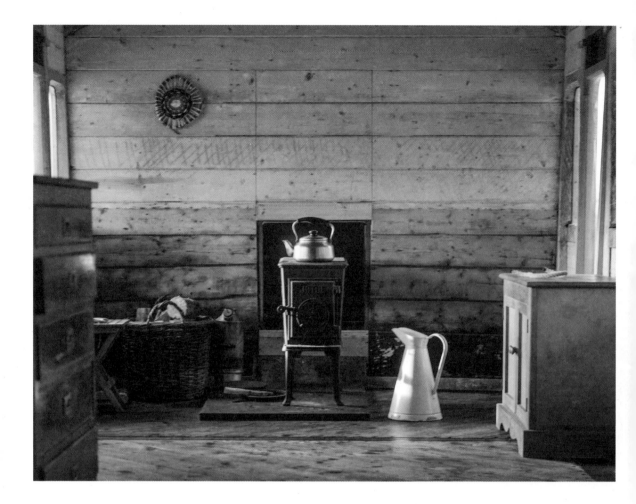

The train car was a restoration of an 1865 Victorian wooden railway carriage. Richard and Anna spent a year living in the carriage before starting work on the cabin, which allowed them to study the movement of light and nature in the meadow.

OPPOSITE The cabin is heated with a cast-iron wood stove during the Cornish winter.

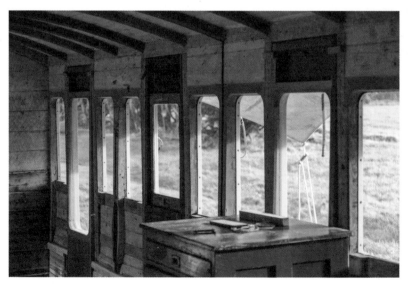

CORNISH CABIN

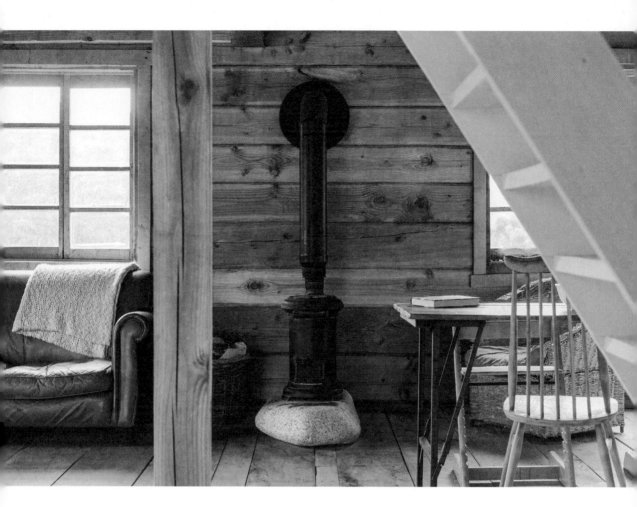

an heirloom, its parts were expensive to replace. But it was a beautiful home in an enchanting corner of England, and Richard and Anna felt lucky to live there.

As Richard describes it, Cornwall is both a magical and challenging place. It is a land of multimillion-dollar vacation homes, a place where getting permission to build a new single-family house is nearly impossible due to land-use laws. During the high season, the region is inundated with tourists and vacationers, and small villages swell to ten times their winter size.

In 2011, a Hollywood director saw a photograph of Richard and Anna's train car and asked to buy it. The director wanted to use it as a studio for writing scripts. The couple had known that eventually they would need a bigger home, so they decided to sell. Richard found a loophole in Cornish law that would allow them to build, so he reached out to Håkan Strotz, a Swedish

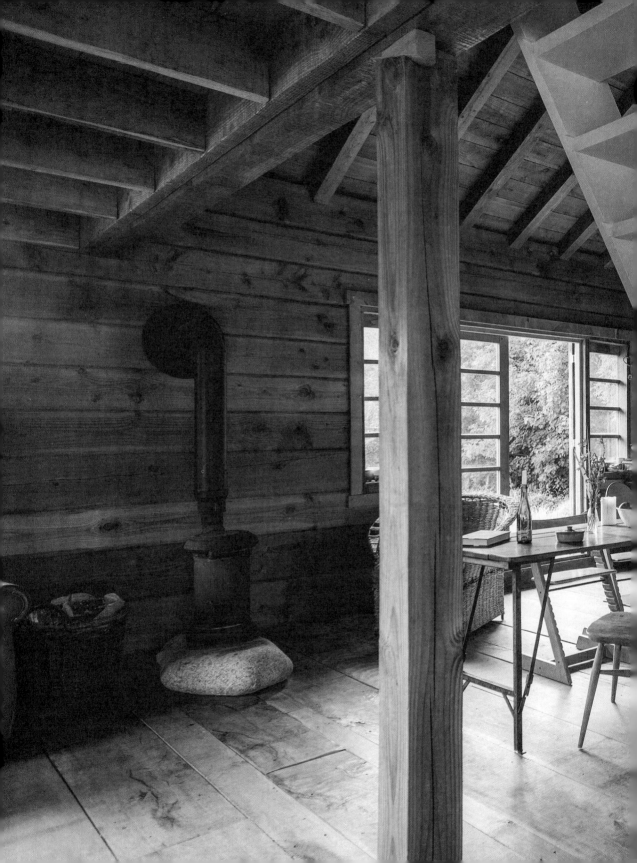

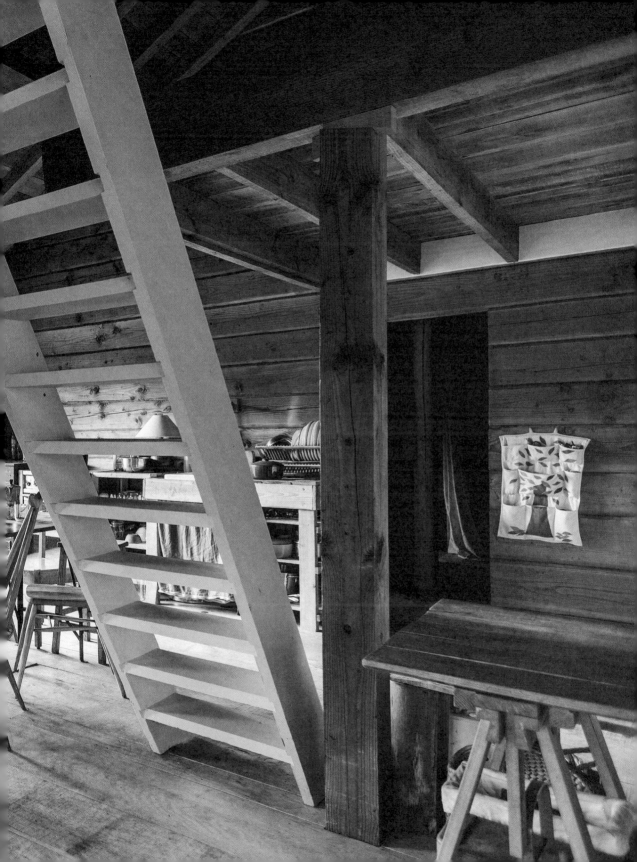

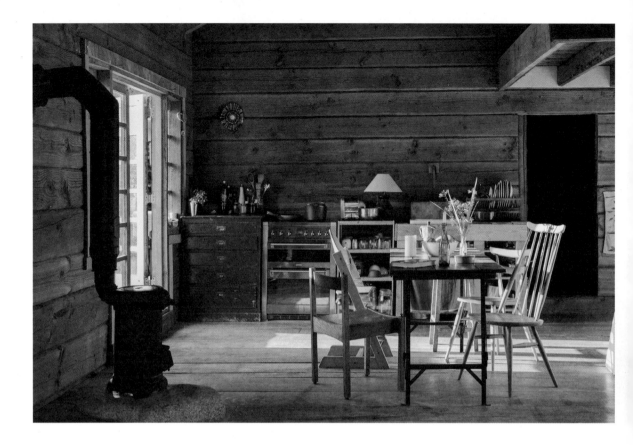

cabin builder known for his URNATUR eco-lodge. Richard had been impressed with Håkan's environmentally friendly "hermitage"—cabins built on mossy boulders in the forests of Sweden—and hoped the man might offer advice on building a similar cabin in Cornwall.

Håkan came to England to see Richard's property for himself. In the summer of 2012, he spent a few days there, advising Richard and Anna on their plans and helping them source materials from around the property. That fall, the couple took their middle daughter, who had become enthralled in the project, out of school, and the family devoted themselves to the nearly year-long effort of building their home.

When it was time to start building, Håkan and a friend from Sweden returned and spent a month in Cornwall, helping the family to construct its cabin. Håkan helped fell trees and taught them traditional Swedish woodworking techniques. The girls were enthusiastic hosts who enjoyed taking a break from their studies to serve *fika*, the Swedish midday meal of coffee and sweet breads.

Richard and Anna's vision was to build from, and reflect, the Cornish landscape. It's a "very special natural location," says Richard, describing the property's placement next to the Helford River, one of the few places in England where forest goes right up to the seashore.

With Håkan's help, the family felled a tree in a nearby valley and determined whether it could be shaped to fit the cabin's design. Then the family handpicked another forty-eight trees from the woodland, which they felled over two days and hauled by tractor to the meadow, to be seasoned and shaped. (The cabin is the length of the shortest tree.)

The family also gathered sixteen granite boulders, along with stones from the nearby beach, to lay as the cabin's foundation. Rot-resistant birch bark became a bed for the logs, which had been jointed and scribed. The family used winches, levers, and pulleys to put the logs in place; the

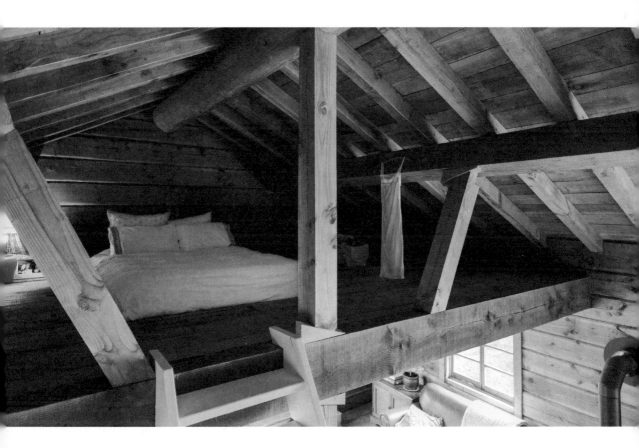

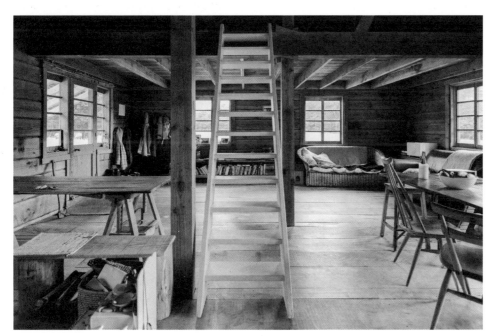

The sleep platform above the main living area, the distinctive roof structure, and the round ridge beam.

L A painted yellow staircase reclaimed from a boat connects the cabin's main living area to the sleeping platform above.

OPPOSITE The solid log internal wall, the wood stove, and the kitchen.

CORNISH CABIN

A bridge connects the main cabin to a smaller utility structure and a bathroom nestled at the edge of the woodland. The bridge is aligned with a glass windowed doorway that allows a view of the woods from the center of the main cabin.

OPPOSITE View of the shower. During the cabin's construction, Richard and his daughters enjoyed washing under a hose attached to a tree in the woods. The bathroom's design was inspired by that experience. The water drains through the floor into a hidden stainless steel trap. At night a clearing in the woodland outside this window is lit by string lights, which reflect on the windows and prevent the occupant from being seen without disturbing the feeling of showering in the forest.

ridge beam, which filled the gaps between them, required a crane. Each log was lined with sheep's wool and held in place by giant pegs shaped on a draw horse by Lila and Sky. The roof was covered in turf dug from the meadow.

While the cabin was being built, Anna and the girls slept at a rental nearby that the family were living in after they sold the train car, while building their own house. But Richard often camped in the unfinished building, which didn't yet have windows or doors. He was accompanied by a family cat, two owls, and a fox that lived downstairs. The feeling of being connected to nature was something he sought to incorporate into the finished cabin. Richard says that he and Anna "wanted to make a home that always and constantly invited you outside." Though they have a flush toilet, not an outhouse, they built their washroom in the woods and connected it to the main house with a bridge.

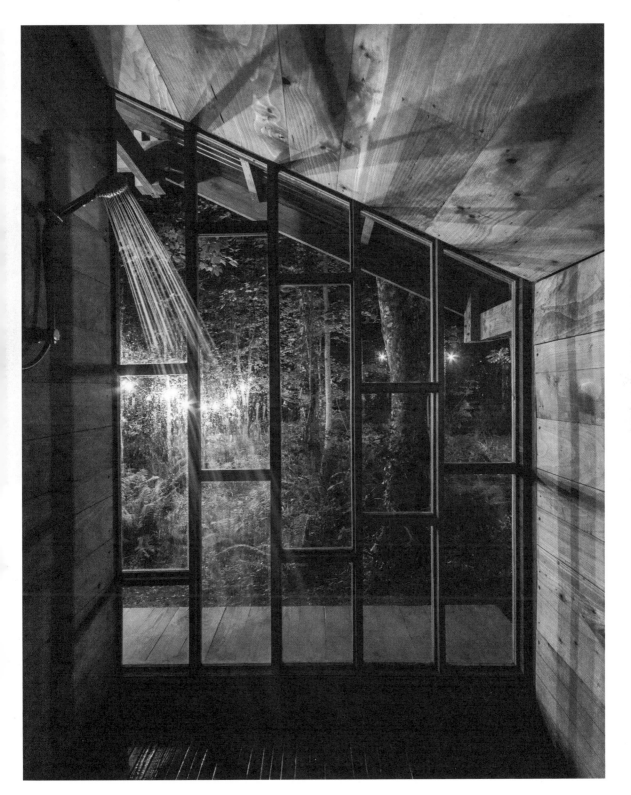

CORNISH CABIN

The cabin was an intensely personal project. With the construction method that the family used, a notch runs the length of each log. In the Swedish tradition, "you're supposed to put little talismans or gifts to the tree spirits" in the notches, explains Richard. "All sorts of stuff went into the actual walls of the cabin to give it a good spiritual blessing." It's like a "time machine," he says.

After the cabin was completed, Richard and Anna lived there, on and off, for several years before deciding to sell it in 2014. When they put the house on the market, Richard left on a monthlong surf trip. When he returned, he was overwhelmed by the response. There were scores of cash offers to buy the home. But more gratifying were the people around the world reaching out to him, just as he'd reached out to Håkan, asking for advice about how to build a cabin of their own.

The cabin at night, facing west. A boardwalk through the meadow leads to the cabin's front entrance while string lights illuminate a clearing in the woods.

CORNISH CABIN

Cuckoo's Nest
Gjerstad, Norway

CONTRIBUTED BY
Jens and Åse Trydal

Cuckoo's Nest was inspired by a typical childhood fantasy—making a treehouse. Working with a local carpenter, its owners, Jens and Åse Trydal, took four months in 2016 to build the two-bedroom structure 20 feet off the ground in the treetops of Southern Norway. It is made of local wood, solar panels provide electricity, and it has a full kitchen with a refrigerator, a stove, and hot water.

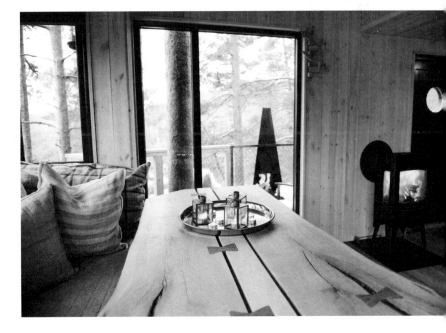

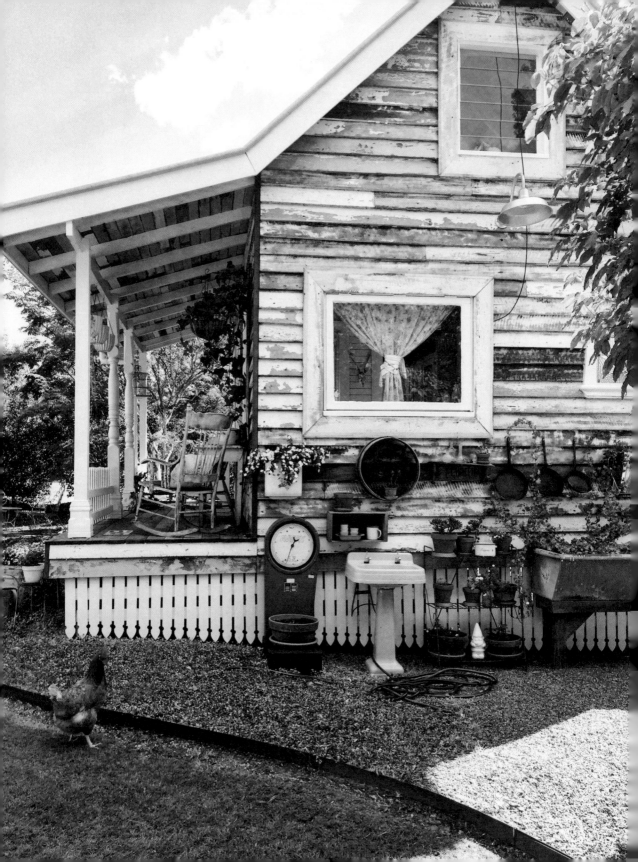

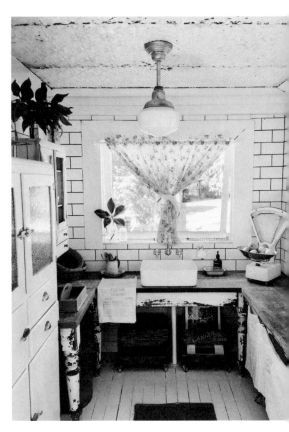

My Bespoke Cabin
Brisbane, Australia

CONTRIBUTED BY Skye Kelly

Skye Kelly built her first dwelling as a way to cope with trauma. The 46-year-old mother of two found the process cathartic—a creative outlet she could pursue despite her modest means and a lack of formal construction and design training. She watched YouTube videos, searched the web, relied on her father for support, and scoured demolished buildings for materials. Among her finds were veranda boards from a century-old farmhouse in the Glasshouse Mountains, double doors from a Nundah State School, and vintage painters' planks that she assembled into a kitchen bench. Kelly later built a second dwelling—a workshop/creative space nicknamed "The Chapel"—while her bespoke cabin has become a favorite destination for family campouts and film and photo shoots.

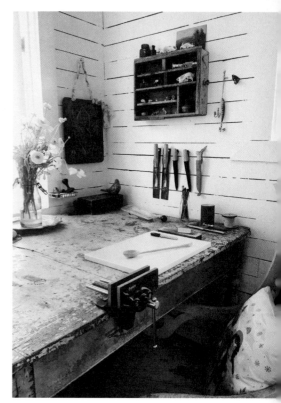

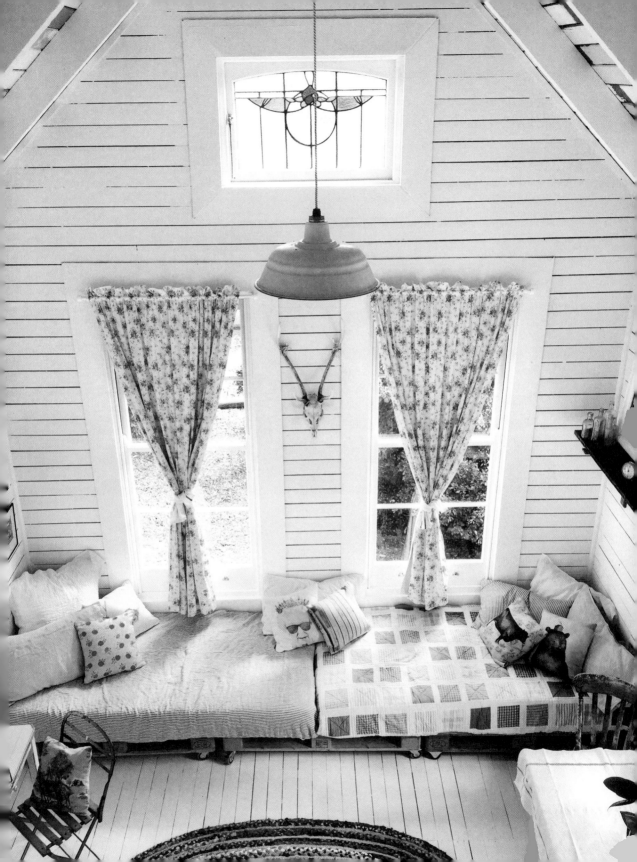

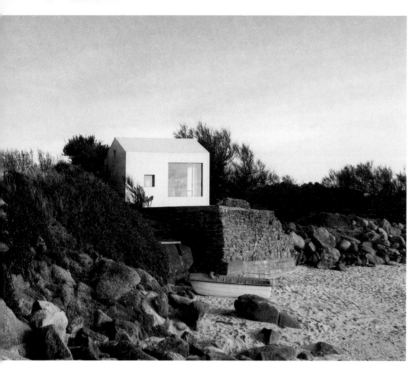

Viking Seaside Summer House
Fermanville, France

CONTRIBUTED BY
FREAKS Architecture

PHOTOS BY Jules Couartou

This refurbished concrete fishing shack on France's Cotentin Peninsula was originally built in the 1950s on a rock facing the sea. Its dimensions match Henry David Thoreau's log cabin in Walden—10 feet by 15 feet—and France's strict coastal regulations meant its size and shape couldn't change during restoration. So FREAKS, a Paris architecture firm, did what it could, adding champagne-colored galvanized metal cladding as insulation and two large sliding windows that open onto the horizon. A double bed is in the mezzanine, a large outdoor terrace looks onto a pink granite landscape, and the lounge area has a table for eight, thanks to folding armchairs designed by Icelandic architect Valdimar Hadarson.

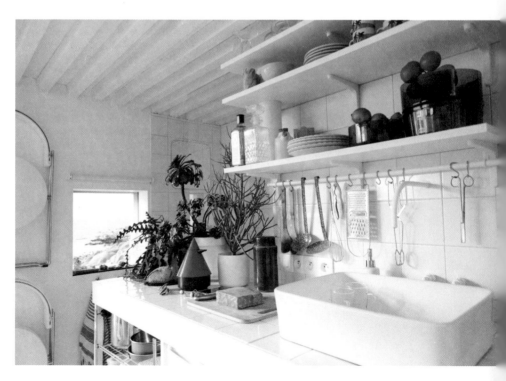

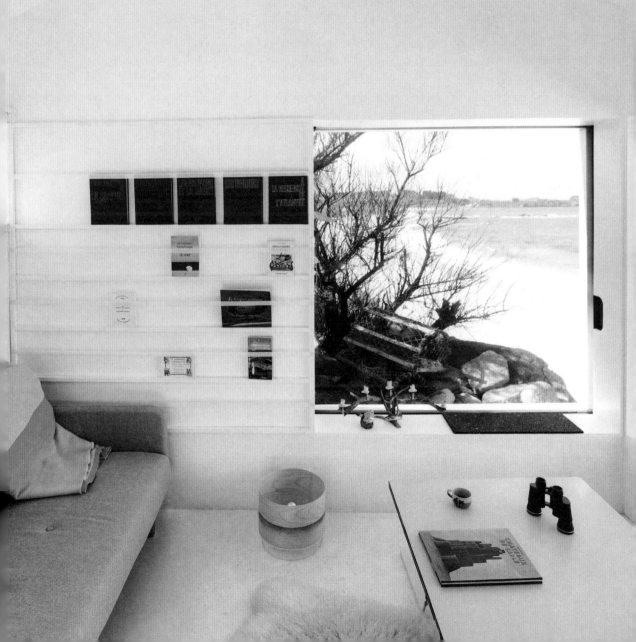

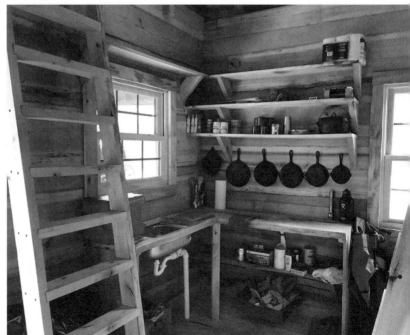

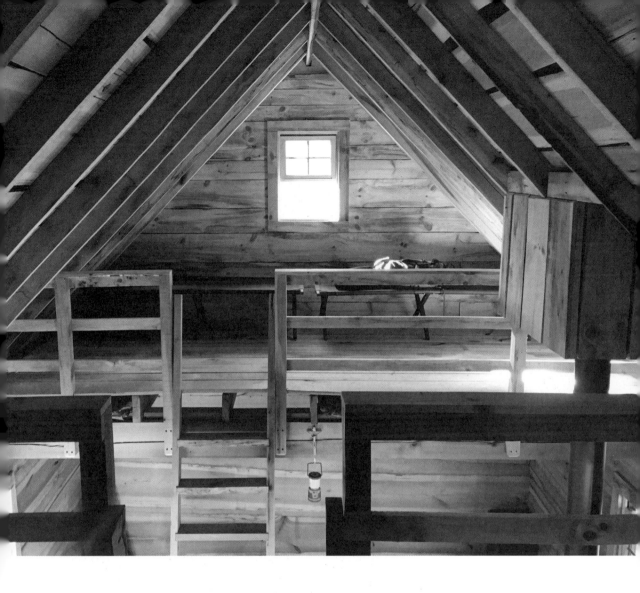

Westbrook Cabin
South-Central Kentucky

CONTRIBUTED BY Seth Spears

This five-year-old cabin was built in the remote woods of south-central Kentucky for hunting trips. Its owner, Seth, had always loved old Appalachian cabins, so when he decided to build Westbrook he relied on the style as a model. A grove of poplar trees on the property provided the wood. The logs were timbered and aged for 10 years, then cut to size with a portable sawmill; each log was notched with a chainsaw and stacked by hand. Seth kept the footprint small, with double lofts that sleep six on cots and a downstairs space that's perfect for cooking, playing cards, and relaxing by the wood-burning cookstove.

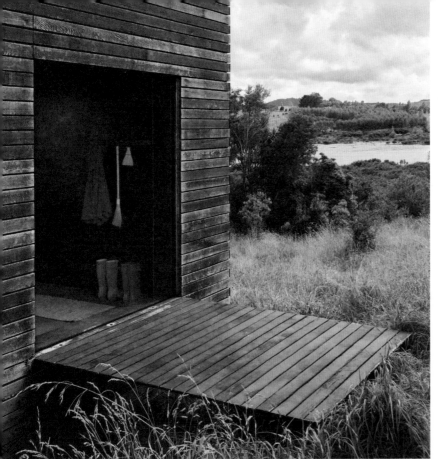

Eyrie
Kaiwaka, New Zealand

CONTRIBUTED BY
Cheshire Architects

PHOTOS BY Nathalie Krag

PRODUCTION BY Tami Christiansen

These twin cabins near Kaiwaka, in New Zealand's Northland, are barely larger than four sheets of plywood. Entirely off-grid, they sit on a sea of rolling grass alongside an estuary, where they collect rainwater and use solar power. Built from fast-growing timber, without paint or polyurethanes, the design relies on oils and a charring process to seal the wood. Each cabin has a tiny kitchen, with a gas burner for cooking, and there's an outdoor shower on a large boulder.

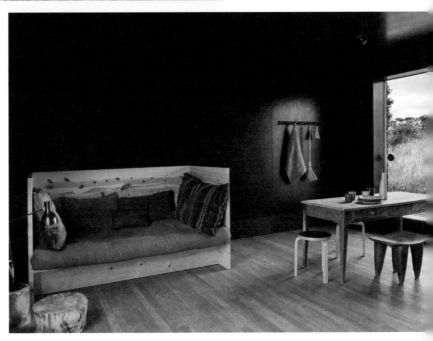

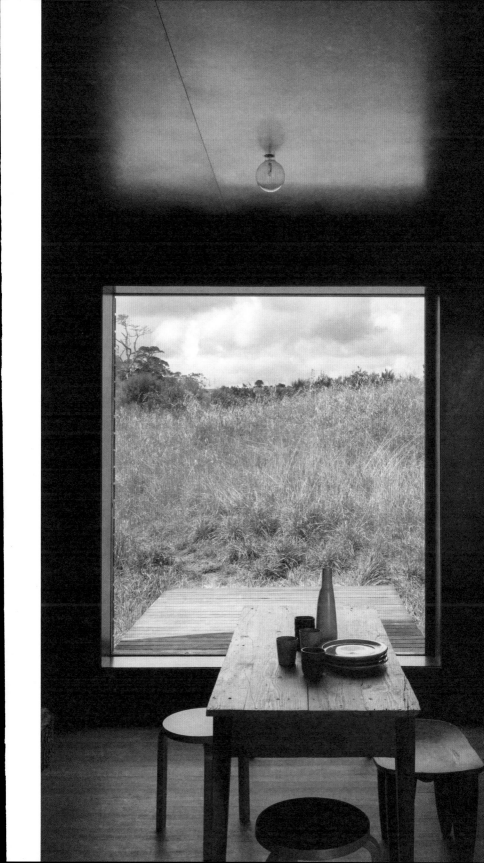

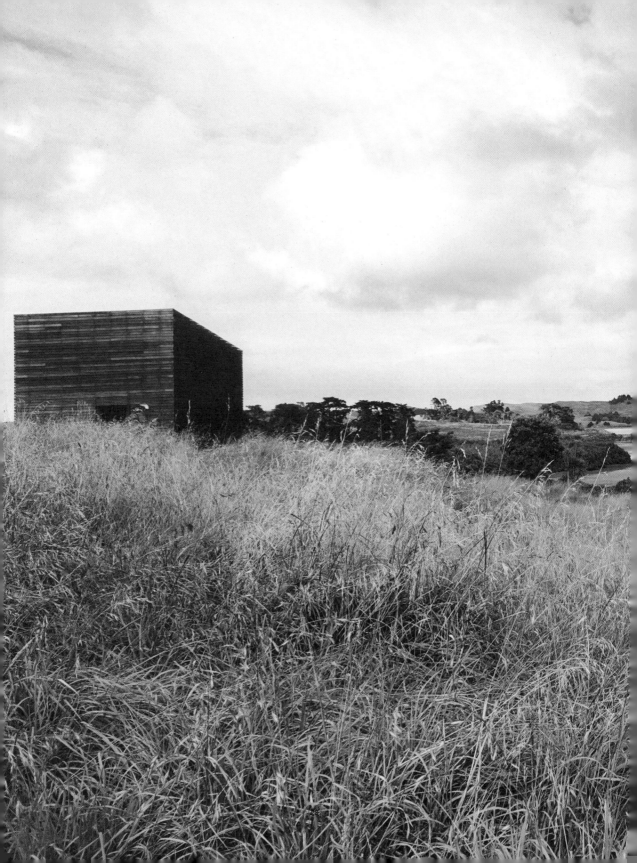

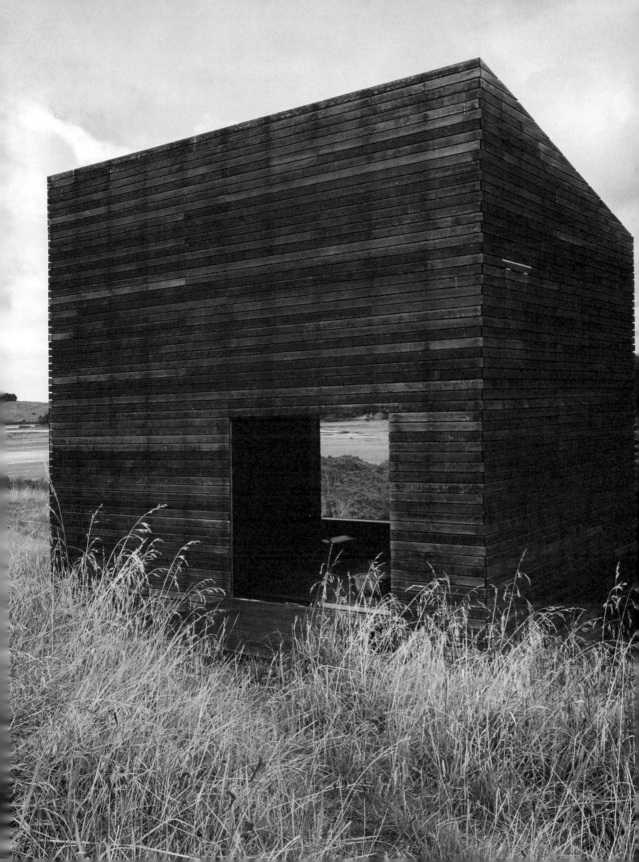

The Birdhut
Windermere, British Columbia

CONTRIBUTED BY
Studio North

The Birdhut is a treetop perch on a forested hillside in British Columbia. Immersed in the canopy, the hut accommodates two people, twelve varieties of birds, and whatever inquisitive critters come by to visit. In addition to being an inviting place for people to nest, the whimsical façade has twelve birdhouses, each designed for various local birds that live in the mountains of the Columbia Valley.

The hut, which sits 9 feet above ground, is nestled in a cross-braced structure built of sturdy lodgepole pines foraged from a nearby forest recently ravaged by fire. The platform and cladding are made of planks reclaimed from an old cabin deck; the front façade is clad with western red cedar shingles cut with a custom rounded profile. The roof disappears with clear polycarbonate panels, allowing the sun to heat the hut; two circle windows ventilate it. A bridge connects the Birdhut to the hillside, and a stone path leads down to a natural spring and campfire.

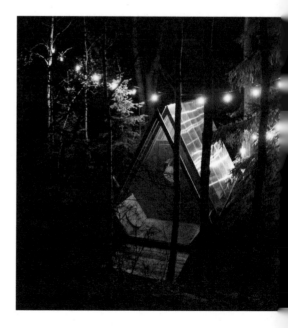

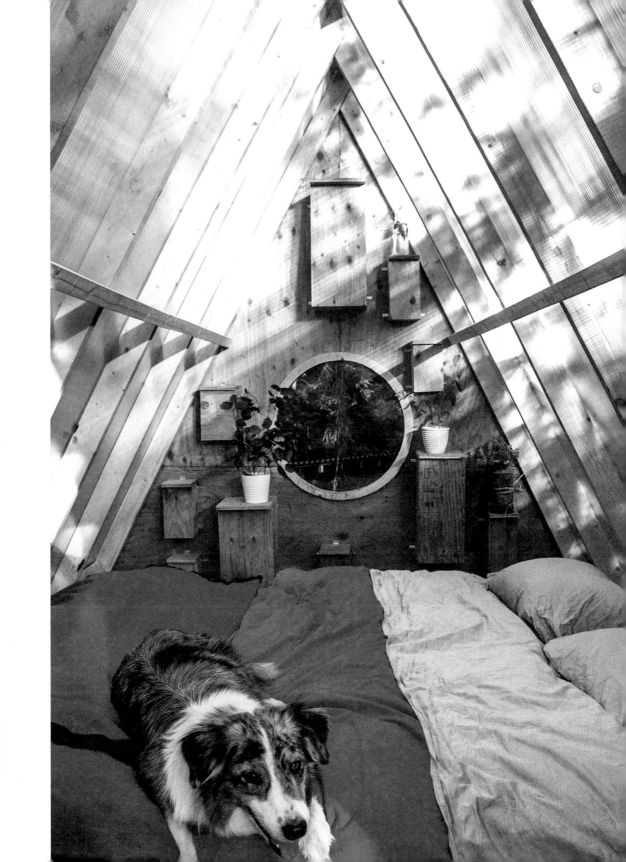

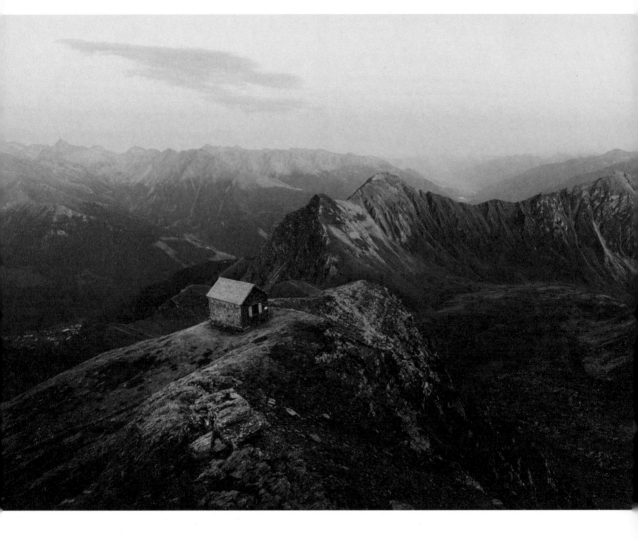

Böseckhütte
Hohe Tauern, Austria

CONTRIBUTED BY DAV Mülheim

PHOTOS BY Felix Finger

Located 8,500 feet above sea level, the Böseckhütte Shelter is located on a high mountain trail in the Austrian Alps. It took 20 years to build—construction began in 1912—and it is as spartan as you'd think: there's no oven and no water. It's just four beds, a few blankets and candles, and the patter of mice.

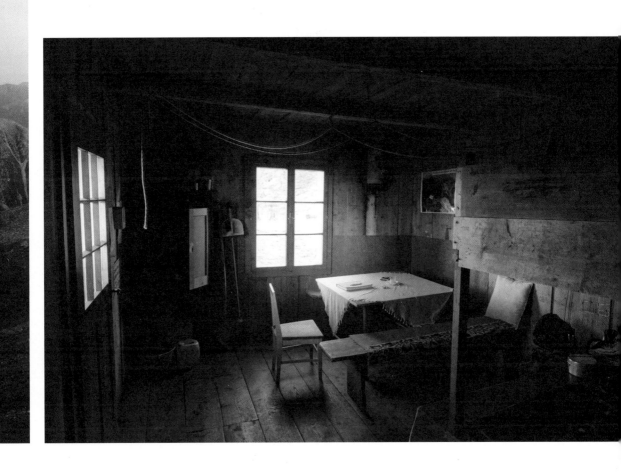

The Rivers of North America

Shantyboat

Contributed by **Wes Modes**

Photographs by **Wes Modes,
Bredette Dyer, Jeremiah Daniels**

At first glance, Wes Modes is an unlikely candidate
for the role of modern-day hobo. For three-quarters
of the year, the fifty-three-year-old is a university
professor in Santa Cruz, an affluent California beach
town, and charged with the weighty responsibility of
shaping young minds. But when summer arrives, Wes
travels to a major river—somewhere new each time—
and drifts downstream for months in a rustic 10-by-8-
foot floating cabin called a shantyboat.

The project is an homage to the historic Ameri-
can tradition of river dwellings built by poor people
and migrant workers around the time of the second
industrial revolution, from the 1850s to the 1950s.
The floating shanties were constructed of whatever
their builders could find or the waters delivered. It's a
tradition that has long since disappeared from American
waterways, but Wes keeps it alive in homage to the his-
tory of the "river people" who made their lives aboard
similar vessels. Wes's shantyboat—named *Dotty* in
honor of his grandmother, Dorothy—was completed
in 2012, but it looks as though it has been "floating in a
bayou for many, many decades," he says with pride.

In recent years, Wes's shantyboat has been towed
behind a Ford F-250 truck along 26,000 miles of road
and floated down 2,600 miles of river. With a rotating
cast of crew members, Wes has explored the Sacra-
mento, the Upper Mississippi, the Tennessee, and the

Shipmates Sebastian Muellauer and Monica Haller
relax on a warm day on the Mississippi River near
Dubuque, Iowa.

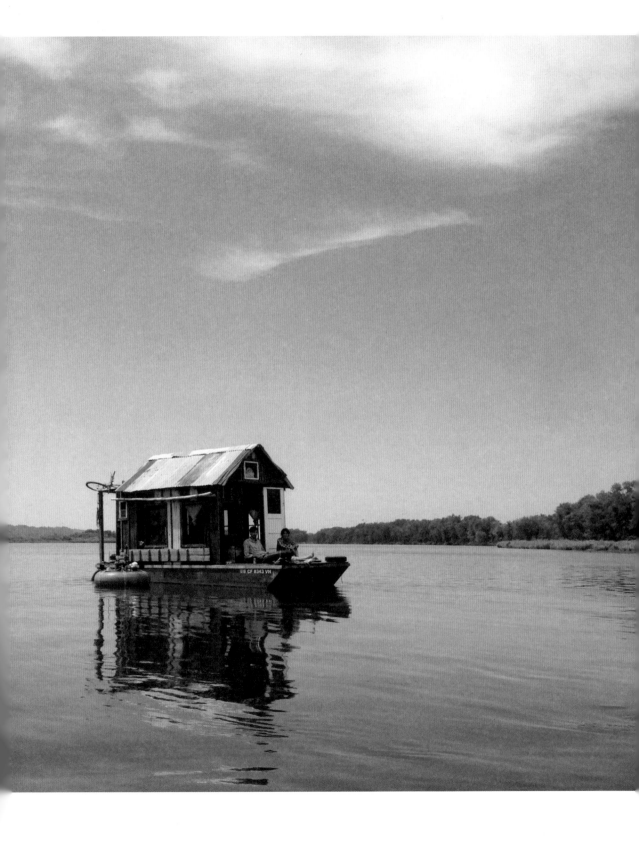

Hudson Rivers. Next, he plans to navigate the Ohio River from Pittsburgh to Louisville, six hundred miles downriver.

Before Wes was an art instructor at the University of California, Santa Cruz, he was a young artist hopping freight trains. Among the adventurers, free spirits, and troublemakers he met while riding the rails in the 1990s was one "hobo" friend who had other friends who were also hopping boats. He understood

the attraction. In both forms of travel, "you're on the back of something more powerful and it requires the same amount of knowledge, caution, and improvisation," he says. He began riding rivers on simple rafts—"stupid unlikely boats"—made of truck tires and salvaged plywood.

During those fledgling trips downriver, Wes developed a fascination with "the backyards of America," the places you see when you're away from the highways. He was amazed at how wild they were, how much nature there

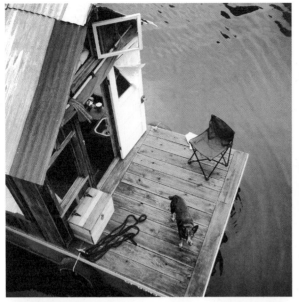

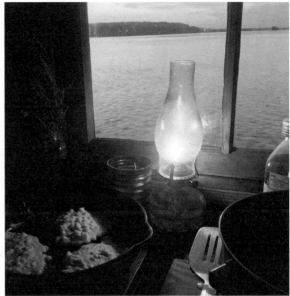

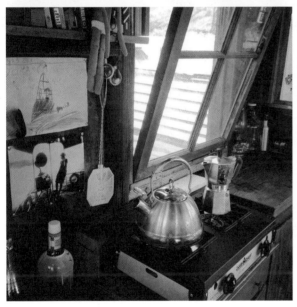

Ship's hound Hazel on the maiden voyage in Minneapolis, Minnesota.

Corn cakes and catfish for dinner on the Mississippi River near Savanna, Illinois.

The tiny galley of the shantyboat *Dotty*.

Gauges in the shantyboat's pilot's corner.

Even with its modest dimensions, the shantyboat has an extensive library of reference books, novels, and trashy reading.

OPPOSITE Every wall and corner has storage. "Shipshape" means a place for everything and everything in its place.

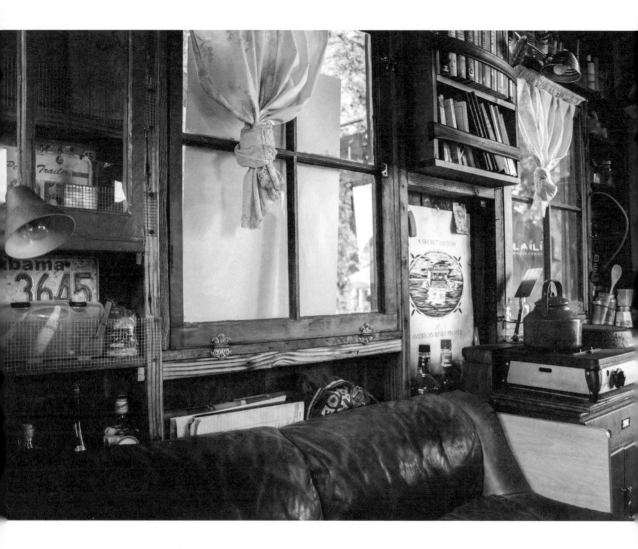

was to experience on American waterways, just around the bend from big cities and major industry.

The rafts that Wes and his friends built were seasonal. They'd put them together over a few days while camped on a riverbank, push them into the water, and spend a chunk of the summer floating downstream. On these simple floating platforms, they might put an old couch they'd bought at a thrift store, some carpet remnants, or a simple tent roof to protect them from summer thunderstorms. The rafts could be plush, Wes insists. But they were unpowered and, ultimately, disposable—built for a moment and left behind after they'd served their purpose.

After five summers of rafting, Wes began to crave a more permanent boat. In 2011, he conceived of a project—part art installation, part oral history, and part

adventure—about the history of American shanty-boats. And he would hand-build his research vessel: a shanty of his own.

Wes began digging through historical sources and archives, including issues of *Popular Mechanics* magazine from the 1940s and '50s, for a suitable design. A first-time boatbuilder, he was primarily concerned with creating a hull that would keep his shanty afloat. He'd initially planned a pontoon-style platform, he says. But as he researched, he became concerned with stability. Pontoon boats "do tend to flip if there's something heavy on top," he says.

Eventually, Wes concluded that a barge-style boat, with a flat bottom and twin keels, or skegs, would be both traditional and stable. After considering a dozen

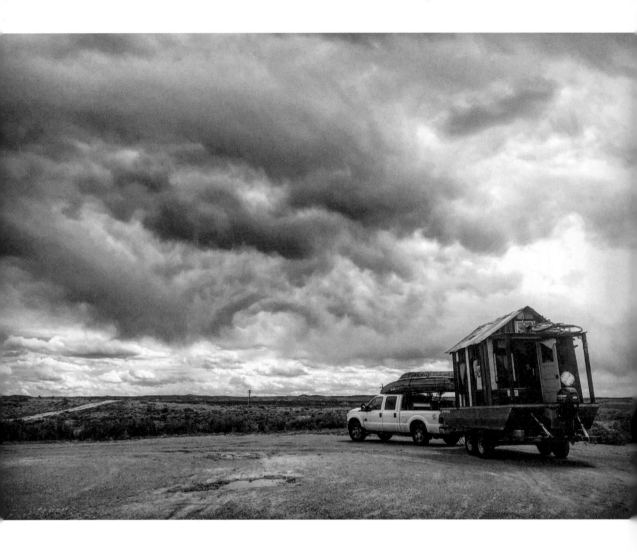

or so different plans, he settled on a hull design from designer Glen L. Witt's book *Boatbuilding with Plywood,* which Wes calls "the bible" of plywood boats.

As an artist, Wes relishes improvisation. But with this aspect of his shantyboat, Wes relinquished creativity, relying instead on the expertise of others and following Witt's plans closely. When it was finally time to build, Wes went to work with the help of like-minded friends, "about a million screws, and many cases of beer."

But once he had his hull and was ready to build the shanty's cabin, Wes gave his creativity free rein. His grandfather was a builder, and Wes was more confident constructing buildings than building boats. Growing up, he says, he'd often wake up to the sound of his grandfather's hammering and leap out of bed to

help. As the two generations worked together on building projects that repurposed old materials, Wes's grandfather "showed me the value of reuse and recycling long before those were values that America rediscovered," he says. With *Dotty,* Wes drew upon the skills and values his grandfather had taught him and, in the shantyboat tradition, built his cabin from scrap.

A century ago, when shantyboats were a common sight on American waterways, there were sawmills up and down most major rivers. People would build their floating homes out of the milled wood that floated downriver. Wes had to work a bit harder for his materials. He pulled apart a hundred-year-old chicken coop for its wood, and when the owners asked if he wanted to take down a nearby outhouse as well, he jumped at the chance. The boat's deck

The shantyboat crew is welcomed to New York City by the North Brooklyn Boat Club on Newtown Creek under the Pulaski Bridge.

OPPOSITE The project has traveled 2,400 river miles and 25,000 miles by highway. Towing a 7,000-pound boat across the continent is the most perilous part of each journey.

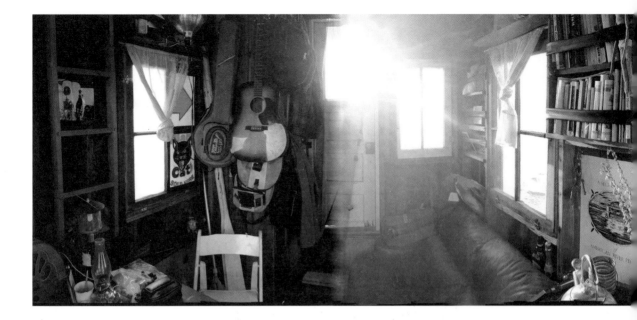

Sunset on the Upper Mississippi River
near La Crosse, Wisconsin.

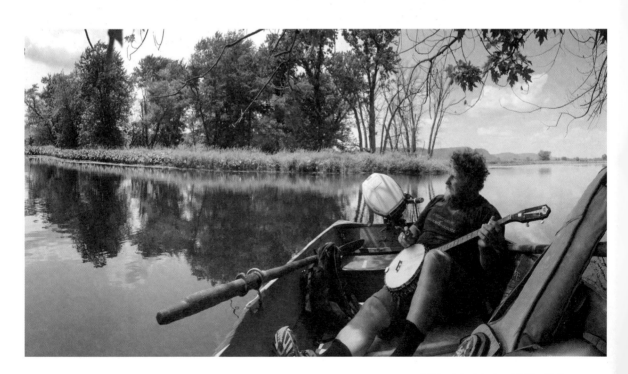

Artist and shantyboat captain Wes Modes
relaxes in the johnboat on the Mississippi
River near Brownsville, Minnesota.

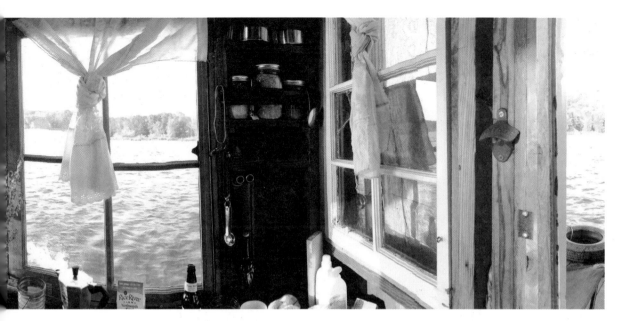

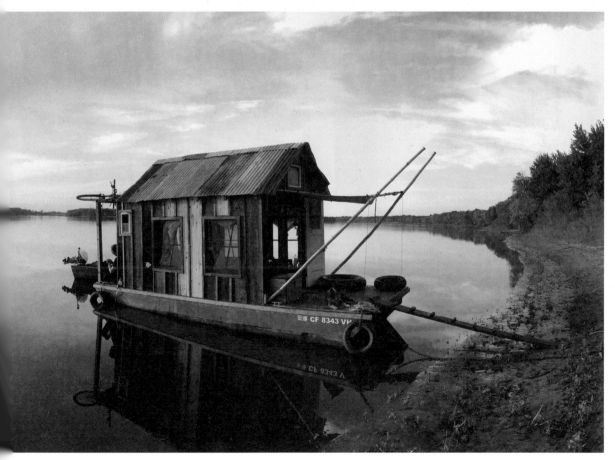

Beached on the banks of Sturgeon Bay in New
Boston, Illinois, on the Upper Mississippi River.

SHANTYBOAT

Friends helped at every stage of the shantyboat being built. *Dotty* was constructed over a period of two years, mostly from reclaimed and recycled material.

OPPOSITE At night the crew cooks, plays cards, and drinks whiskey. Here, they're beached on the quiet shores of the Sacramento River near Grimes, California.

was built of old-growth redwood fence boards because "everyone has a fence in California." He topped his shanty with a gabled roof. The choice was initially an aesthetic one. But soon, Wes saw the practical merits of the design and built a loft into the gable that's just big enough for a cozy but comfortable double bed.

Historic shantyboats were built by people on the margins of society—migrant laborers who constructed these simple structures to take their homes and families in search of new opportunities. For Wes, *Dotty* is a tangible connection to that tradition, which he documents in his ongoing oral history project, A Secret History of American River People.

But the shantyboat has other joys. Everything has a place: "I love that feeling of needing something and

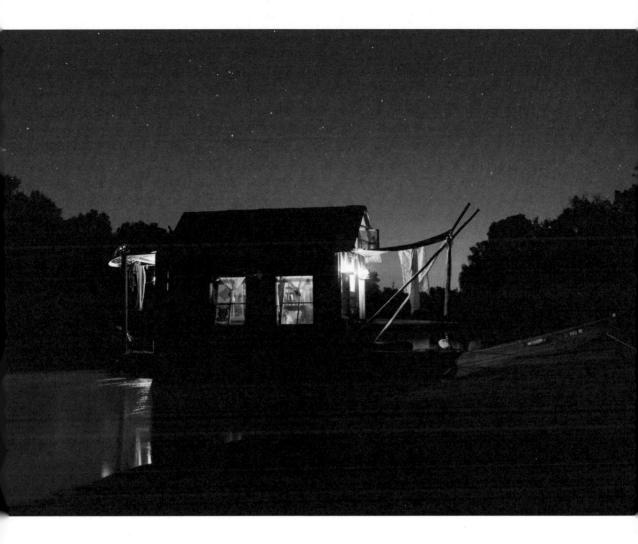

knowing exactly where to find it," Wes says. There are built-in food cabinets and bookshelves, a bar behind the couch, and shelves in "every nook and cranny." Over the years, Wes has continued to improve his shantyboat, installing electrical outlets for when *Dotty* is plugged into shore power, lanterns for added light, and more storage for things that have proved essential: "pencils and marine radios, maps and rope, towels and spices." Wes says that despite its 80-square-foot layout, *Dotty* doesn't feel crowded even when there are several people working on the boat at once.

Next, Wes will launch *Dotty* in Pittsburgh, Pennsylvania, and float past some two hundred riverfront towns before ending his trip in Louisville, Kentucky, in August of 2019, when it's time to resume another semester in Santa Cruz. From friends, he's heard that the Ohio River is "big and immensely beautiful," with low banks and farmland on the northern and western shores and rugged Virginia and Kentucky mountains to the east and south. Unlike other builders, Wes has no fear of tiring of his cabin's setting. The Ohio River alone could occupy his attention for several summers. It's nearly a thousand miles long, he explains, "so there will still be more to explore later."

For Wes, there will always be more to explore later.

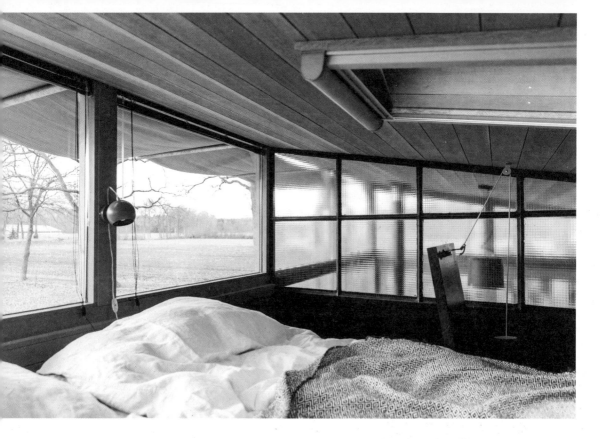

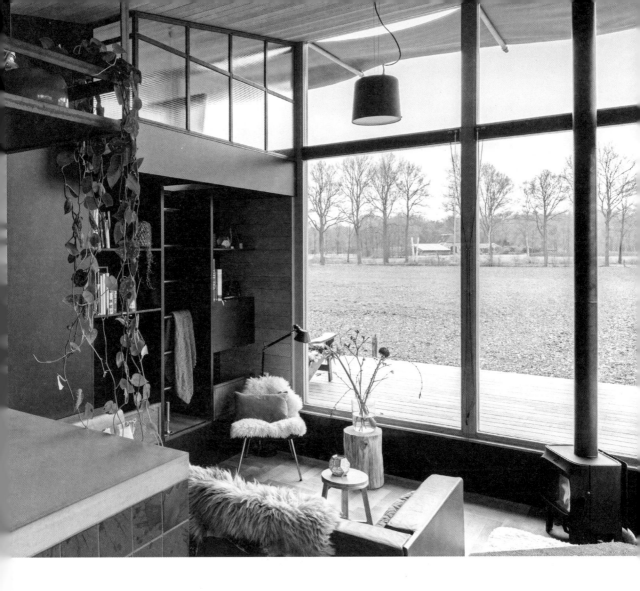

Cabin 01
Lettele, The Netherlands

CONTRIBUTED BY
Getaway Projects

PHOTOS BY Margriet Hoekstra
and Barbara Natzijl

Never able to find "a nice place to stay" while vacationing in their own country, Paulien van Noort and Arno Schuurs decided to create one themselves. They built their cabin of Oregon pine in two prefabricated parts with the help of a contractor who was also a friend. Once completed, they needed a home for Cabin 01. They ended up finding an ideal spot—10 acres of forest surrounded by meadows—near their home in Diepenveen.

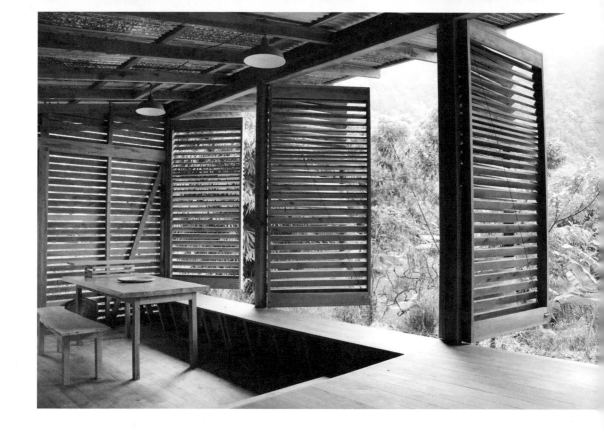

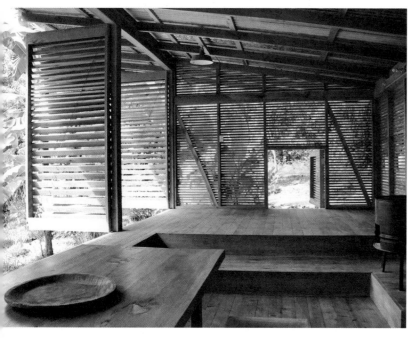

The Dugout
Tumbas, Costa Rica

CONTRIBUTED BY Andrew Sieger

The Dugout is a 300-square-foot hand-built cabin on a farm in southwest Costa Rica. Constructed of a local species of cypress grown and milled near the cabin site, the cabin was built by Andrew and friends under the guidance of Jeffrey, a local carpenter. Enclosed in slatted walls and large shutters, the cabin acts as a sheltered viewing platform overlooking the surrounding jungle. Deep eaves protect a single interior space with room for eating, living, and sleeping. The sleeping level, raised 18 inches above the main floor, allows for a comfortable bed and meditation area while connecting to the rest of the space by a full-length bench and step designed for hanging out. Though the cabin is small, the large shutters fully open to reveal views of a 600-foot jungle-covered palisade and an experience much larger than its footprint suggests.

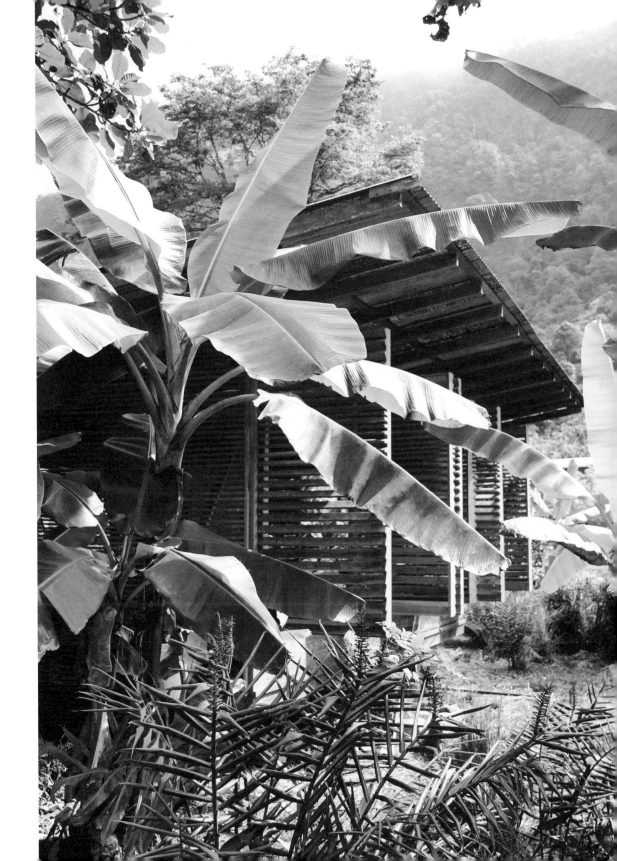

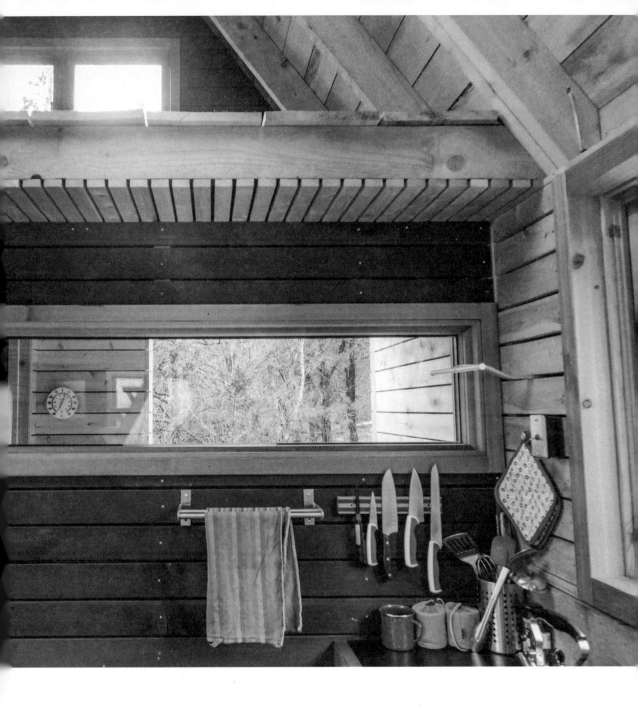

The Raven House
1,000 Islands, Ontario

CONTRIBUTED BY Pete Long

EXTERIOR PHOTO BY Finn Long

INTERIOR PHOTOS BY Chris Daniele

Built in 2016, the Raven House is off-grid, solar powered, surrounded by forest and water, and designed to offer a refuge from city life. One of its owners, Pete Long, designed and built the cabin over four months using locally harvested cedar, pine, and spruce from a small, local mill; he dug up most of the windows, doors, and skylights from a Habitat for Humanity project.

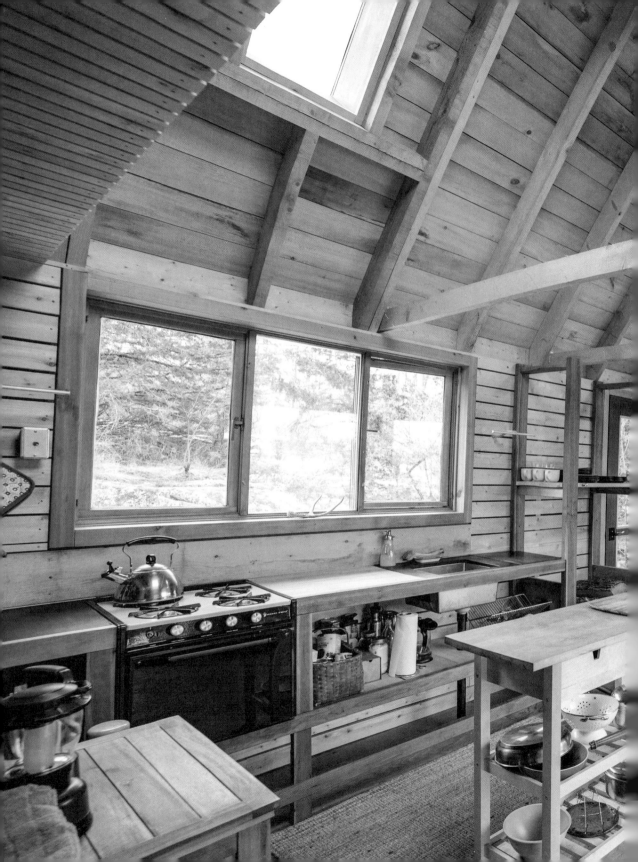

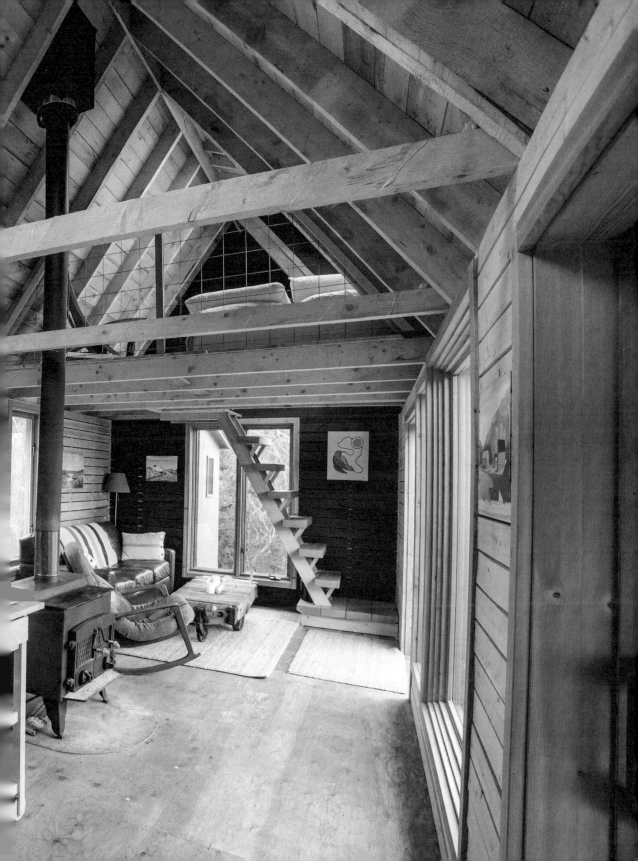

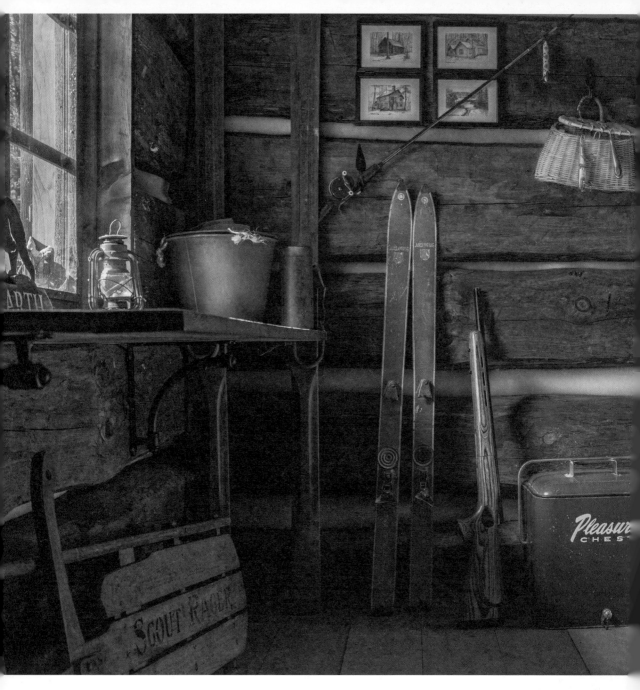

Campbell Family Cabin
Kawartha Lakes Region, Ontario

CONTRIBUTED BY Luke Campbell

Kirk Campbell built this log cabin in 2016 for maple syrup season, when the trees drip sap and his family gathers to harvest it. The structure is entirely handmade from dovetailed pine logs, a mortise and tenon log railing, and a pine ladder leading to a loft. Kirk's son, Luke, says the structure was inspired by Richard Proenneke, the naturalist and talented craftsman whose legendary Alaskan cabin is now listed on the National Register of Historic Places.

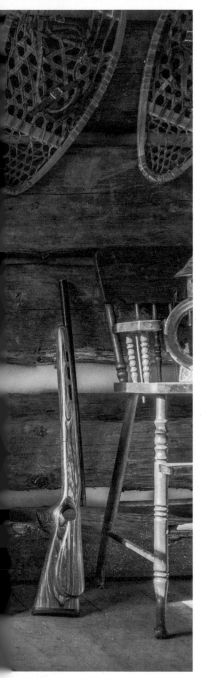

Sky Den
Keilder Forest, England

CONTRIBUTED BY Studio Hardie

PHOTOS BY Jack Boothy

Set in northeastern England, Sky Den was built in the Keilder Forest for the British television program *George Clarke's Amazing Spaces*. Its designers sought to "blend together the best of outdoors and indoors" with a versatile space that includes fold-away furniture, a wide balcony with impressive views of a fast-moving river below, and a roof that opens entirely, revealing an unobstructed look at Northumberland's amazingly dark skies.

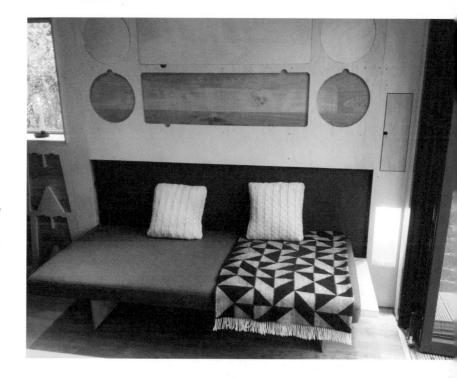

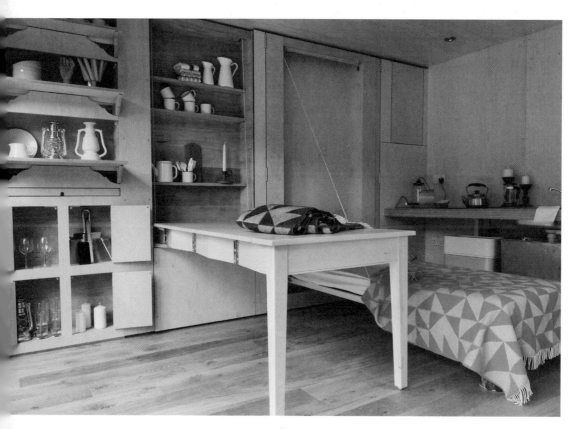

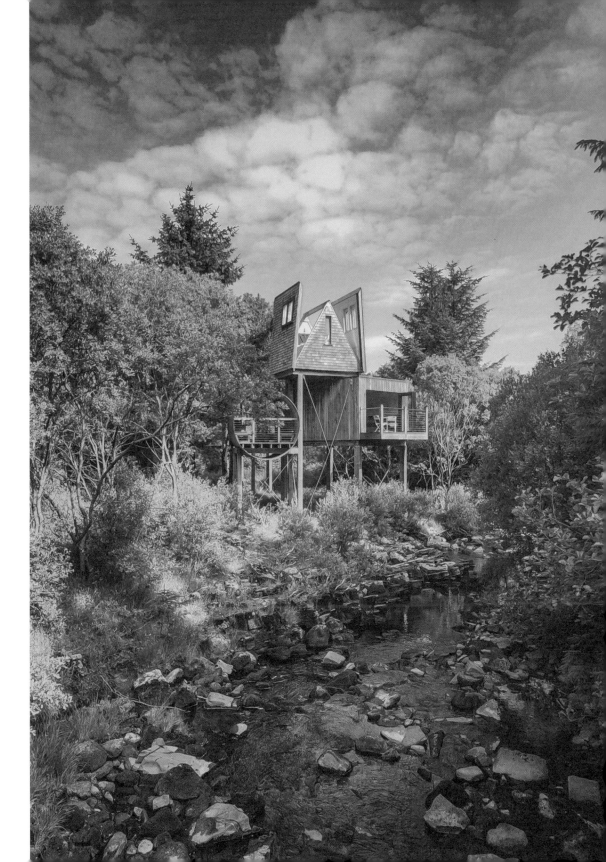

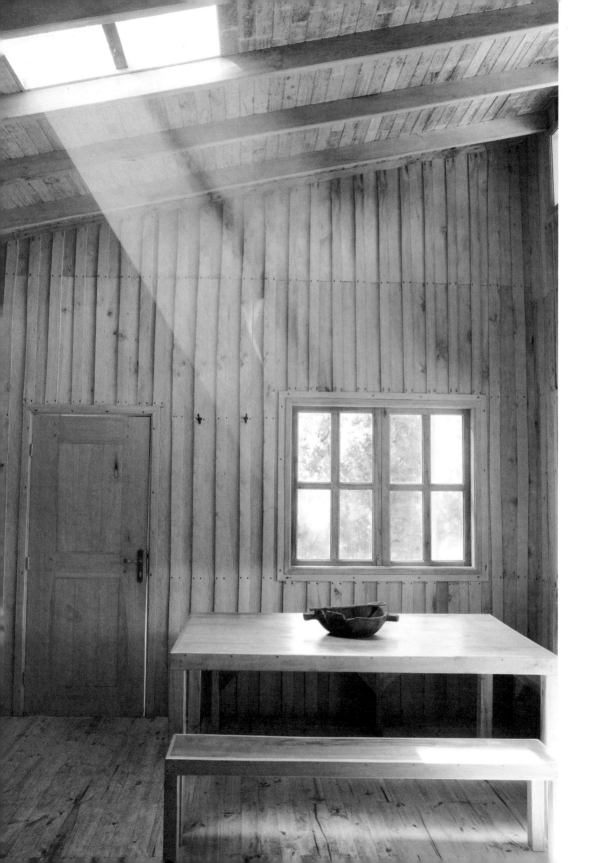

Refugio
Patagonia, Chile

CONTRIBUTED BY
Brady Liljemark, Brian Nash,
Charlie Ferguson

PHOTOS BY Charlie Ferguson

Built in a remote corner of
the Chilean Patagonia, this
cabin was dreamt up by three
longtime friends who met
while serving as Peace Corps
volunteers. They fell in love with
the region during a trip there
and left owners of a rugged,
wildly beautiful, often boggy
patch of Patagonia. Though
the land was six hours from
the nearest road, the friends
were determined to make it
a core part of their lives. So
they began designing a cabin.
Functional simplicity was their
guiding principle: one room
for shelter, a wood-burning
stove for cooking and heat, two
platforms for sleeping plenty of
friends and family, and ample
windows for natural light.

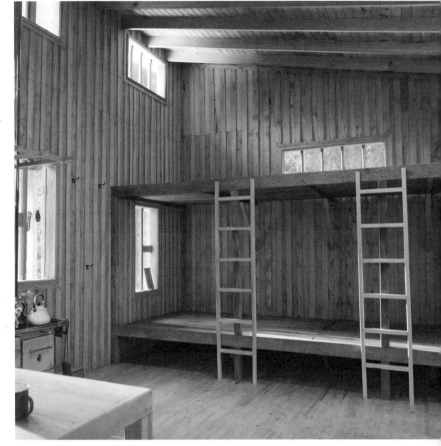

Despite the project's remote
location, they found a local
master carpenter and a three-
person crew with experience
building in the region. Supplies,
tools, a generator, a wrought-iron
stove, and food were hauled
in by pack horse; nearly all of
the wood came from dying
native trees that were felled
and milled on site. Four months
later, the cabin was done. Its
central room was spacious and
light-filled with high ceilings.
The kitchen has a stove, while
a hand-crafted wooden table
allows communal dining. A
nearby spring and the magic of
gravity provides the cabin with
running water. The three friends
and their families begin every
year with a trek and stay at the
cabin. They spend the rest of
the year dreaming about it.

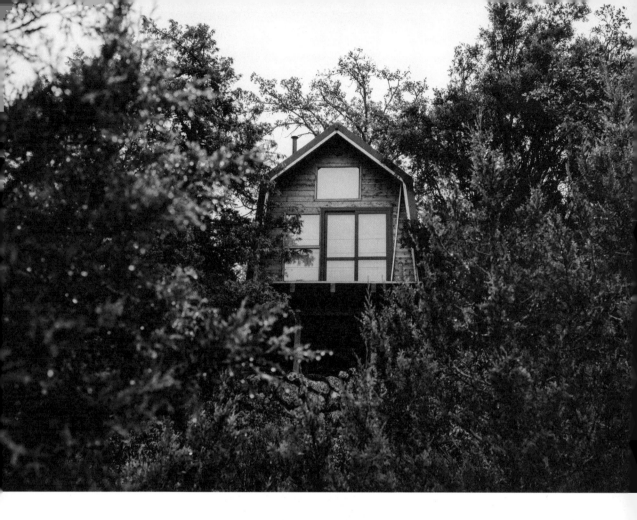

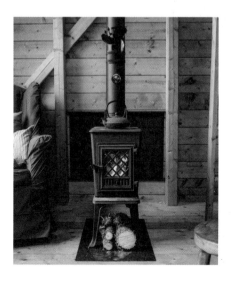

La Cabin Boreal
Segovia, Spain

CONTRIBUTED BY
Javier, Arturo, and Juan Herrero

The Herrero family built La Cabin Boreal in a remote valley in Segovia, Spain, with the aim of creating a space for creativity and inspiration. After carefully selecting an elevated spot between three trees—an oak, a holm oak, and an old juniper—the gambrel-style structure was built atop granite boulders with wood and salvaged materials. It has two skylights, two large windows, and two floors, one with a kitchen and one for sleeping or relaxing.

The brothers behind the cabin—Javier, Arturo, and Juan—say they built a place that's not just an escape hatch from the strenuous rhythms of life, but a "shrine" for family and friends, a place where "one can heal the soul and view life from a different perspective."

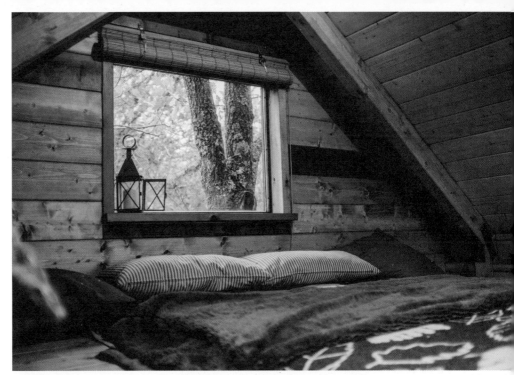

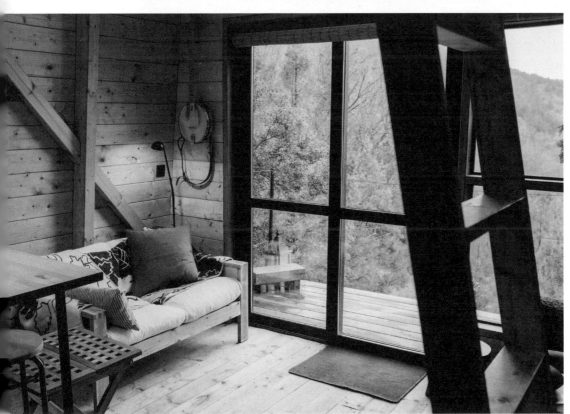

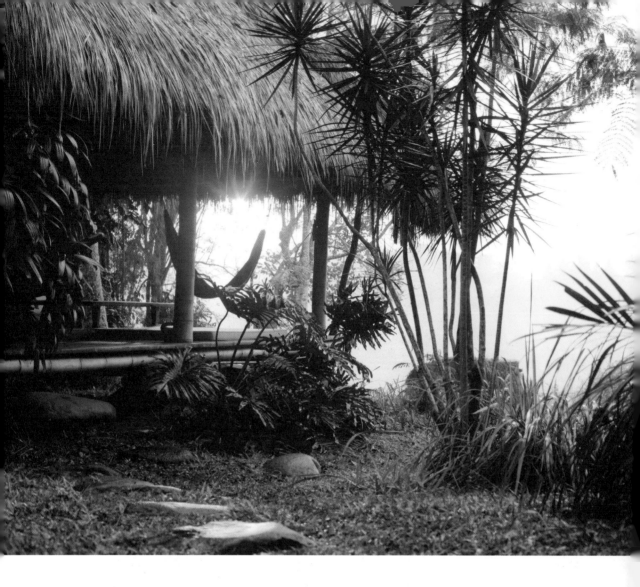

Bonzu
Bali, Indonesia

CONTRIBUTED BY Zissou

Bonzu was designed with a challenge in mind: its builder and owner, Zissou, wanted to live as close to nature without forgoing modern luxuries like electricity and hot water. So he built a bamboo and grass thatch structure with no walls, doors, or windows. He has no paintings, no ornament—"nothing extraneous or without practical purpose and nothing that can't easily and cheaply be replaced or repaired," he says. The result? "A tremendous sense of freedom."

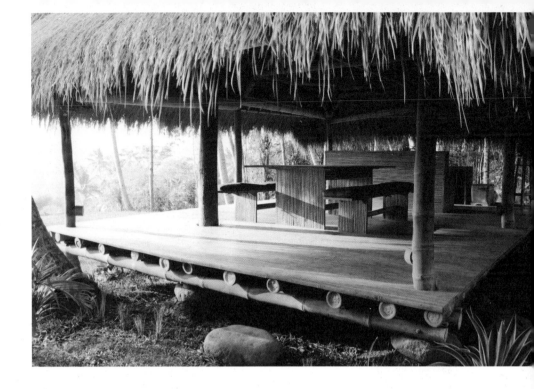

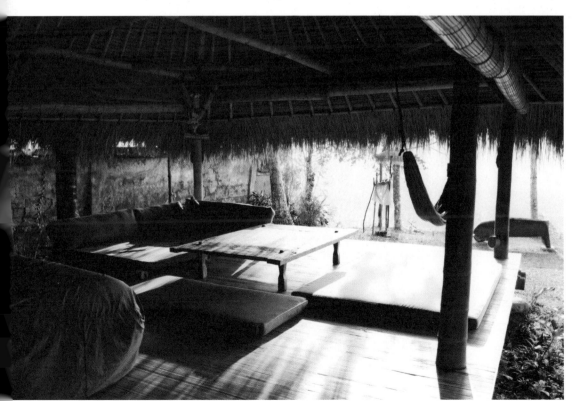

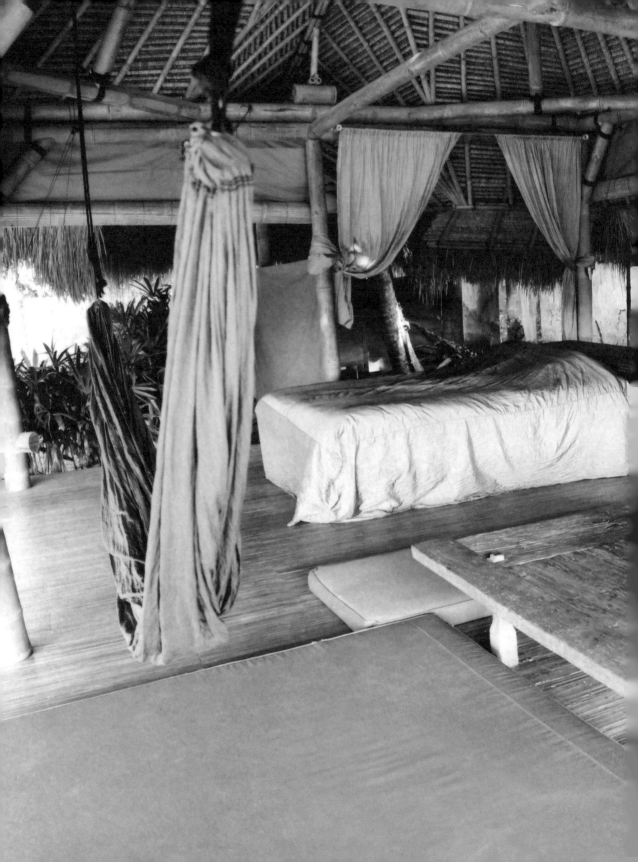

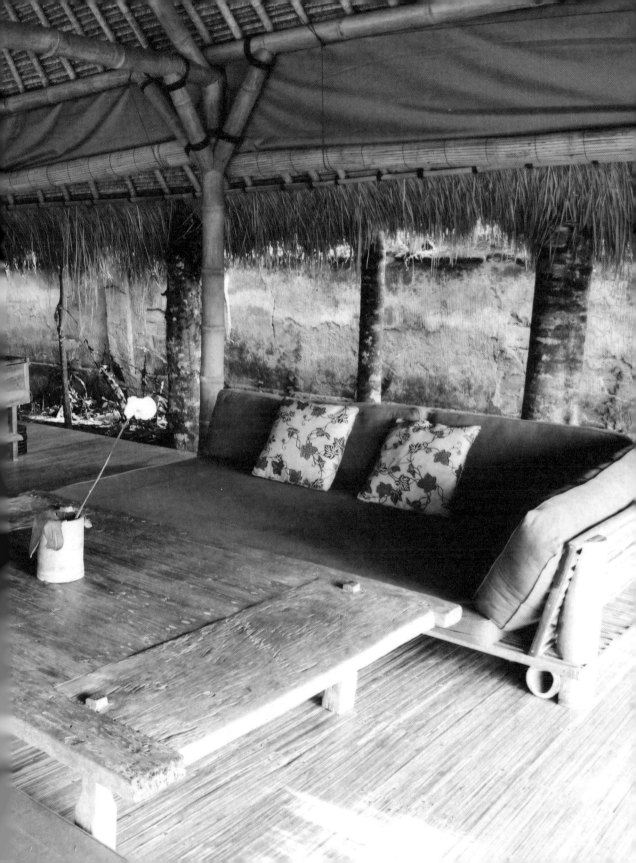

Naganuma, Japan

Naohiro's Escapes

Contributed by **Naohiro Nakamura**

Photographs by **Naohiro Nakamura**

Naohiro Nakamura was working in Tokyo as a systems engineer, a well-paying job in one of the most exciting cities in the world, when he decided he'd had enough. Originally from the northern prefecture of Hokkaido, Nao had found beauty in Tokyo's frenetic urban landscape. "When I got off the train at Shinjuku for the first time," he says of the city's flamboyant entertainment district, "I remember thinking, Is there a festival today?"

But despite the stimulation of life in Tokyo, Nao says he felt as though he "lived to work." So in 2007, he, his wife, Meguri, and their Italian greyhound, Napoli, took off on a two-month road trip from one end of their archipelago nation to the other. It was an adventure, the kind you have when you're a young couple shifting your direction and trying to find your path. Nao and Meguri's ultimate destination—and eventual new home—was the rural prefecture where he was born and raised and where he and Meguri met, through friends, when he was just nineteen. But the trip itself would shape the life they'd lead upon their return.

During their road trip, Nao and Meguri slept in their tiny Volkswagen Golf IV, cooked with a portable camp stove, and made do with little more than a sleeping bag and two pots. Sometimes, to take a break from car camping, they stayed with friends of friends

In the warmer months Nao throws a tarp up so he can use the deck area for meals.

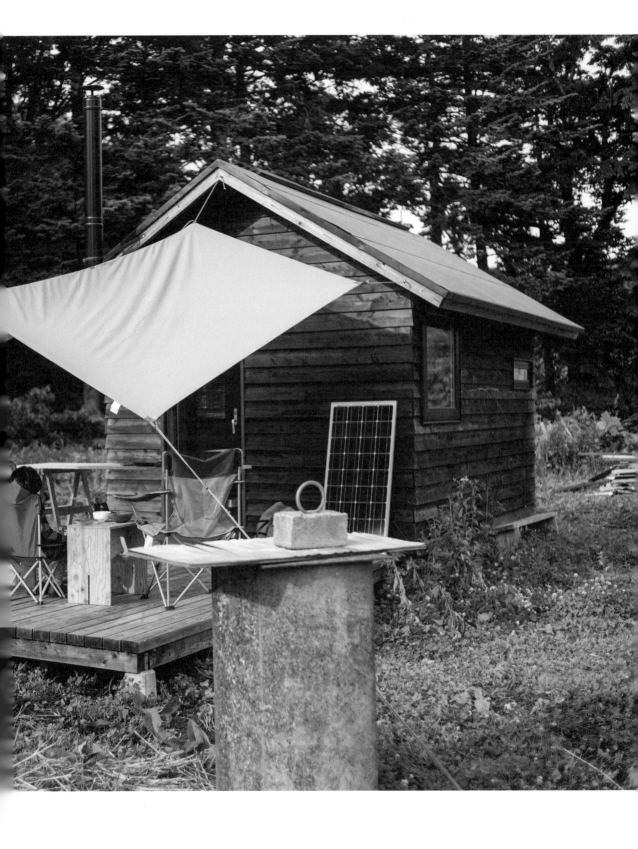

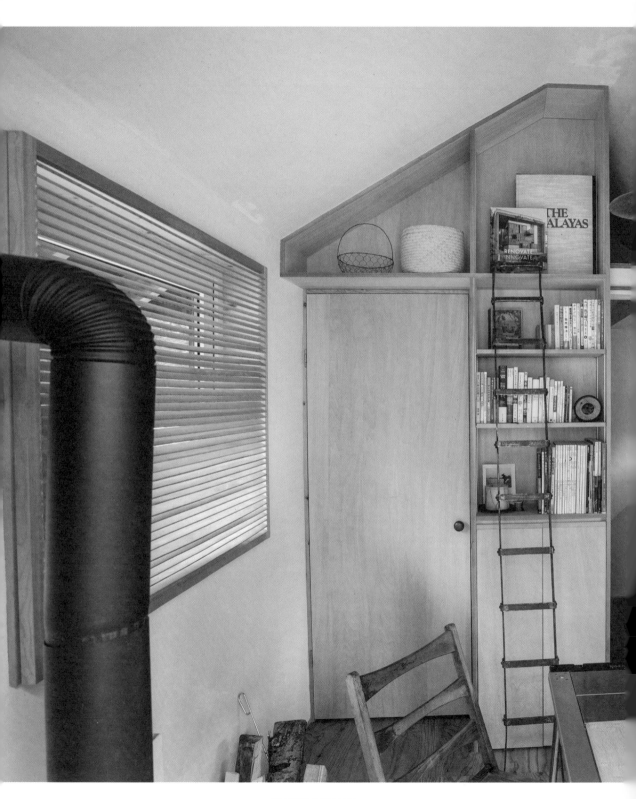

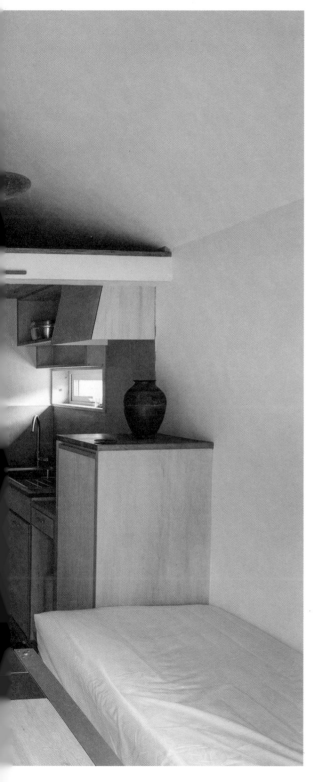

and visited organic farms that would graciously host them. Many of these rural homes had been built by their owners. "This was a revelation," says Nao. "Until that point, I hadn't met anyone who'd done this. The thought of building a home myself was incredibly amazing."

At the time, Nao was twenty-seven and wondering if there might be a different life for him than that of a big-city tech worker. In reflecting on his travels, he realized that many of the people whose lives he most admired seemed to have found a "harmonious balance between life and work," he says, "not letting one rule the other." He wanted that balance for himself, and decided to create a home that would sustain it. But first he had to learn to build—a skill he would turn into a career in his home prefecture.

Hokkaido is Japan's wildest region. It is the northernmost of the country's four major islands, populated by the Ainu, an indigenous people who have cultivated this fertile but challenging land for two thousand years. Though Nao's family is not Ainu (his great-great-grandfather was a farmer who came searching for land), he believes that Hokkaido's indigenous history should be a source of pride for all its inhabitants—a reminder for him and other descendants of the mainland Japanese that they are tenants on Hokkaido soil.

Nao's dad worked in the city hall in Iwamizawa, a small city south of Sapporo, Hokkaido's capital, while his mom raised him and his older brother. Despite Nao's suburban childhood, living on the mainland made him appreciate what set Hokkaido apart: Its wilderness. Its self-sufficiency. Its abundance. "For me it is almost unfathomable, and refreshing, that so much of this vast, rich land has remained so close to its natural state," says Nao.

Living room, kitchen, bookshelf, toilet, bed, and fireplace. All on a 10-square-meter, or 108-square-foot, footprint.

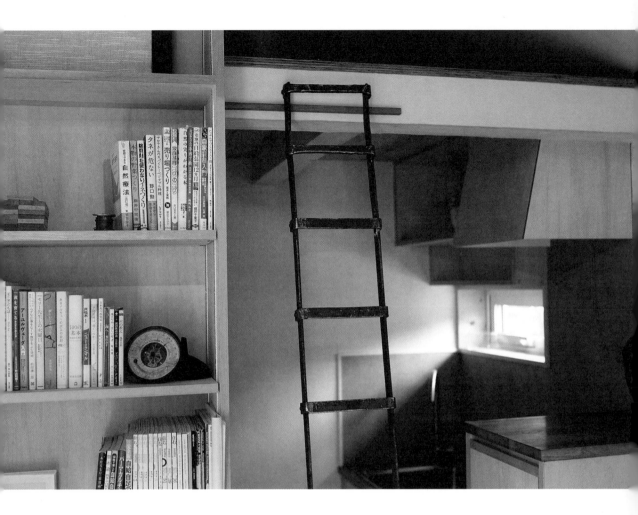

In plotting his return to Hokkaido, Nao scoured online maps for a town that he and Meguri might make their home. Finally, they settled on the eleven-thousand-person farm town of Naganuma, which was rural but still commutable to Sapporo. The community had a thriving cultural scene of artists and writers, artisan woodworkers, glassblowers and ironsmiths, as well as chefs and restaurateurs drawn to the produce of Naganuma's fertile farmland.

But returning home had its challenges. Nao's family didn't immediately embrace his decision to leave a successful career in Tokyo. "I returned without a clear idea of what I was going to do," he says. "They were a little concerned." But Nao signed up for a two-year program at Sapporo Carpentry School, followed by a three-year apprenticeship. As he established his new

career as a builder and launched his own carpentry and design company, his family's worries lessened.

Finally having settled into his new profession, Nao went about bringing his home and work into balance. He and Meguri rented a forty-year-old house outside Naganuma—an old house for Hokkaido, where most homes are nearly new. The property had a pond and plenty of surrounding acreage on which to build a work-shop and plant an extensive garden. It was the ideal home for Nao's fledgling carpentry business—and the perfect place to pursue "an uncluttered, simple life."

Building a cabin was central to his vision. Nao designed a 108-square-foot building to sit just steps from his house. The self-contained cabin would function as an office, a prototype for showing clients what he was capable of, a guesthouse for visiting family and friends,

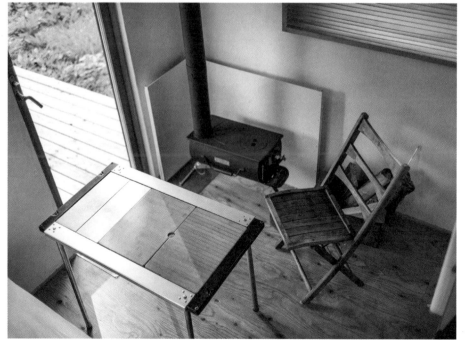

These wood blinds take time to make but Nao appreciates the diffused light they create.

L Nao's favorite seat to read a book. It's warm by the fire, within reach of the firewood, and has a view to the garden.

OPPOSITE Nao's grandfather made this ladder over 40 years ago for his own shed. Nao has "borrowed" it, he says, because it fits perfectly here.

NAOHIRO'S ESCAPES

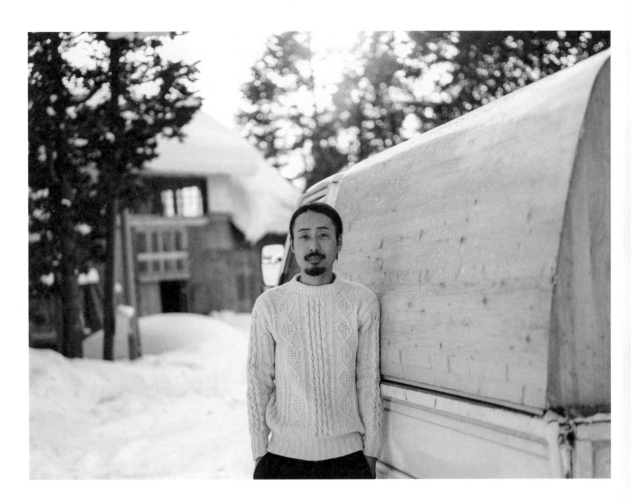

Naohiro Nakamura in the afternoon sun on a clear day in winter.

OPPOSITE Nao built this rocket stove mainly for pizza and bread. It also grills food well.

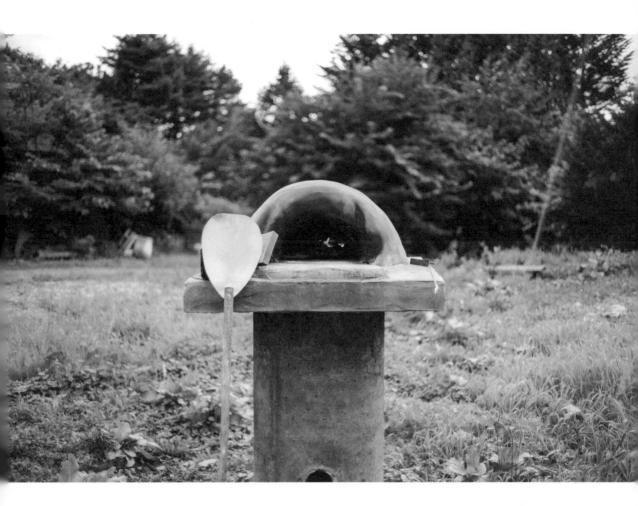

and a place to watch a movie or read a book. Within its minimalist floor plan, he included a kitchen and a toilet, a dining table and chairs, a bookshelf and storage, and a bed. Keeping with his taste for simplicity, Nao gave his design a utilitarian name. Yomogiya Cabin, as he calls it, is solar-powered and propane-fueled, with a compostable toilet and running water provided by a foot-operated pump.

Yomogiya was designed to be functional, but its personal touches hint at the idyllic rural life of Nao's dreams. Because his six-year-old son, Kinari, loves pizza—and there isn't a pizzeria nearby—Nao built an earthen oven alongside Yomogiya's wooden porch. "When I lived in Tokyo, I solved everything with money," Nao says. "If there was an issue at home, I just called the tradesman, and if there was anything I wanted, it was readily available." Now, he says, "if there's something that needs doing, I will try to do it myself." Nao sees the parts of rural life that seem inconvenient—like fieldwork in the summer and

shoveling snow in the winter—as opportunities. "You do not need to go to the gym here," he says.

Yomogiya is not a stand-alone project. Instead, it's one piece of what Nao describes as a system to facilitate his "ideal life." Yomogiya is surrounded by vegetable fields where he grows rice and tomatoes, cucumbers and potatoes, zucchini and soybeans, green beans and mizuna, carrots and cabbage, and much more. "In this lifestyle I feel happy in a way that I didn't experience when living in the city."

"The Hut"—the second piece of Nao's system— "allows me to take this lifestyle on the road," he says. Nao calls his traveling cabin, a 1994 Toyota Hiace truck with a striking, hermit crab–like removable shell top, Hut on a Truck. It is both an extension of Offgrid and a stand-alone retreat—a pared-down mobile home that is also Nao's work vehicle. It was inspired by another, more ancient human conveyance: the canoe.

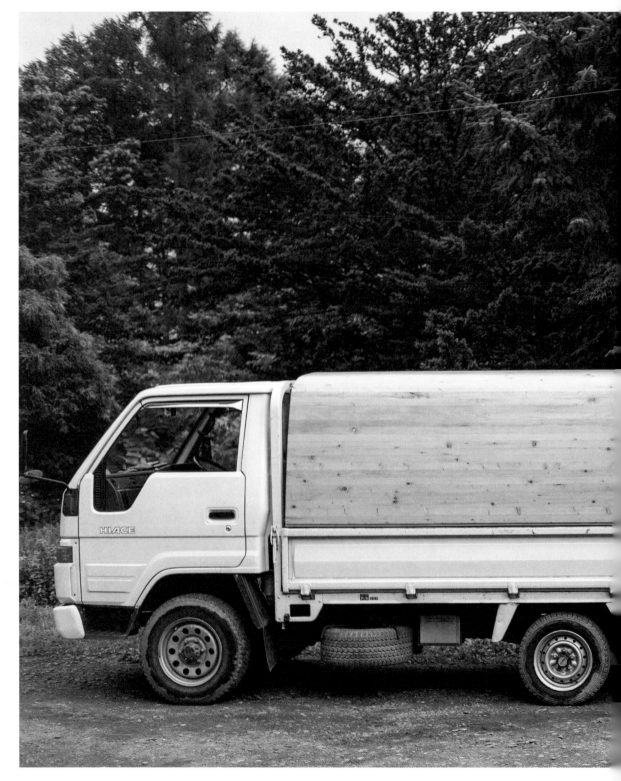

Hut on the Truck in camping mode. The kitchen
flat-packs and the tarp 'ceiling' is also used as
the door when not covering the kitchen.

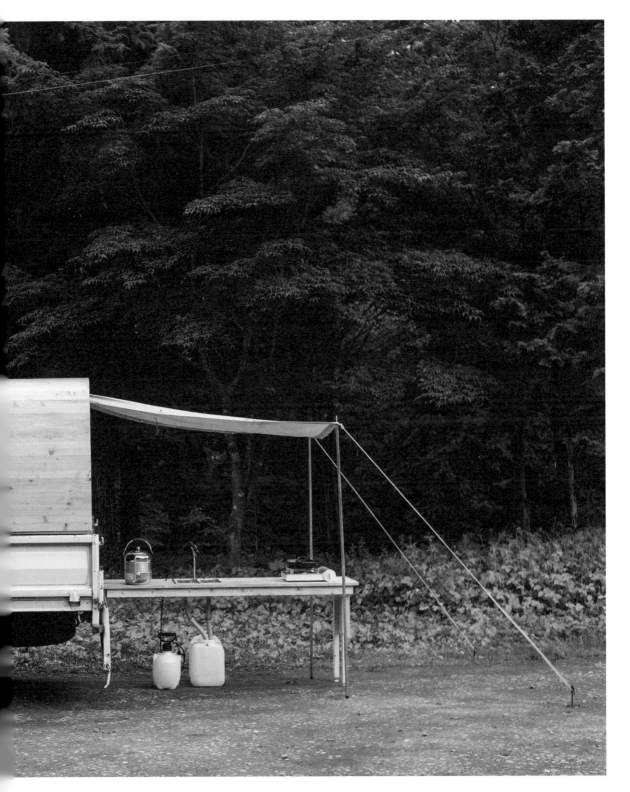

NAOHIRO'S ESCAPES

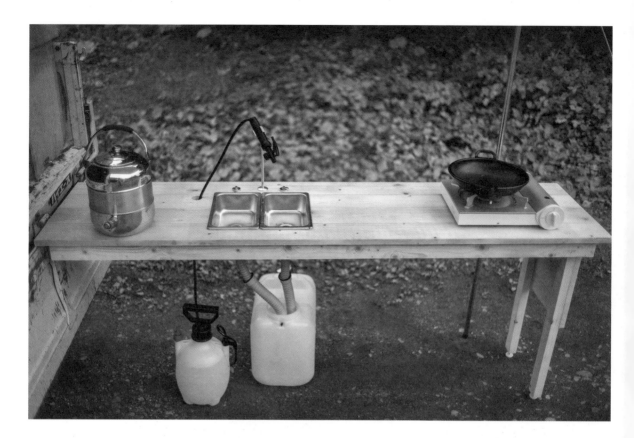

Mobile kitchen system. Water
is dispensed by a simple pump
pressure tank and the stove is a
mobile gas burner.

R Hut on the Truck in daily work
mode. Because Nao needs
access to all areas of the truck
bed, he's created convenient
side doors. The door covers are
not shown.

OPPOSITE Camping mode
showing the simple layout of the
queen bed and storage space
underneath.

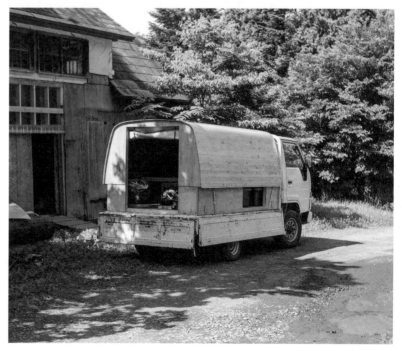

NAOHIRO'S ESCAPES

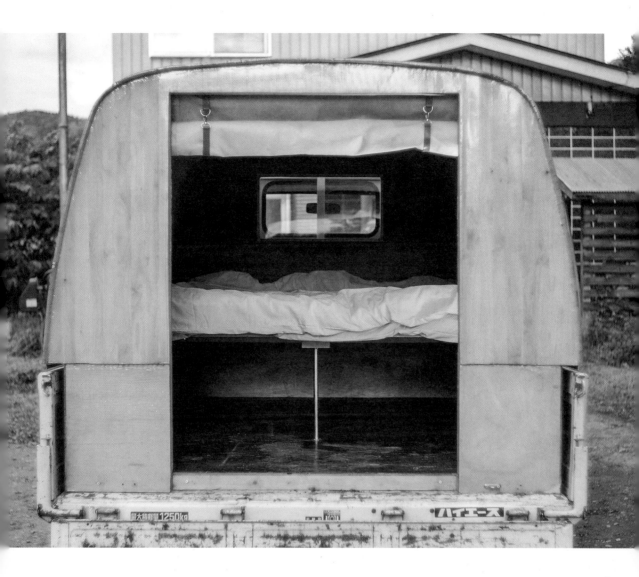

While most campers are boxy, with a clear distinction between the ceiling and walls, Nao was attracted to a seamless design. Equally important was that his truck-cabin be waterproof and lightweight. "One day, as I was pondering over these challenges, a friend was securing a canoe on top of his car," Nao says. "As I looked out over the river we were about to paddle, I thought, Let's make a big canoe!"

Nao, now a working carpenter, uses the Hut nearly every day for transporting supplies. He built a raised bed, with storage beneath that protects his tools and materials. Though the current design lacks insulation, he plans to build the next model so that he can take longer leisure trips year-round.

When asked, Nao will confess to missing the crowds and packed trains of Tokyo. And he's still unlearning some of his ingrained prejudice toward manual labor. "Seeing my hands after a hard day's work building or restoring," he says, makes him realize the difference between life in Tokyo versus Hokkaido. "A skill is being stained in my hands, in contrast to knowledge being stored in my head."

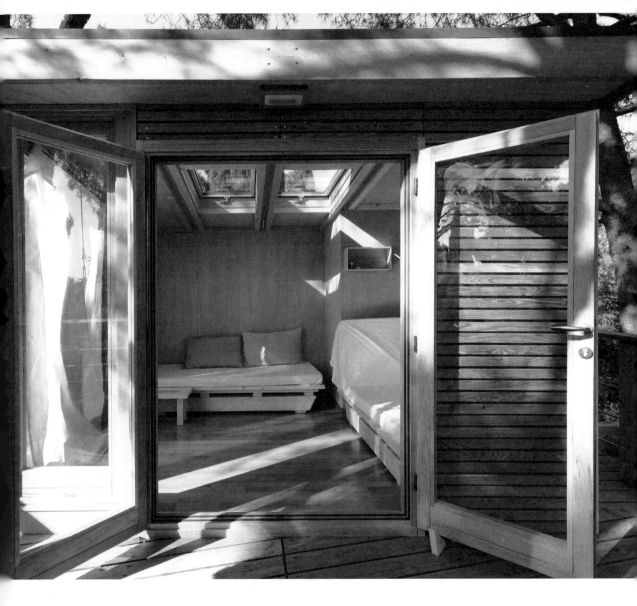

Casajolanda
Rome, Italy

CONTRIBUTED BY
Daniele del Grande

Built by three people using
ladders and ropes, this refuge
in the trees sits 22 feet above
the forest floor in a park outside
Rome. The handrails are carved
from chestnut, the windows
are oak, and the interior is built
with pinewood panels; a small
toilet and electrical system offer
a bit of modern convenience.

The cabin is suspended with
steel cables and load belts,
and stabilized with adjustable
wood clamps, allowing the
structure to sway safely with
the wind and move vertically
with tree growth.

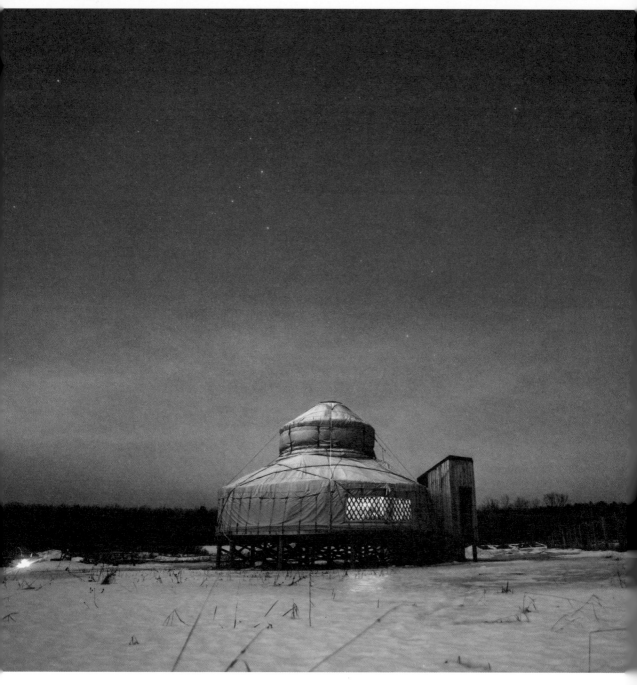

The Buffalo Suite
Mattawa, Ontario

CONTRIBUTED BY Shara Gibson

PHOTOS BY Zach Baranowski,
Wade Montpellier,
Darrin Stevens

This two-story yurt was built by a family that left suburban Toronto behind in search of a new life in northern Ontario. After moving to Mattawa six years ago, they started a small family business and began building off-grid accommodations. The Buffalo Suite is their latest, and it's Canada's only two-story yurt, with a 10-foot-long window overlooking a buffalo pasture, timber framing, hand-tied interior lattice walls, and a roof with balsam fir saplings.

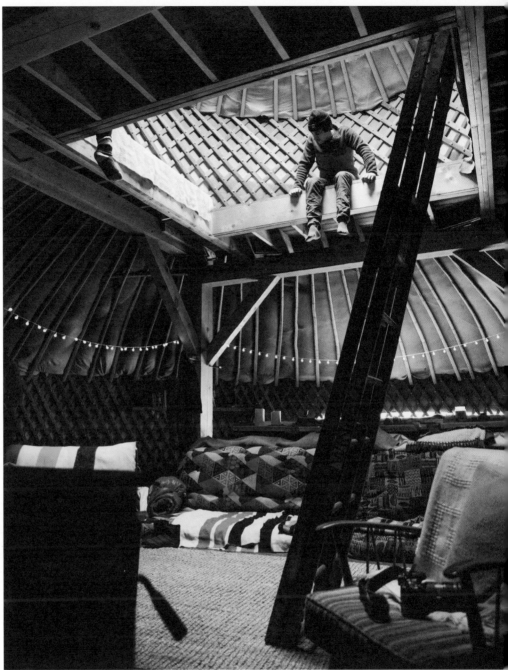

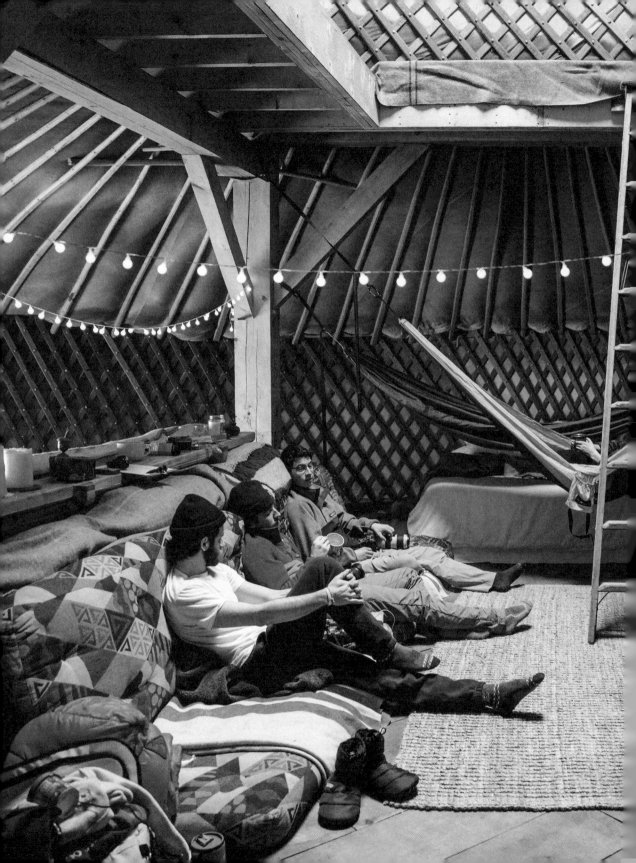

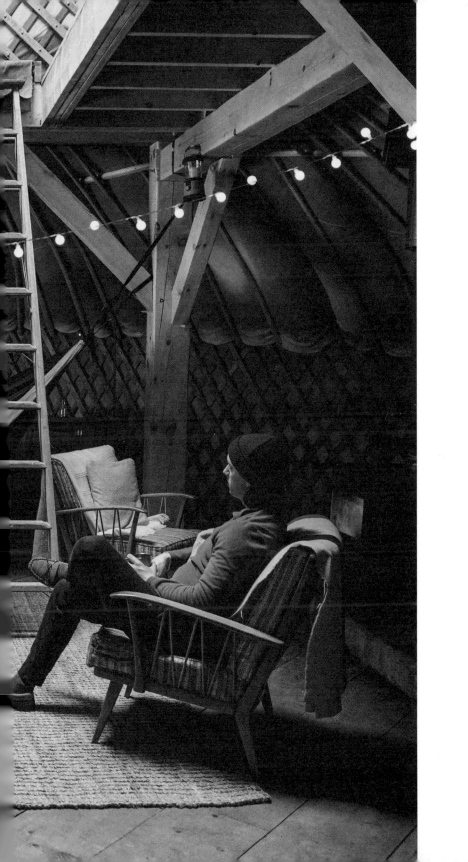

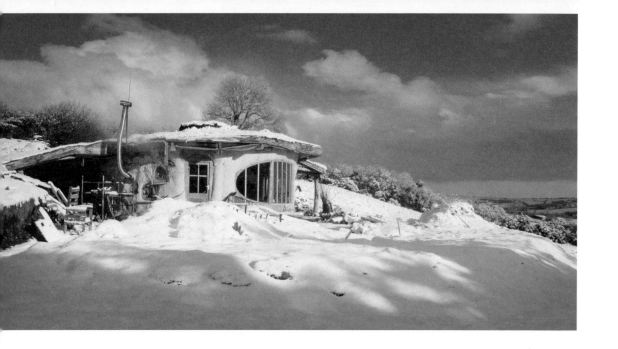

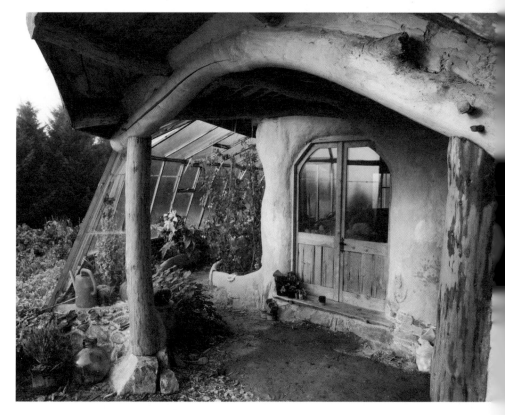

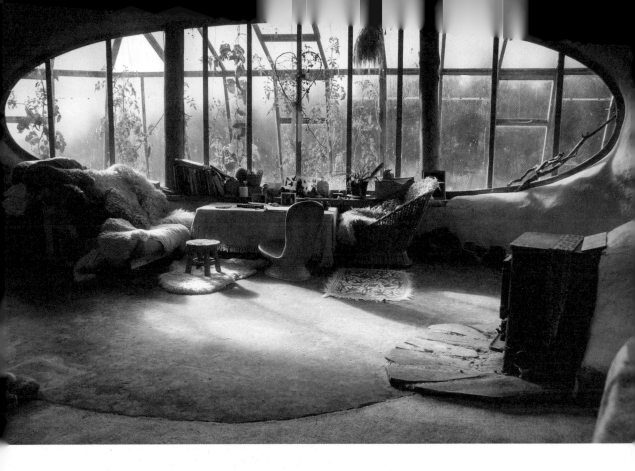

The Undercroft
Berllan Dawel, Wales

CONTRIBUTED BY
Jasmine and Simon Dale

PHOTOS BY Simon Dale

Undercroft is an earth-sheltered roundhouse set in an off-grid Welsh eco village. Built in 2009, it was inspired by earthship design principles, with a reclaimed glasshouse that provides insulation and a perfect spot to grow tomatoes, cucumbers, and other vegetables.

The cabin's location—a hillside—protects it from the wind while allowing in sunlight. Heat, meanwhile, is supplied by a small log burner and the earth: a flue pipe is sculpted around a thermal mass of shale and subsoil, providing extended radiant warmth.

Bent Apple Farm
Londonderry, Vermont

CONTRIBUTED BY Ben Sargent

PHOTOS BY
Elisabetta Fox Piantoni

Inspired by a dollhouse made by his mother, Ben Sargent bought a 200-year-old barn in Hoosick, New York, dismantled and reassembled it—with the help of builder Patrick Arellano—on his family's Morgan horse farm in Vermont's Green Mountains. The process took nearly two years, but every board, post, and beam was eventually back in its original fitting. The barn has an impressive chef's kitchen and a massive Glenwood stove, which provides a crackling fire and a functioning cooktop. At the same time, much of the interior remains intentionally simple and rough—hand-built, repurposed, or salvaged, including the floors, which came from a nearby schoolhouse.

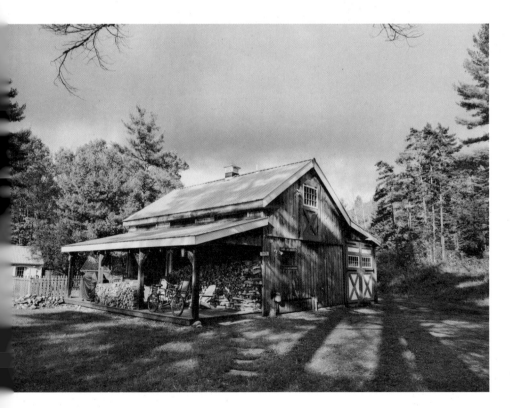

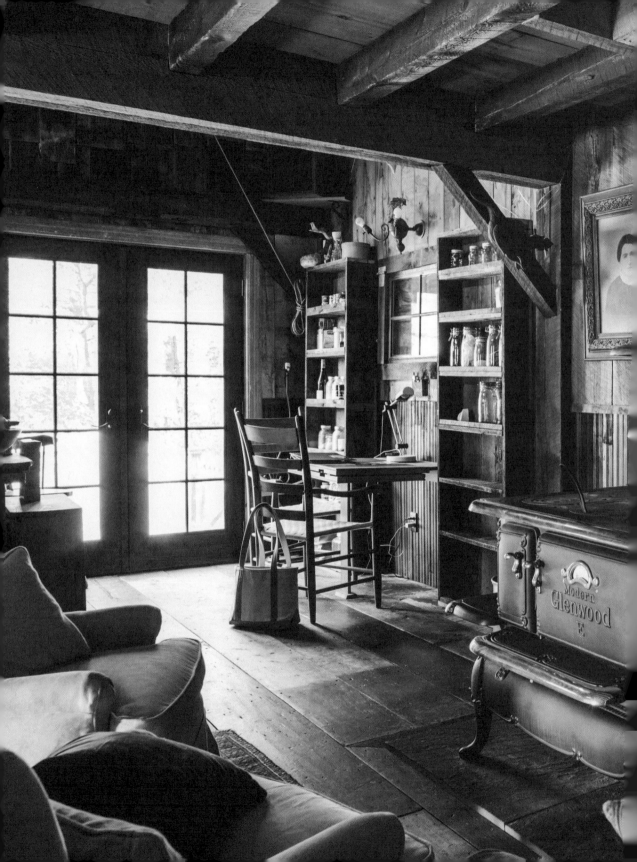

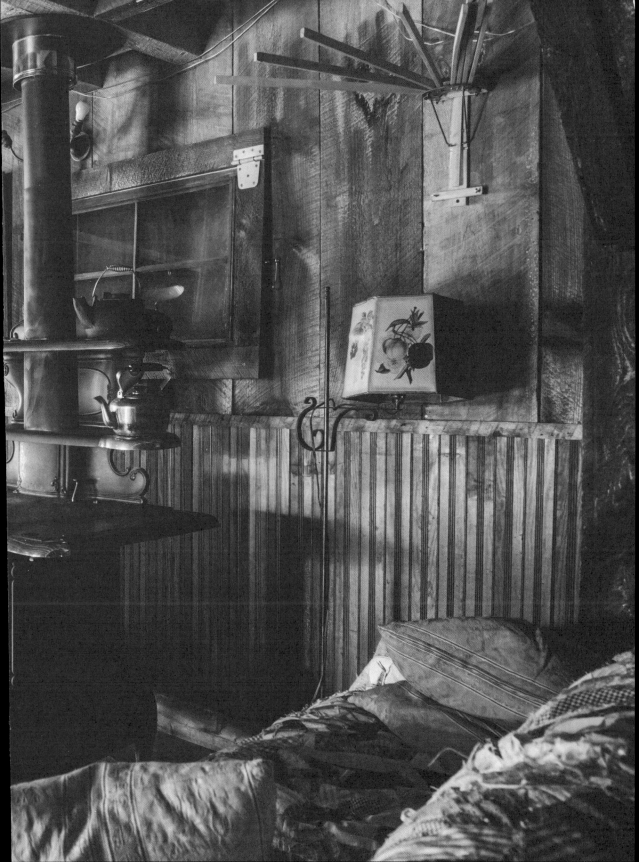

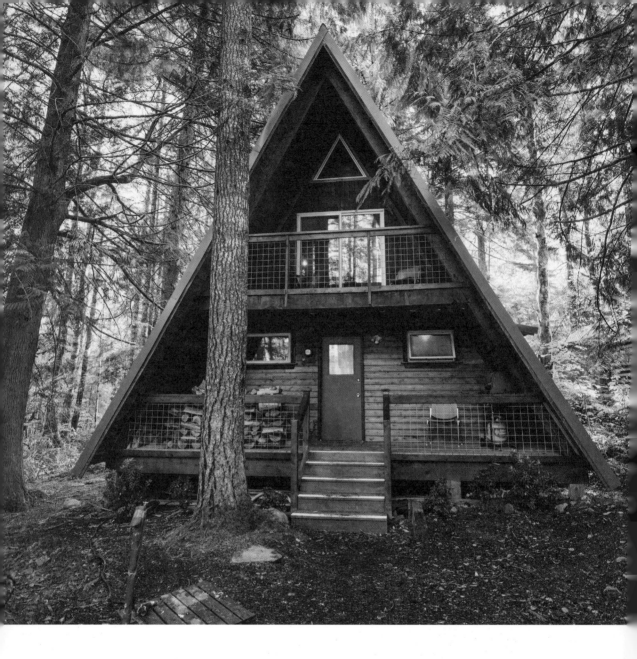

Little Owl Cabin
Mount Rainier, Washington

CONTRIBUTED BY Valerie Neng and Ryan Southard

PHOTOS BY Erik Jensen

Valerie and Ryan began their cabin search after a ski vacation to the Dolomites in Northern Italy, where they stayed in small, simple, thoughtfully built lodges. After nearly a decade, they dropped everything when they saw this A-frame set in a dense Pacific Northwest forest.

Their favorite interior element is the floors—after being ignored by local contractors, they threw up their arms and took on the project themselves with plywood, paint, and polyurethane. Bolstered by success, they next tackled building a new deck, complete with a cedar hot tub.

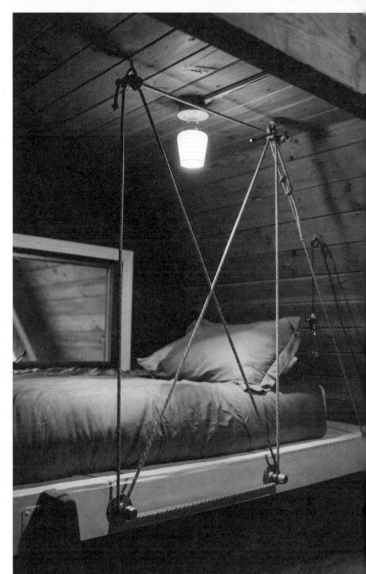

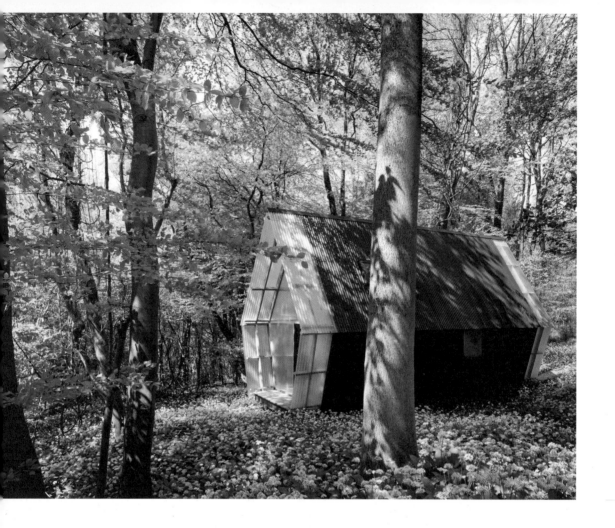

Trailer Prototype
Bath, England

CONTRIBUTED BY Invisible Studio

PHOTOS BY James Stephenson

This relocatable prototype cabin, located in Bath, England, is designed to act as an affordable trailer or permanent home. Designed by Invisible Studio, it was built with removable wheels and a fiberglass and steel trailer; the insulation was scavenged, the roof lights were discounted, the internal lining was crafted with used shuttering plywood, and the gable ends are glazed with a high-performance interlocking polycarbonate. The structure's builder aims to offer this style of trailer as a versatile, low-cost space, one that any DIY builder could easily adapt for a variety of purposes.

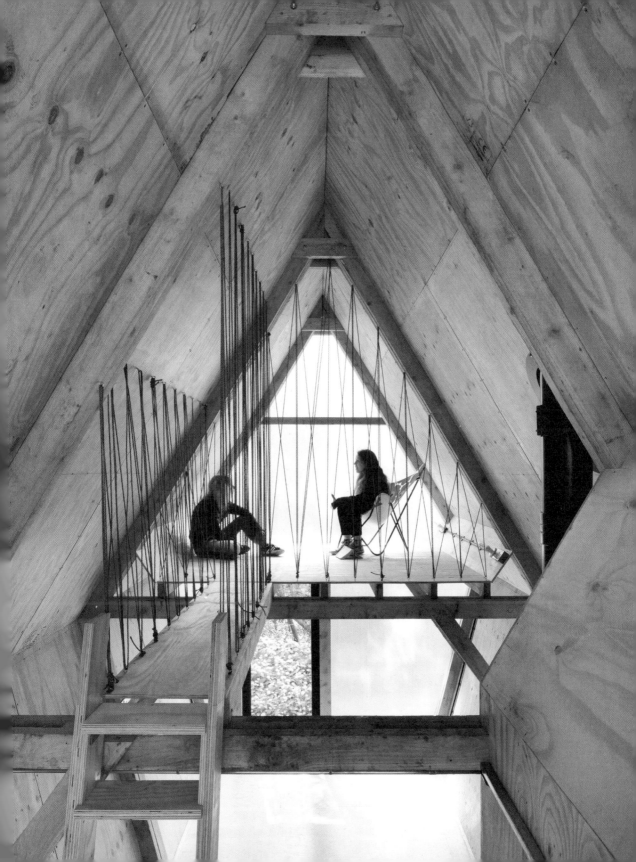

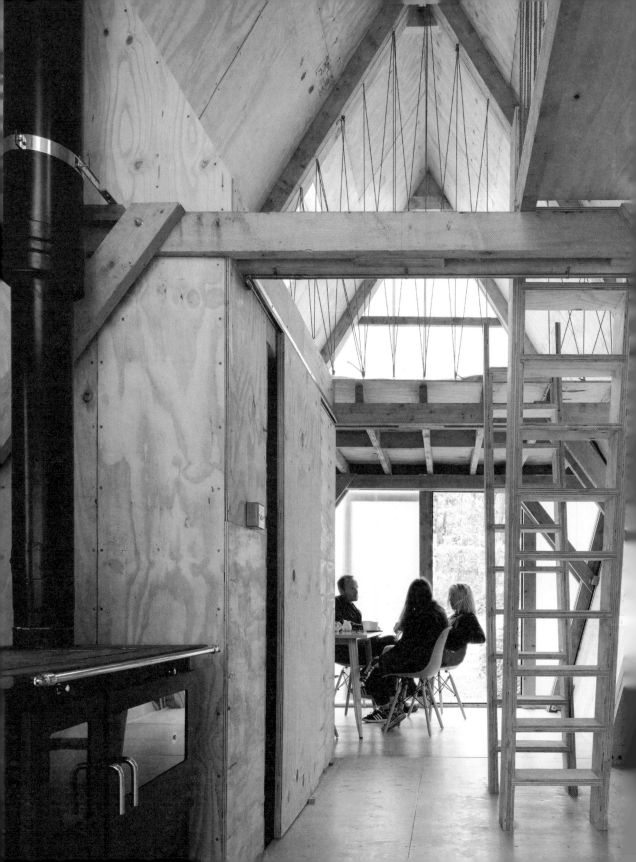

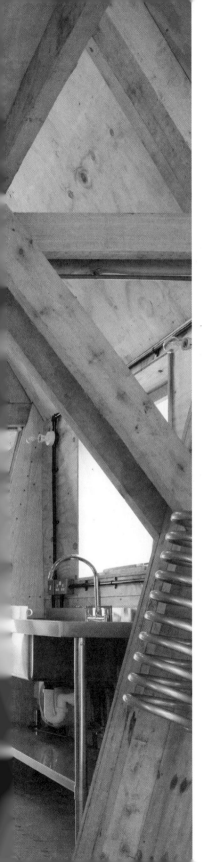

Bruny Island Hideaway
Tasmania, Australia

CONTRIBUTED BY
Maguire + Devine Architects

PHOTOS BY Rob Maver

Set amid 99 acres of forest on the Australian island of Bruny, this off-grid cabin aims to be the ideal spot to decamp and spend some time reading, playing violin, and stargazing. Inspired by the simplicity of traditional Japanese architecture, its interior contains just two pieces of furniture—a low table and a mattress. Everything else is built in. The cabin is built with bushfire-resistant timber and alloy-coated steel cladding, while essentials are mostly supplied by the elements: photovoltaics for solar power, a collection system for rainwater, and an oven-woodfired heat. Only gas is needed for cooking.

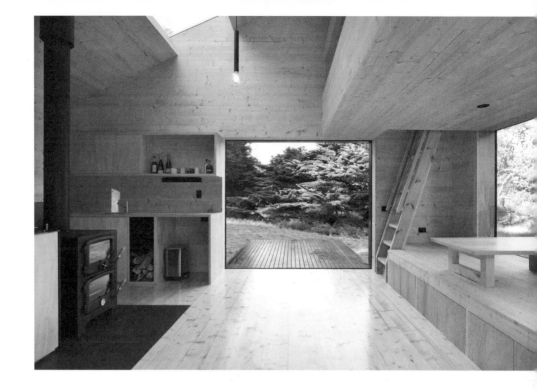

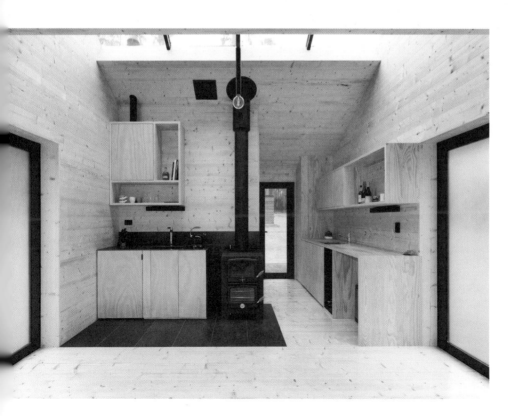

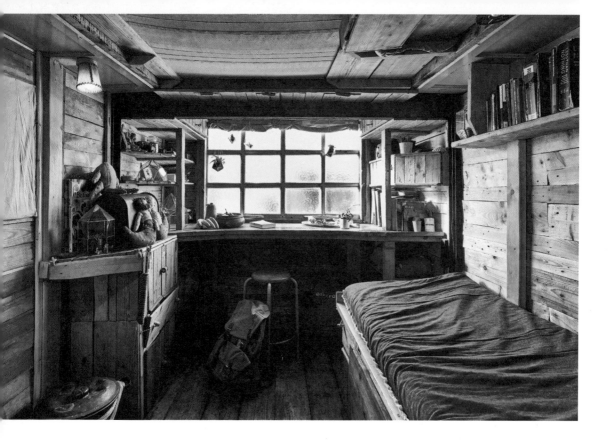

Keet
Ghent, Belgium

CONTRIBUTED BY Bianca Apostol
and Daniël Vernooij

PHOTOS BY Jan Verlinde,
Ann de Wulf, Hand Vd Bauwde

Keet is a four-wheeled cabin made almost entirely of garbage. Inspired by vernacular architecture, a style of construction that focuses on local materials and traditions, Keet was built in Breda, Holland, in 2013, and it's been moved, by tractor, to a forest, a farm, a modern art museum, and its present location, the Port of Ghent, in Belgium. It's nearly 20 feet long, 8 feet wide and 12.5 feet tall, and it's filled with hidden drawers and compartments, and objects with double or triple functions. Keet's occupants, a 27-year-old designer and artist (Bianca), and

a 28-year-old student at the Royal Conservatory of Ghent (Daniël), say some people react to their home (and them) with derision, with a view that the pair are lazy freeloaders. "This condescending attitude stems in the misconception that functioning outside wage-labor structures is impossible and morally questionable," Bianca says. "However, our decisions were not grounded in economic logic. In fact, most meaningful decisions in people's lives generally aren't. Nor is science or art. Or any endeavor worthy of your time."

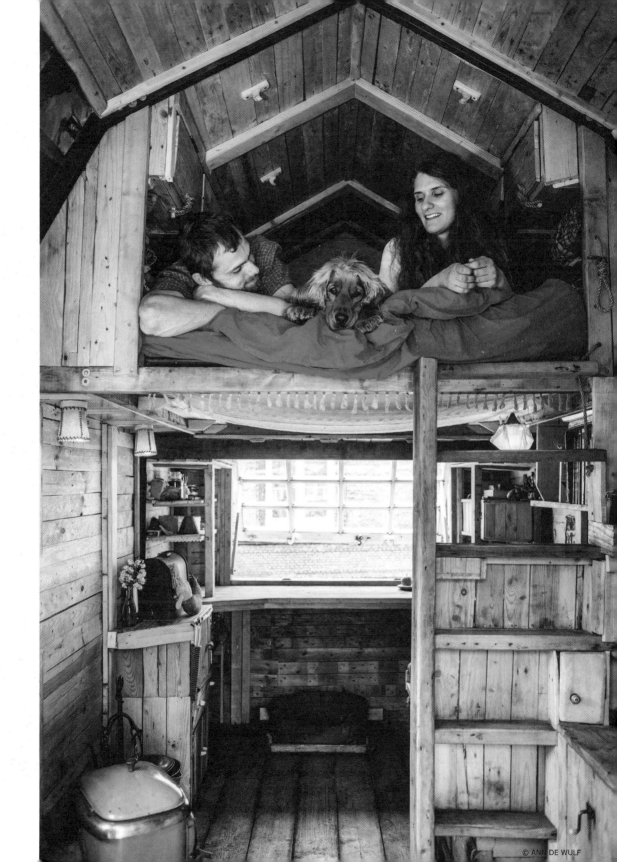

Beavers Lodge

Contributed by **Charlotte and Mike Beavers**

Photographs by **Mike Beavers, Jess Bianchi**

Mike Beavers landed in the Santa Monica Mountains the way he finds his way to lots of things: it just felt right. A friend was moving to the East Coast for graduate school and needed someone to look after his home while he was away. The two friends share a worldview, Mike says, that "no challenge is too difficult to approach nor any idea too far-out to consider." So when his friend suggested that Mike turn a long-neglected shack that clung to the edge of his hillside property into a caretaker's cabin, the arrangement felt natural.

At the time, Mike was living in San Francisco. He and his now wife, Charlotte, a painter, had been dating for only three months. The couple met at the Mission District frame shop where they both worked; he was an apprentice woodworker and she oversaw the shop's fitting room. The slog of city life and the dampness of the Outer Sunset neighborhood, where Mike lived, were wearing on him. He felt "soggy," he says, and was attracted to Southern California's dry air and wet suit–less surfing. But he had also fallen for Charlotte, a Bay Area native. "I've never been super impulsive with relationships," he says, but the two fit together so well that he asked her to join him. Charlotte agreed, and together they spent the next two years deconstructing and rebuilding a tiny, dilapidated hut set amid California live oak, walnut, and chaparral.

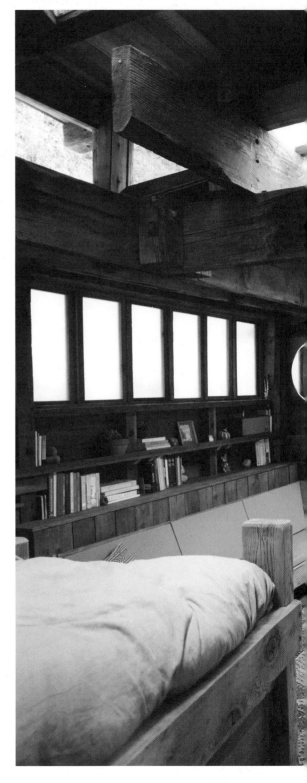

The bed is tucked directly behind the front door. It felt like an awkward idea, but it works well. It feels hidden in plain sight. The wood stove was centrally placed to evenly warm the one-room cabin.

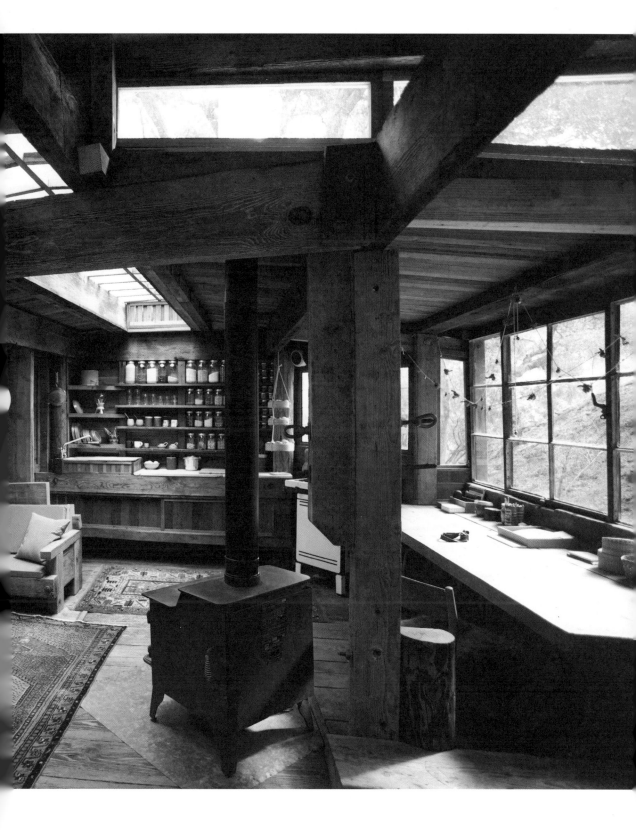

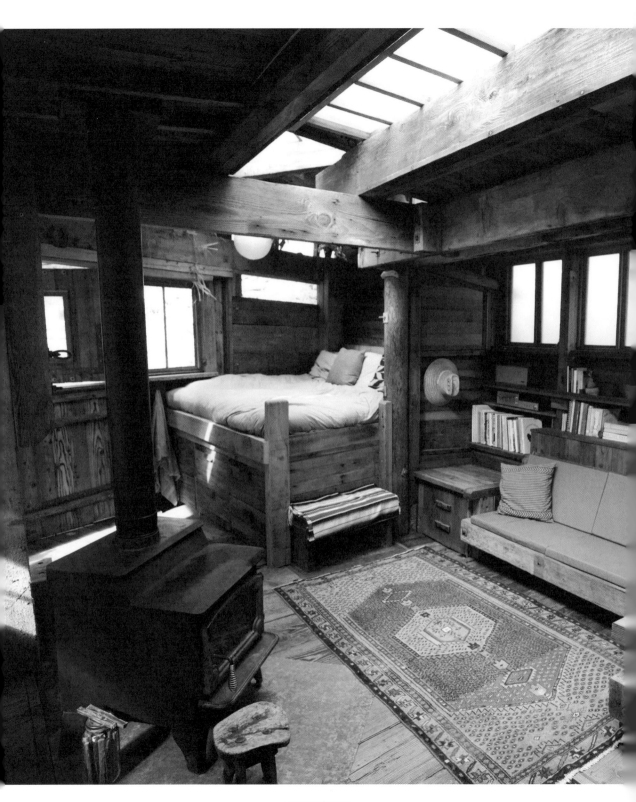

BEAVERS LODGE

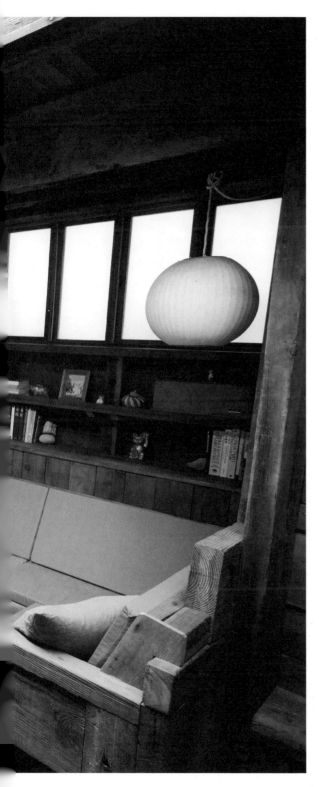

The rug was a wedding and housewarming gift. The bench alongside the bed is a both a place to sit and a step up to the raised bed. Below the rug are removable floor panels and a storage area.

Initially, Mike and Charlotte lived in the main house on the property, which is larger than the cabin but similarly unconventional in its design and features. Despite its Southern California location, the house was cold, with big drafty windows and floors salvaged from a Los Angeles bowling alley. The couple worked through the winter to build a fairy-tale path to the cabin with more than sixty round stepping-stones serving as stairs. "When you get on the path," Mike says, "you're going somewhere else."

That "somewhere else" is a misshapen wooden cabin—there's not a single 90-degree angle in the place—built into the hillside. Mike didn't know how long it had been there or when it was last used; his friend hadn't learned its history but guessed it had been decades. "It was in pretty rough shape when I arrived," Mike says. His vision for the building was simple: it would be a comfortable, habitable space created as affordably as possible.

"My first notion was to just replace the roof and to try to bring in more light," he says. But soon the challenges of rehabbing a who-knows-how-old cabin came into focus. When it rained, the structure became a "dark cave that took forever to dry out." It needed more work than Mike had initially realized. "As I started to peel the layers"—old cedar fence panels, creosote-stained lumber, and plywood—"it really seemed best to take apart almost everything."

So they did, one board at a time.

This wasn't Mike's first DIY rebuilding project. He grew up between Florida and Georgia, and eventually settled in Oklahoma for high school and college. He worked in restaurants in his twenties and then decided to open a coffeehouse. The former antique shop that he had leased needed significant work in order to get a food permit, and because he was on

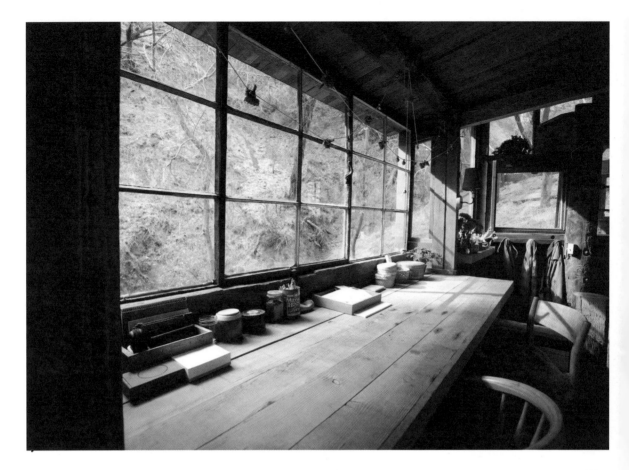

The table was made from boards Mike's friends salvaged while removing a wall at their store. The flowers strung across the window are leftover decorations from the Beavers' wedding.

R The entry nook is among Mike's favorite parts of the cabin. Also, the most practical. The bench provides a place to sit while putting on shoes. On the right is the only electrical switch in the house. All of the lights are on a single circuit, so everything is either on or off. The nook is a portal to the outdoors with a coat rack, shoe storage, and some nails for hanging hats and headlamps.

OPPOSITE Mike and Charlotte fit a king bed into their sleeping nook. Laundry is tossed into the overhead basket and the drawers below are extra deep for storing clothes. Bath towels hang behind the door.

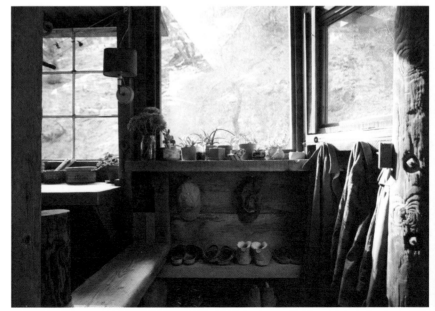

BEAVERS LODGE

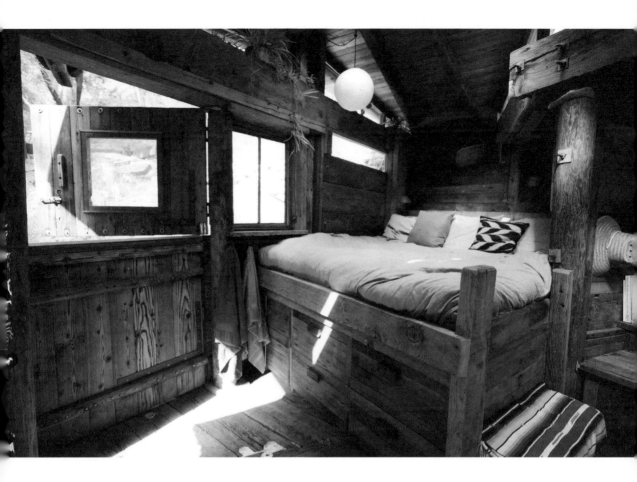

a budget, Mike ended up doing much of the renovation himself. He learned how to break concrete, run plumbing, build bathrooms. The challenge was thrilling. Once the shop opened, he spent his time managing his staff and found that to be "pretty uninspiring compared to the excitement of building." He sold his shop, rented his house, moved into his Sprinter cargo van, and drove to California.

In Charlotte, he'd met his match. "She'll be in her studio all day," he says, "and come out at the end of the day with some pants that she's made for herself." While building their cabin, she pulled nails and hauled buckets of dirt uphill in the rain. "She has a really high tolerance for punishing work."

Charlotte was up for anything, including potentially life-threatening adventures, like helping to replace a critical support column that held up the cabin. Mike placed an ad online and was offered a 25-foot utility pole, which had been left behind after its lines were buried; the property

owners wanted it gone. Though he had never felled a tree and didn't have much experience with chainsaws, Mike watched a YouTube video and went for it, cutting down the pole in the property owners' driveway. He loaded it into a borrowed truck and gathered a group of friends for manpower. "We somehow flipped it into a hole I'd dug without any major issues," he explains. "The whole endeavor felt intimidating, reckless, and dangerous. But it's really impressive how much is possible when you can get all hands on deck."

With the cabin's walls and roof shored up and its foundation stabilized, Mike turned his attention to its interior. He gathered materials wherever he could. Friends told him about a house that was being gutted, leaving a pile of Douglas fir free for the taking. And when American Apparel shuttered its retail stores, he loaded his van with sheets of the thick Plexiglas the company had used for shelving. Mike turned the shelves into skylights, sanding the sides that had been

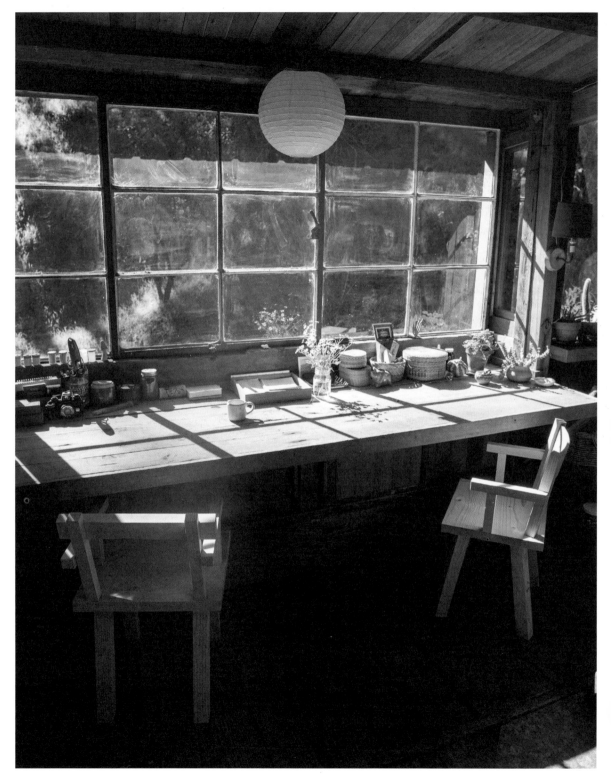

The table serves dual functions: for dining and working. Mike and Charlotte each have their own side. Mike built the chairs from leftover lumber.

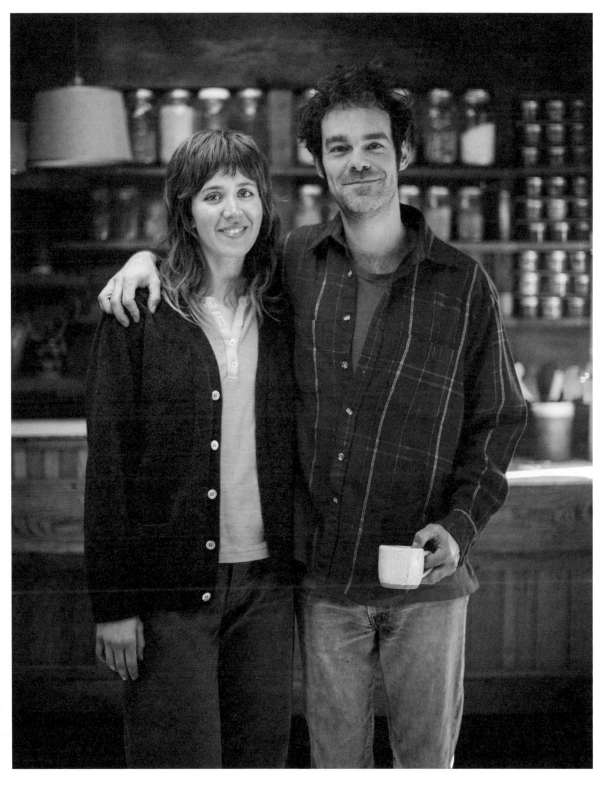

Charlotte and Mike in their kitchen. Their
friend Aya Muto made the mug he's holding.

Mike built the sofa and Charlotte made the cushions. The sink that's in the kitchen had been discarded and was sitting in a pile of old building materials on the property. Above it is the the built-in dish drying rack that also works as dish storage.

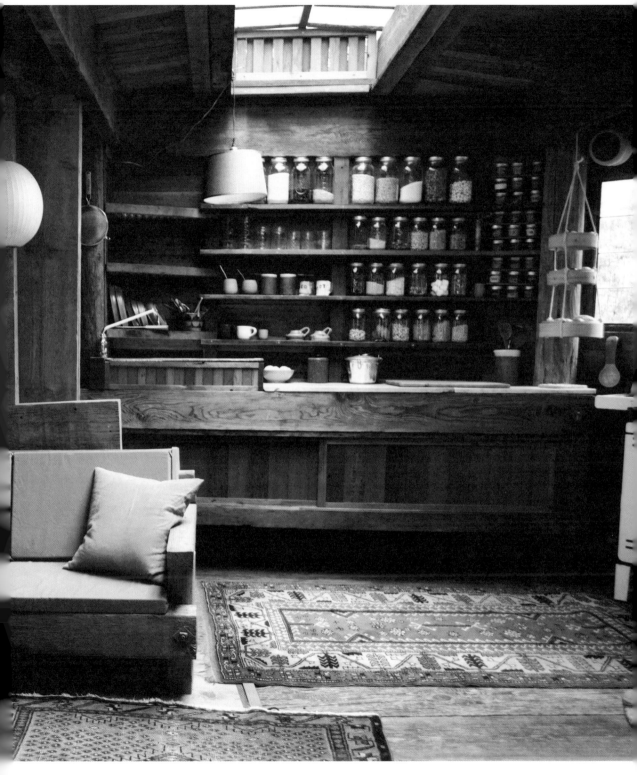

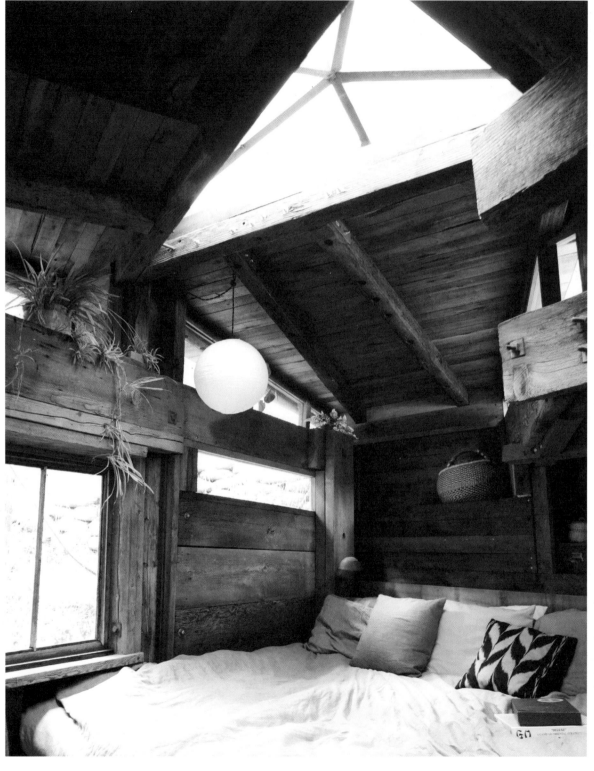

BEAVERS LODGE

The ceiling joists are made of old crossties from
utility poles and the ceiling is tongue-and-groove fir,
salvaged from a friend's project in San Francisco.

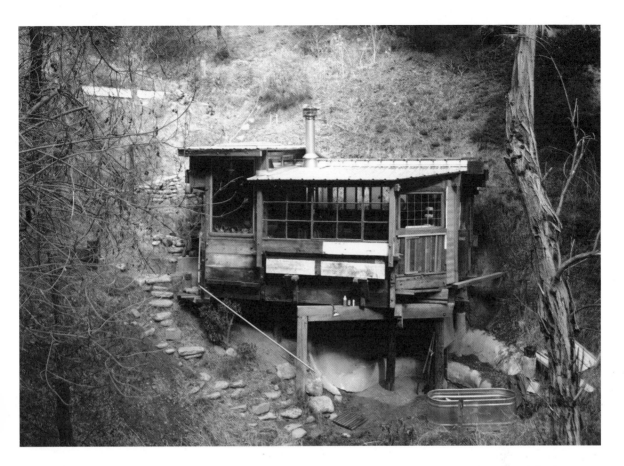

scratched from wear to create a frosted effect. "It's such a fun way to build," Mike says, "to surround yourself with materials that all feel really good and to puzzle-piece them together based on how they feel."

Though the property was close enough to the Los Angeles airport for Mike and Charlotte to see planes taking off and landing, it was surrounded by wildlife: skunks and rats, but also howling packs of coyotes, bobcats that screeched all night, a great horned owl that hooted overhead, and a gray fox—Mike calls it "Charlotte's favorite"—that lurked nearby. At one point during the renovation, while the roof and walls were gone, flycatcher birds made a nest inside.

As the cabin took shape, Mike "got into a flow with the materials and the structure," he says, "and felt like I knew how it was all supposed to connect. It felt like I was at the center of this storm that I was conducting."

Mike finds inspiration in small spaces, which he believes force us to think about what we want from life and what we need in order to feel comfortable. That meant

creating a three-tiered shelf above the sink where dishes can both drain and be stored once dry, and a designated space under the bed for Charlotte's art supplies and paper.

Mike and Charlotte planned their September wedding to coincide with the cabin's completion. The first night they spent there was their wedding night. "It's fun to throw some symbolism into the mix sometimes," says Mike. Charlotte took his last name, and together they christened their new home "The Beavers Lodge."

Mike rigged a shower below the house. The couple uses eco-friendly soap because the shower drains into the landscape and to a plum tree they planted.

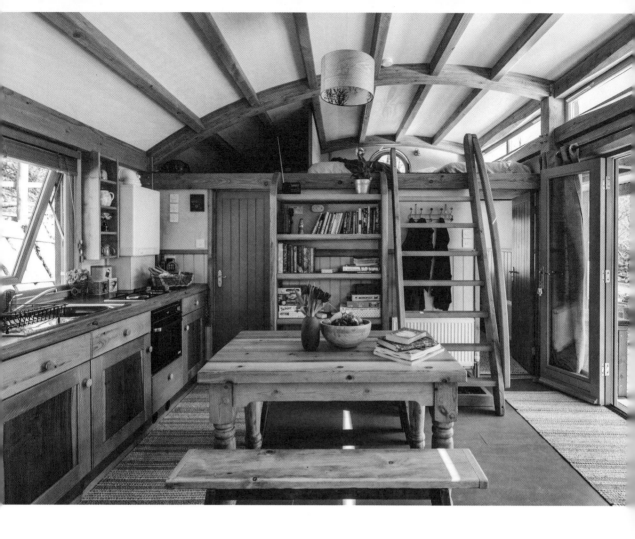

Carpenters Cabin
Devon, England

CONTRIBUTED BY
Barrel Top Wagons

PHOTO BY Iris Thorsteinsdottir
EXTERIOR PHOTO BY Matt Heritage

Located in southeast England, Carpenters Cabin is an off-grid structure inspired by showman caravans. It uses solar panels, a state-of-the-art composting toilet, and a wood burner; a gas boiler (for the shower) and radiators (for heat) are the cabin's only concessions to fossil fuels.

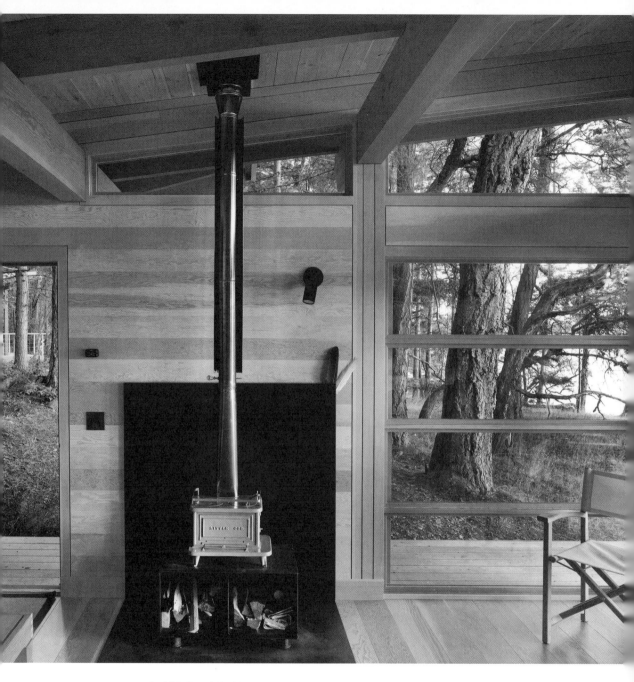

Gulf Island Cabins
Gulf Islands, British Columbia

CONTRIBUTED BY Osburn/Clarke

PHOTOS BY Nic Lehoux

These four cabins are located in the Gulf Islands, off the British Columbia coast. They're designed for private, summer use, and to be off-grid and self-sufficient: their low-voltage LED lighting system is powered by solar panels; water is collected from the roof; a wood-burning stove provides heat; and large windows maximize natural interior light—and provide amazing views of the surrounding scenery. In the off-season, the buildings are closed up with an exterior sliding shutter system.

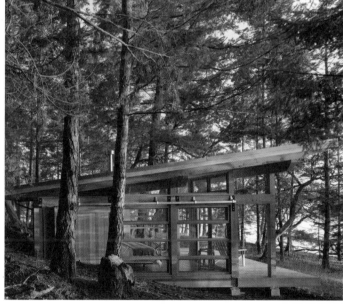

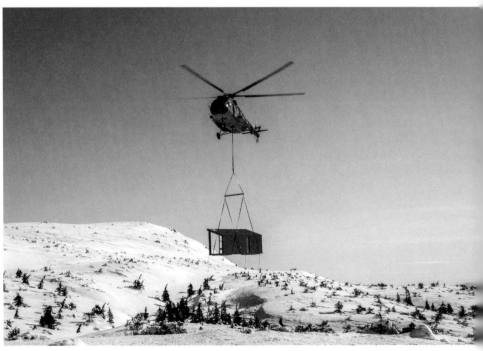

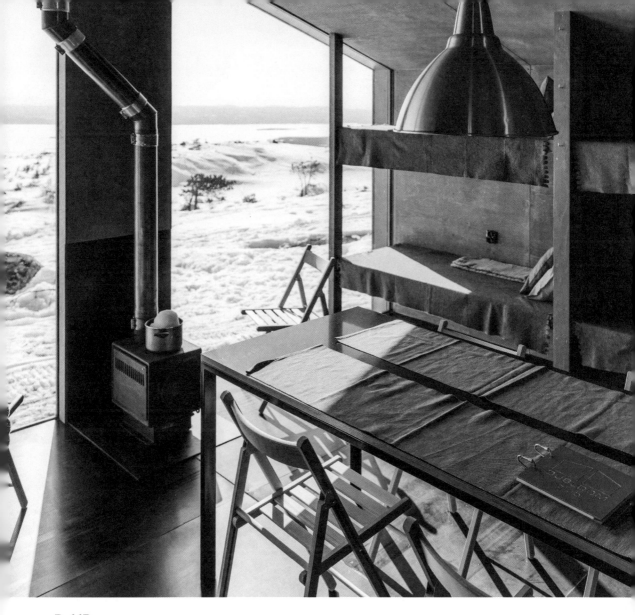

DublDom
Kandalaksha, Russia

CONTRIBUTED BY Art Lasovsky

PHOTOS BY Art Lasovsky,
Galina Latushko

A few years ago, a Russian architecture firm awarded one of its prefabricated cabins—a "DublDom"—to a man named Alexander Trunkovkiy and the remote Arctic town of Kandalaksha. Contestants had been asked to provide photos of the place they thought the cabin should go, along with an explanation of why it should go there. A mountainous spot near Kandalaksha, with its cycling paths and hiking trails, river rafting and fishing, was selected. So the metal-framed cabin was helicoptered in and placed atop six pillars. It can house up to eight travelers in four sets of removable bunk beds that line the walls. At the shelter's center is a table and gathering place that offers vivid views through floor-to-ceiling windows.

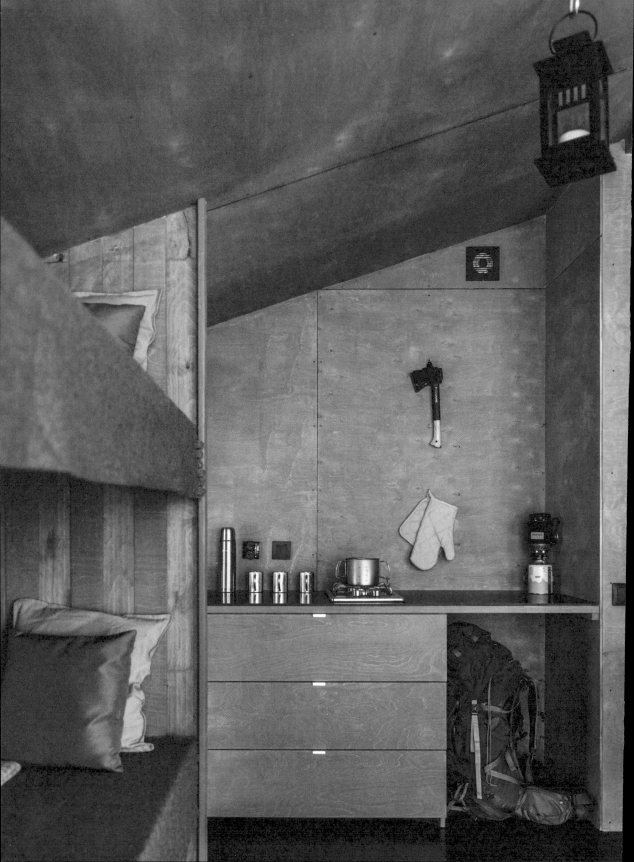

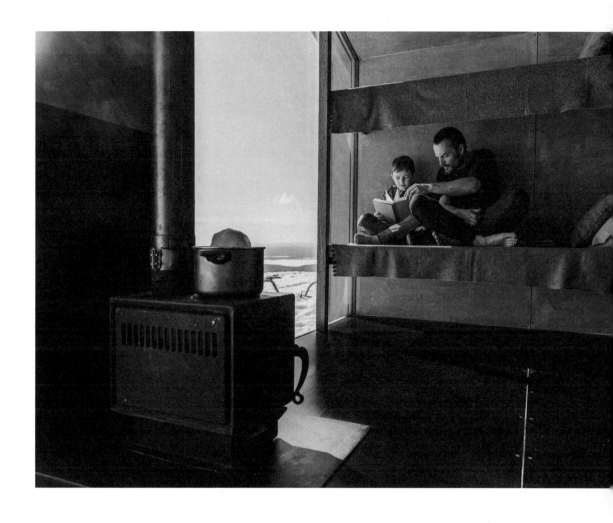

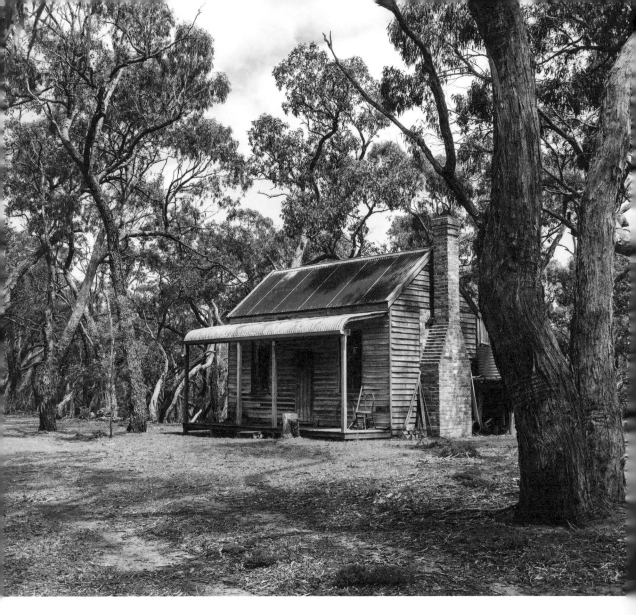

Grampians Shack
Victoria, Australia

CONTRIBUTED BY
Paula and Dean Thomson

PHOTOS BY Sandy Goddard

When Paula and Dean were kids, they used to pass an abandoned cottage in the Australian state of Victoria each day on the way to school. Years later the cabin was slated for demolition, so Dean offered to do the job. Thinking he'd recycle the wood, he found its Baltic pine cladding, lining, and floorboards—all imported at the turn of last century—and Australian messmate frame were in good shape. He dismantled it, numbered the timbers, noted the construction method, and moved everything 31 miles away, to an undeveloped parcel of land next to Grampians National Park. It took two weeks for the rebuild and another two weeks to assemble the brick chimneys. All of that work—and all of the firewood cutting, birdwatching, and wildflower spotting that followed—is a foil for the family's true aim: getting away into the bush for a cup of tea.

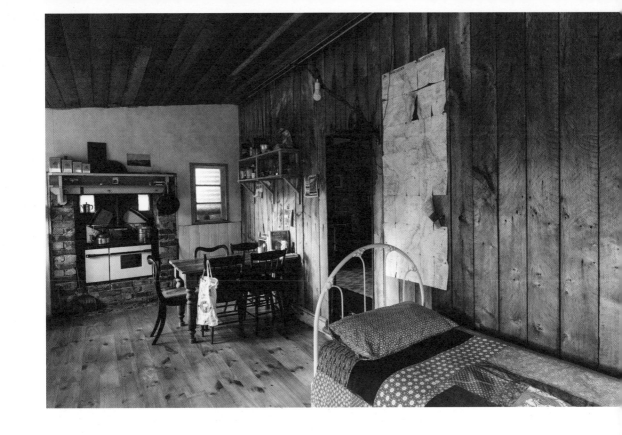

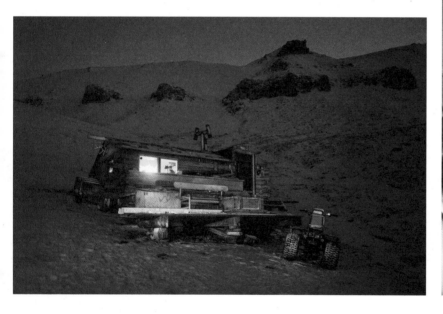

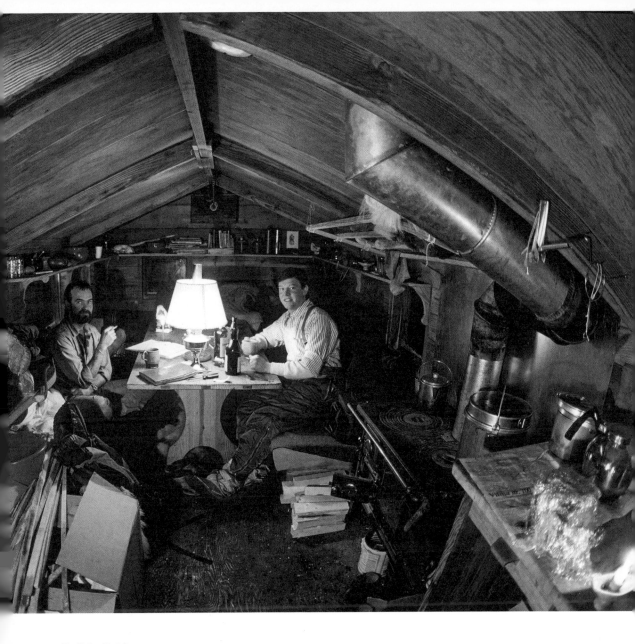

Erik's Cabin
Thule, Greenland

CONTRIBUTED BY Jim Pire

Erik Larsen built his cabin in one of the most remote corners on the planet—eight miles south of Thule Air Base, on Greenland's northwest coast, and a meager 941 miles from the North Pole. Larsen ran the base's hobby shop, which meant he had access to all the lumber and tools he needed to build the 8′ × 16′ structure. He also had the dogsled and the ATV to drag everything there.

The Hab
Thickwood Hills, Saskatchewan

CONTRIBUTED BY Crystal Bueckert

PHOTOS BY Carey Shaw

The Hab sits on the shore of a quiet lake in the Thickwood Hills of Saskatchewan. Named after the shelter in the 2015 film *The Martian,* the structure was built by owner/designer Crystal Bueckert to be a self-sustaining, off-grid pod that could be fully functional in the middle of nowhere. Clad in black corrugated metal with cedar soffits, the 8-foot by 12-foot cabin has an interior of whitewashed pine plywood and a 7-foot by 7-foot cedar deck. Inside is a daybed, a collapsible desk, a small kitchen, a sleeping loft, and a composting toilet. Webbing keeps books and pantry items secure while pine crates offer storage beneath the daybed.

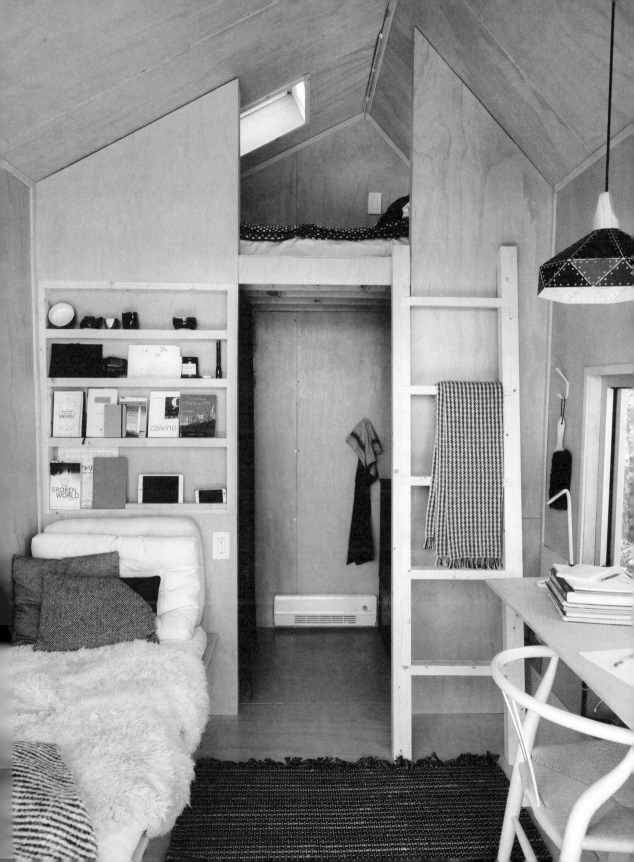

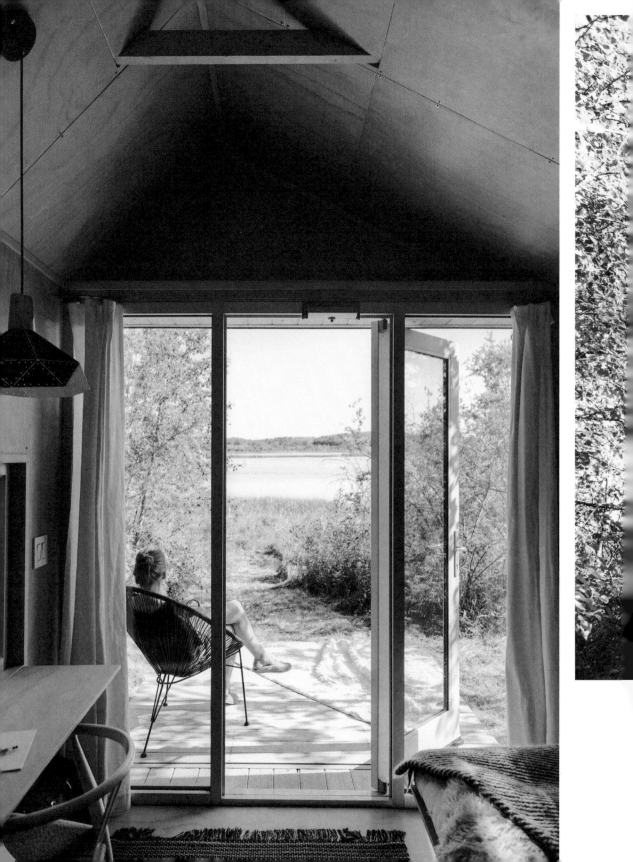

Micro Cabin
Gotland, Sweden

CONTRIBUTED BY
Designers on Holiday

PHOTOS BY Mark McGuinness

The Designers on Holiday residency is meant to offer a range of creative professionals "a place to play." Built in 2017 on the Baltic island getaway of Gotland, this simple single-room cabin—it has a small bed and a sliding wall that doubles as a door—was designed it to fit perfectly behind a tractor, allowing residents to wake up each morning with a different view. The structure, which is made of wood, metal, fabric, and linseed oil, was inspired by the Norwegian "Gapahuk." This traditional camping structure can be found on many a Scandinavian hiking trail, featuring little more than the bare essentials—three walls, a roof, and a large opening facing a fire pit.

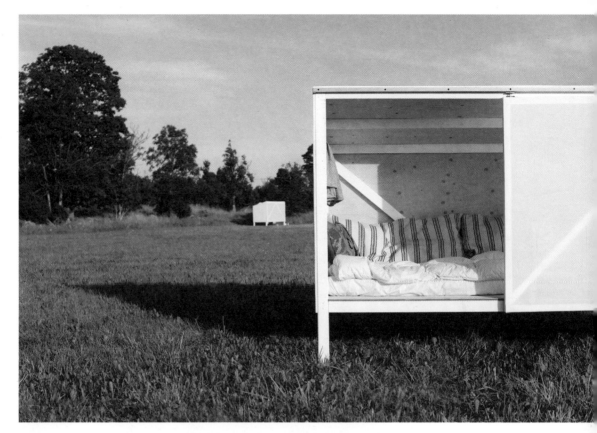

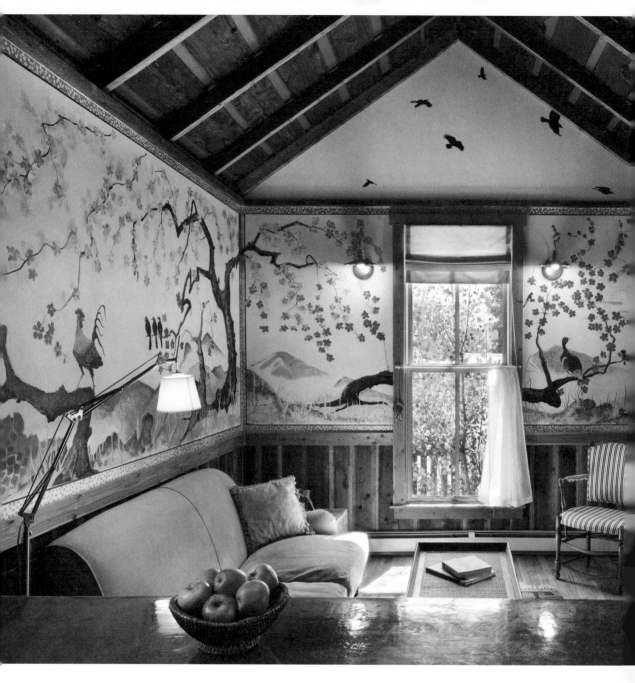

The Cajun Cabin
Creede, Colorado

CONTRIBUTED BY
Avery and Cat Augur

PHOTOS BY David O. Marlow

Located in the remote mountain town of Creede, Colorado, the Cajun Cabin is a former mining shack that was restored in 2007. Constructed largely of recycled wood, this one-bedroom cabin is adorned with vivid murals and elegant woodwork.

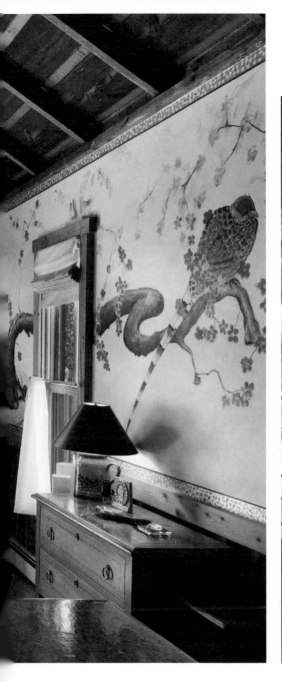

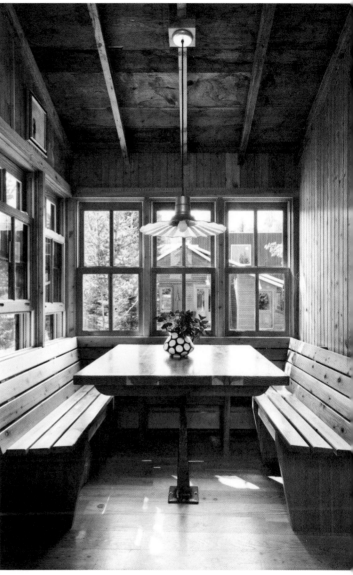

Scotland

Bothy Project

Contributed by
Bobby Niven and Iain MacLeod

Photographs by
Andrew Ridley, Johnny Barrington

Bothies are simple shelters scattered across the rocky, mossy green countryside of Scotland and the northern reaches of the United Kingdom. They're remote, off the grid, and unglamorous; "bothy" comes from the ancient Scots word *both*, which means "booth." Bothies are free to use and open to whoever passes through—a step above tent camping, but just barely.

Historically, bothies accommodated those who worked the land: shepherds, ghillies (guides), and gamekeepers. In the twentieth century, they became places of recreation as middle-class men and women took up hiking, hunting, and fishing for pleasure. Crumbling historic shelters were renovated and preserved, becoming part of a volunteer-run network called the Mountain Bothies Association.

In 2010, artist Bobby Niven and architect Iain MacLeod—friends in their late thirties who have known each other since high school—had an idea. While restoring an old crofthouse on Tiree, a Scottish island, they imagined an artist's studio that would restore the bothy as a place of work rather than play. Instead of hosting itinerant shepherds, their cabins would host artists in residence. They'd provide shelter—not only from Scotland's notoriously cold, wet weather but from the noisy onslaught of modern life. Instead of providing a retreat *from* work, Bobby and Iain's bothies would be places to settle in and *do* work.

Inshriach Bothy in a traditional Scottish woodland area of the Cairngorm National Park.

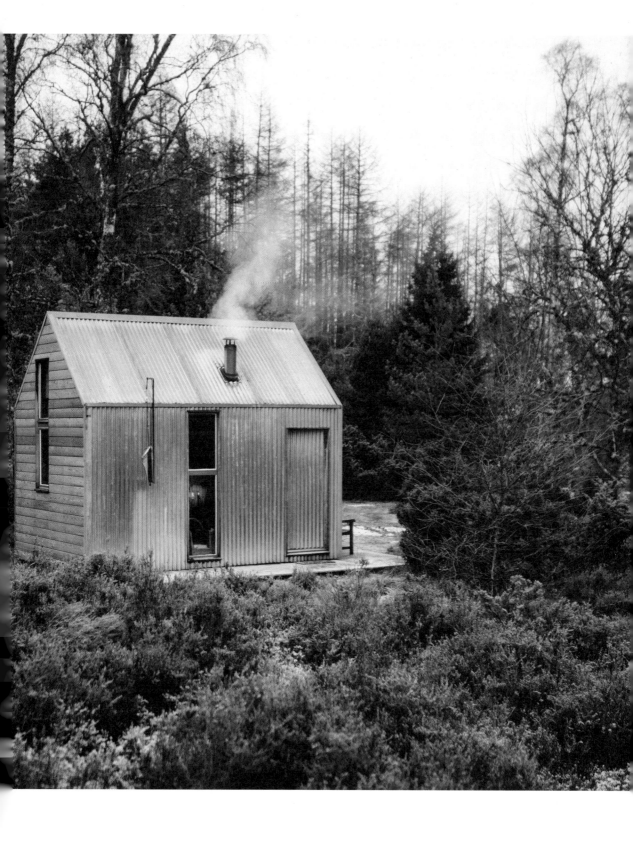

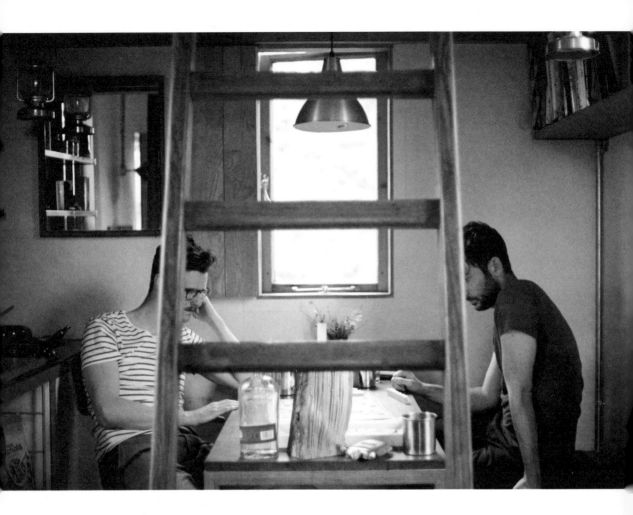

The Bothy Project, as Bobby and Iain named their collaboration, began with a single cabin. The friends received a grant through the Royal Scottish Academy Residencies for Scotland and, with minimal funding, built their bothy in the parking lot of Edinburgh Sculpture Workshop, then a warehouse studio and art center in Edinburgh's New Haven neighborhood.

At the time, Bobby and Iain hadn't yet found a permanent home for their design, which meant it had to be universal. They brainstormed and workshopped and drew the rough dimensions and layout with a stick in the dirt. It was a vernacular shape, Iain says, like the classic image "that a kid might draw of a house."

They focused on simplicity. They designed the necessities for survival—a stove, a bed, a place to store and prepare food—to take up only half of the bothy's modest floor plan. The rest of the space could then have a flexible layout

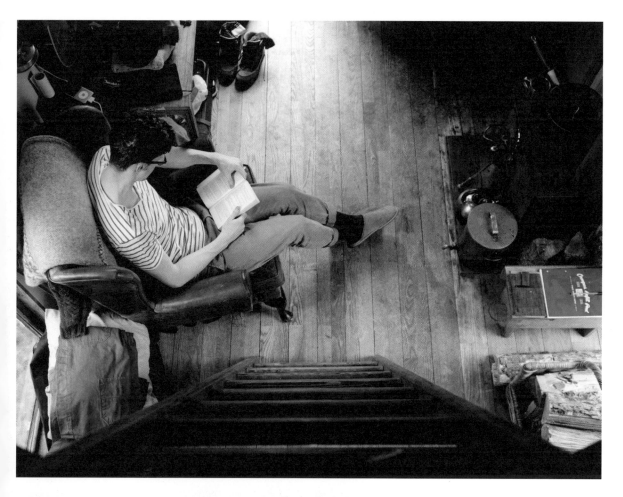

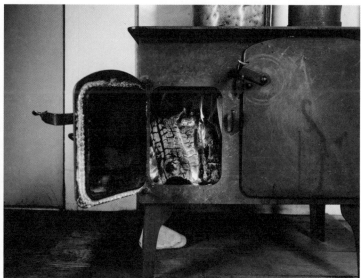

View from mezzanine, looking
down the Mackintosh ladder.

ʟ Louis Ranger stove by Windy
Smithy, a fine cooking stove for
a small cabin, with oven and
large cooking surface.

devoted to creativity. Iain, an architect who loves modern design but lives in a city filled with tightly regulated UNESCO World Heritage sites, played with clean contemporary lines and simple materials: corrugated metal, plywood, and sheep's wool insulation.

They used tall and narrow old tenement windows, salvaged from Bobby's renovated apartment, which they positioned so that wherever the bothy ended up, it would have a view—a bridge, says Iain, "between the nature outside and the shelter inside." The panes also allowed for maximum wall space—crucial for artists who want to hang their work. The windows have big, heavy internal shutters, made from reclaimed ash floorboards. They keep the space "cozy" at night, says Bobby, by helping the room stay warm and hiding the blackness through the panes.

Another interior detail became meaningful in retrospect. While Bobby was studying at the Glasgow School of Art—one of the most beautiful buildings in Scotland, in his estimation—he found a ladder that someone had left outside in a dumpster. The building, known as the Mack, was the work of the country's most famous architect, Rennie Mackintosh. While Bobby can't be sure that the ladder itself was a Mackintosh, it appeared to have come from the college. In 2018, the college burned down, making that ladder an "especially precious piece," Bobby says.

Once they'd built their bothy, Bobby and Iain had to find it a home.

Fortunately, Bobby had a lead. After returning from Vancouver, Canada, in 2006—he'd gone to graduate school there—Bobby was burnt out on the art scene. After toiling in galleries for a while, he went to work in Glasgow's community gardens. He liked using his hands, building and growing and helping to cultivate community. A friend from the gardens introduced

Galvanized corrugated steel reflecting the last light of day.

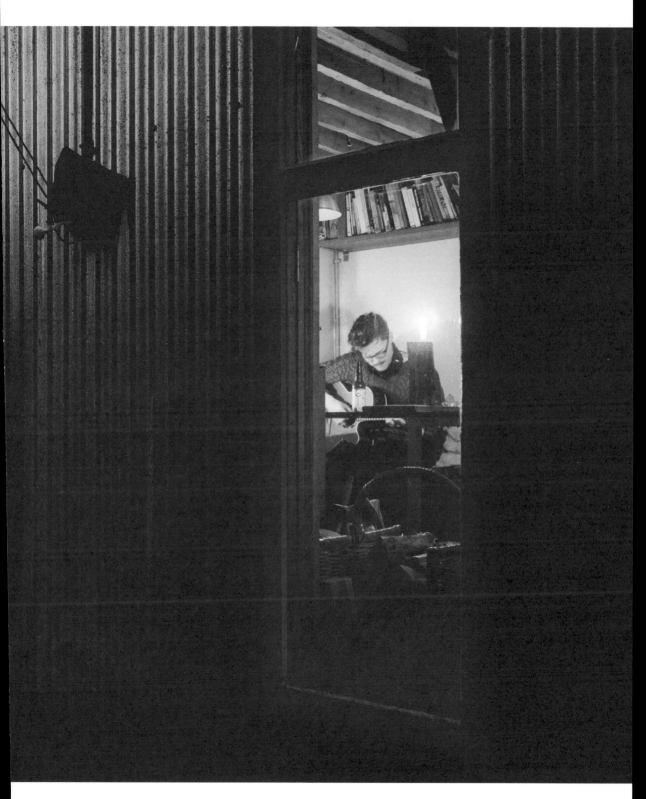

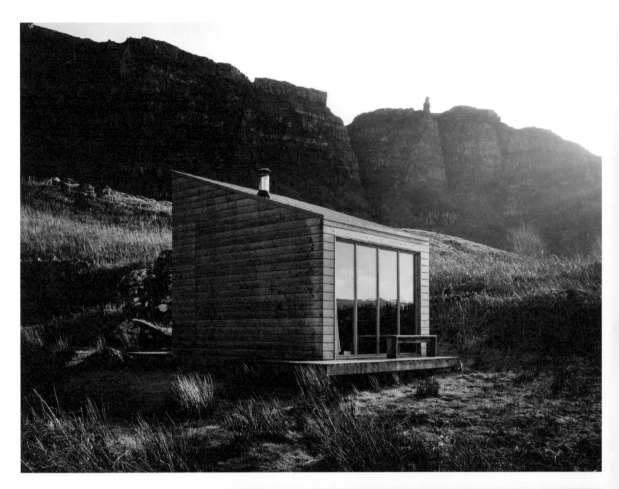

Sweeney's Bothy, below the "Finger of God," on the Isle of Eigg.

R Interior of Sweeney's Bothy with all the essentials: a map of the west coast of Scotland, an aloe vera plant for applying to cuts, a small library, liquor, binoculars, and desk lamp.

OPPOSITE A compact kitchenette with cast-iron gas stove.

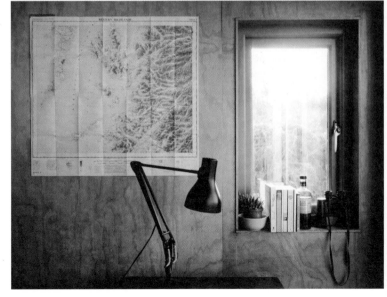

BOTHY PROJECT

him to Walter Micklethwait, the owner and manager of Inshriach Estate, a historic 200-acre property with an Edwardian country house, a large herd of Blackface sheep, and a stunning location in Cairngorms National Park along the River Spey. The area is famous for its salmon fishing and whiskey production, and it made an ideal setting for Bobby and Iain's bothy.

There were already a couple of oddball accommodations on the property: an old 1954 Commer fire truck that had been outfitted with a bed, and a 16-foot yurt with a wood-burning stove where the estate hosted tourists. Bobby and Iain suggested a dual-use arrangement: for half of the year, the bothy would be used as an artists' retreat for people who applied through the Bothy Project; for

the other half, Walter could rent the cabin to tourists at market rates. Walter agreed and the bothy was dubbed Inshriach, in honor of its new home. It was then loaded onto the back of a flatbed truck and transported two and a half hours north.

There, Bobby and Iain painted the outside of the shutters the color of lichen "to match the lichen on the birch and rowan trees," says Bobby. They installed a handmade Windy Smithy wood-burning stove, the Louis Ranger, which has a large stovetop and an oven for baking homey dishes, like casseroles. Because Inshriach is off-grid, the stove was a key piece of equipment—used for heat as well as cooking and washing. For showering, the Bothy Project

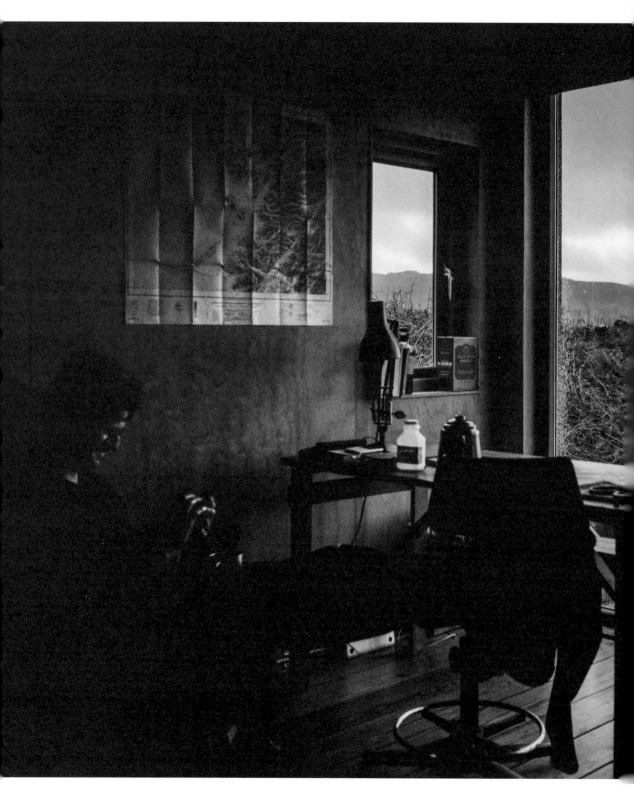

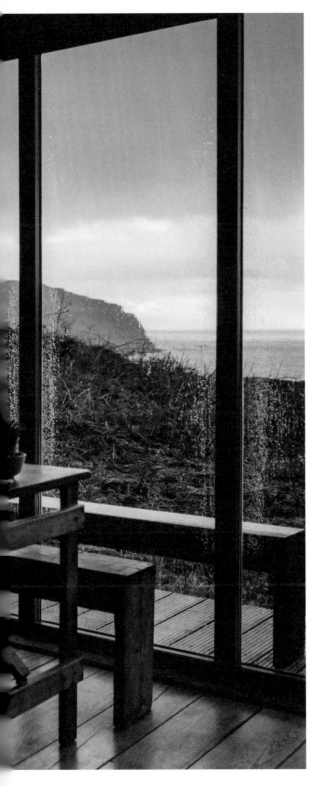

commissioned Trakke, the Scottish manufacturer that makes all its waxed canvas bags in Glasgow, to design an unusual camp shower. The 20-liter sack is Scout green—the same hue as the iconic tents used by Scottish Scouts—and raised into position by a pulley system. It holds enough water for a five-minute hot shower.

The artists who visit this minimalist space are asked to reflect on their weeklong stay and make a contribution to the Bothy Project's blog. Photographer Andrew Ridley, a former artist in residence himself, used the blog to describe the region's unusual light in cinematic detail: "The sun dropping behind the Cairngorms casts colors across the sky that bring to mind peaches, gold bullion, candy floss, the aphrodisiac neon of the urban—things that have no place here amidst the timeless Scottish hues of brown earth, of white frost, of mustard yellow and mauve heather."

But it's not just the Scottish Highlands' striking beauty that resonates with the artists who visit; it's also the daily routine there—the way something as basic as brewing a morning cup of coffee requires an elaborate, almost ritualistic process: chopping wood for the stove, making a fire, slowly heating water to a boil, tending to the ground beans in "ecclesiastical ministry," as Andrew Ridley puts it.

"Everything is slower here," he writes. "And gratitude comes easily."

Since the Bothy Project began in 2011, Inshriach has inspired two additional residences. The first, Sweeney's Bothy, sits offshore of Scotland's west coast on the Isle of Eigg. A collaboration between Bobby and Iain and the artist Alec Finlay, it perches on a cliff overlooking the sea and the Isle of Rum—a far more remote location than Cairngorms. Reaching it from Edinburgh requires a nearly four-hour drive followed

A "view with a room," looking out over the Atlantic to Barra and beyond.

Pig Rock Bothy, a glowing polycarbonate cabin on the
grounds of the Scottish National Gallery of Modern Art.
ABOVE, FOLLOWING PHOTO: Johnny Barrington

EVERYTHING IS GOING TO BE ALRIGHT

by an hour-and-a-half ferry trip. Cars are left behind and the only way to get around the island is by foot, bike, or taxi.

The project's most recent design, called Pig Rock, was commissioned by the Scottish National Gallery of Modern Art in Edinburgh, where it was supposed to sit for three months before relocating to a striking spot at the trailhead to Suilven, a mountain in the Scottish Highlands. But the bothy proved so popular in its Edinburgh location that it ended up staying. It is a rare bird: an urban bothy. When it finally relocates, it will become the third artists' residence in the bothy network.

After eight years of operating the bothies on the volunteer labor of their fellow artists, Bobby and Iain turned the Bothy Project into a nonprofit that *funds* the work of artists as well as hosting them. And in a bid at self-reliance, Bobby and Iain have created the Bothy Stores, an online museum shop selling artfully crafted items like unusual enamelware and colorful artist aprons. But the store also sells something much more novel and ambitious: the Artist Bothy, a rough replica of Inshriach. The riff on their original bothy has been adapted for prefabricated production and international shipping. It doesn't come with the unique palette of the Scottish Highlands light, but it's still a long way from the art class where Bobby and Iain met as boys.

The commercially available, prefabricated Artist Bothy traveling through the snowy Scottish Highlands to be delivered.

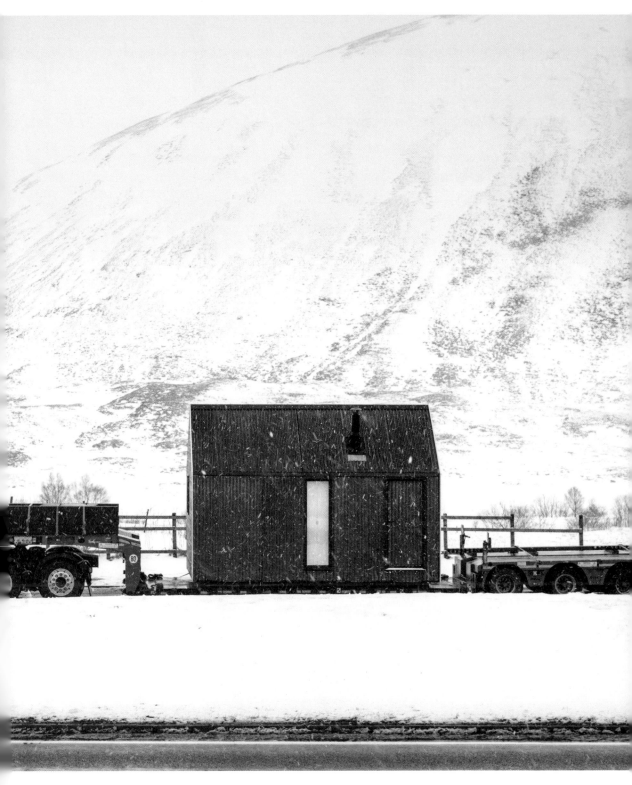

BOTHY PROJECT

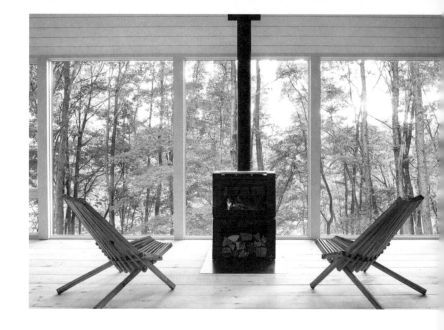

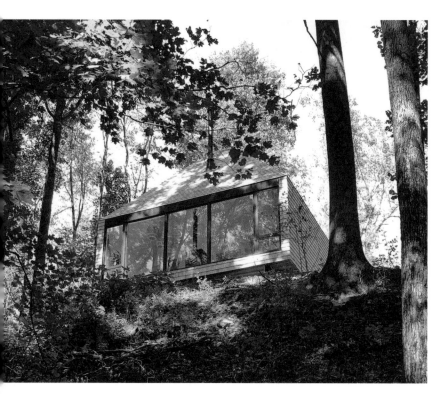

The Hut
Belmont County, Ohio

CONTRIBUTED BY Greg Dutton

PHOTOS BY Lexi Ribar

The Dutton family built this 600-square-foot off-grid hut on a former strip mine in eastern Ohio. The area is now a working cattle farm, and the cabin sits in the middle of its 2,000 acres. The outside is clad in white cedar shingle; the interior is pine shiplap and pine flooring, with a 26-foot-wide window wall that overlooks a forest and valley. A wood burner provides heat and concrete piers with a steel beam foundation allows the building to levitate over the ground.

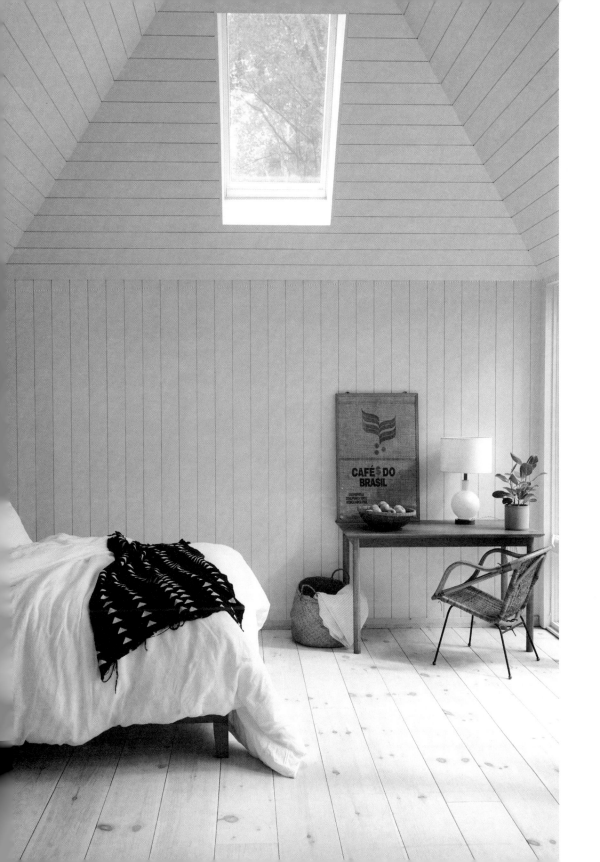

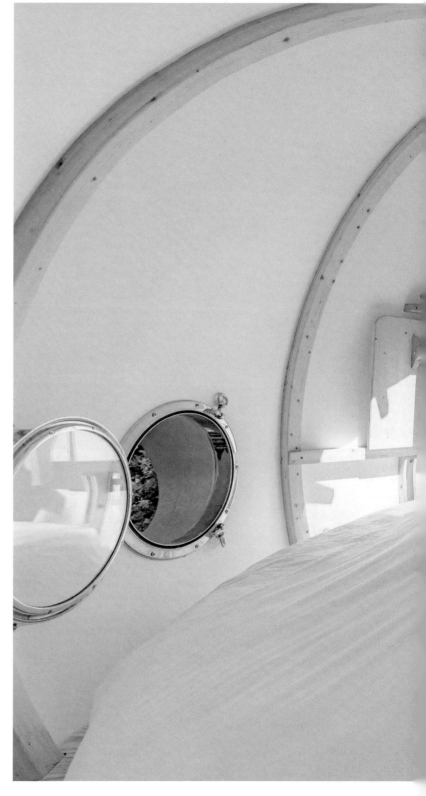

Coucoo
Grands Reflets
Joncherey, France

CONTRIBUTED BY
Gaspard de Moustier and
Emmanuel de la Bédoyère

PHOTOS BY Yoan Chevojon

Set in Joncherey, in northeast
France, the Comète Lov'Nid
blends in with the forest around
it. The builders prioritized
natural materials, and the cabin
is insulated with sheep wool.
A giant pine cone, reachable
by a rope bridge nearly 20 feet
above the forest floor, serves
as the bedroom. Inside, guests
will find a timber-framed oval
with a double bed, an open,
panoramic roof for stargazing,
and portholes for viewing the
surrounding canopy. On the
other side of the bridge is a
terrace with a Nordic bath. To
access the bedroom, guests
have to cross a rope bridge.

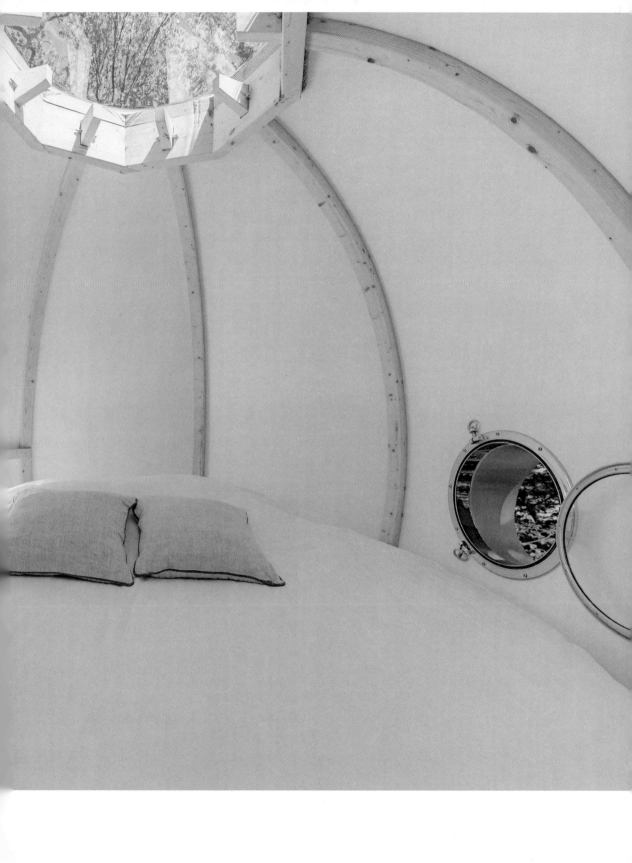

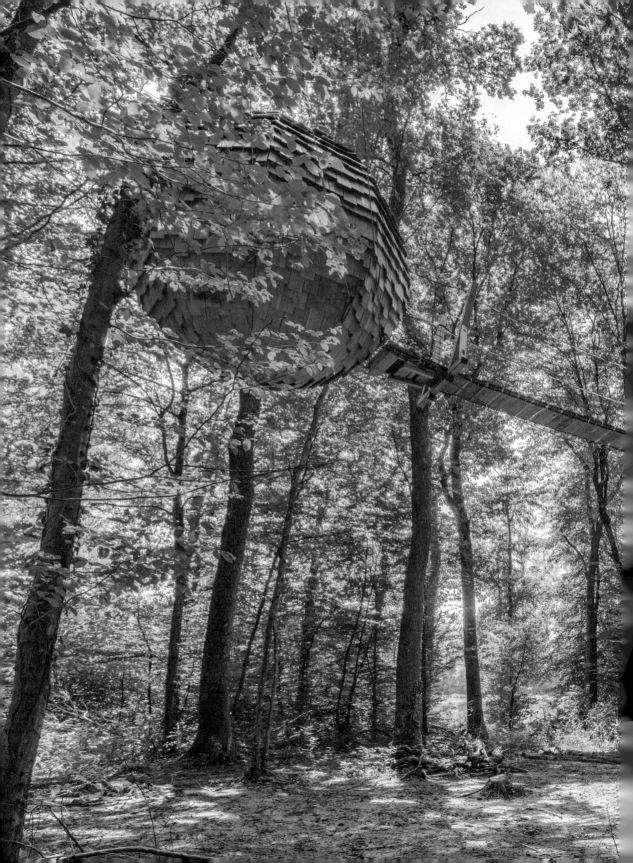

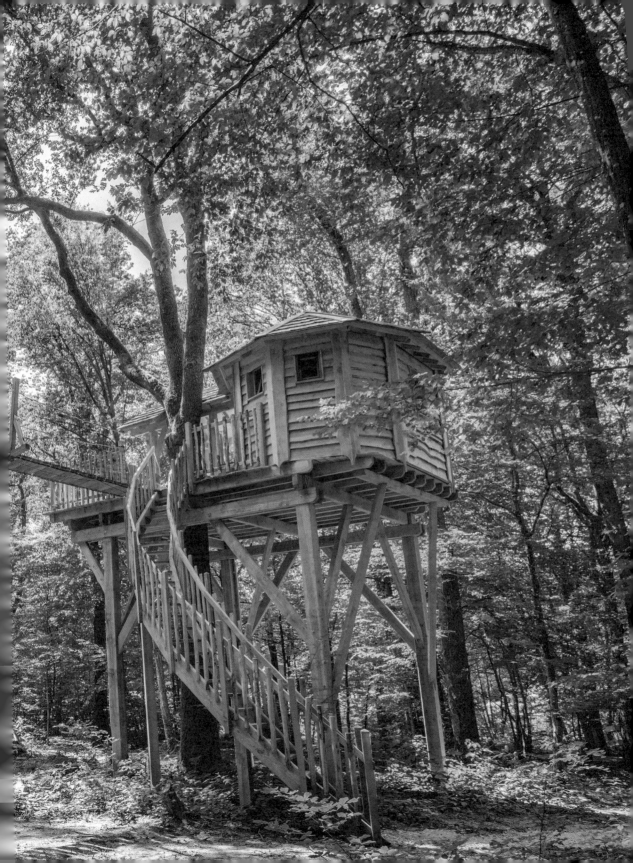

Coucoo Grands Lacs
Chassey-lès-Montbozon, France

CONTRIBUTED BY
Gaspard de Moustier and Emmanuel de la Bédoyère

PHOTOS BY Yoan Chevojon

One of the first floating cabins in France, the Lagon cabin is accessible only by boat. It is equipped with fresh water and a solar panel, and was designed to be a faraway floating paradise.

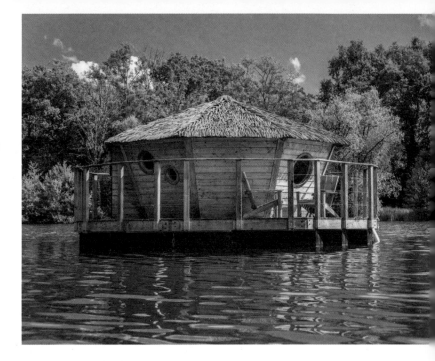

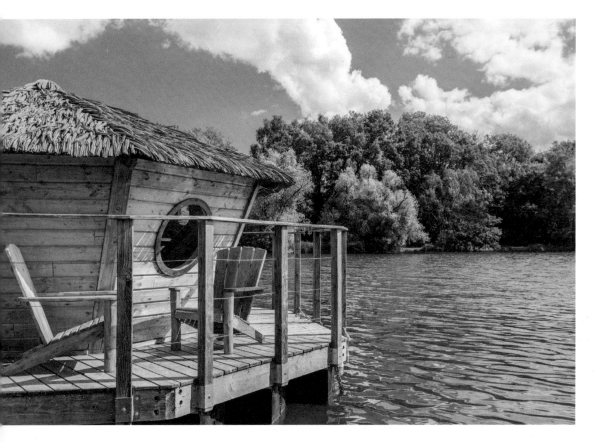

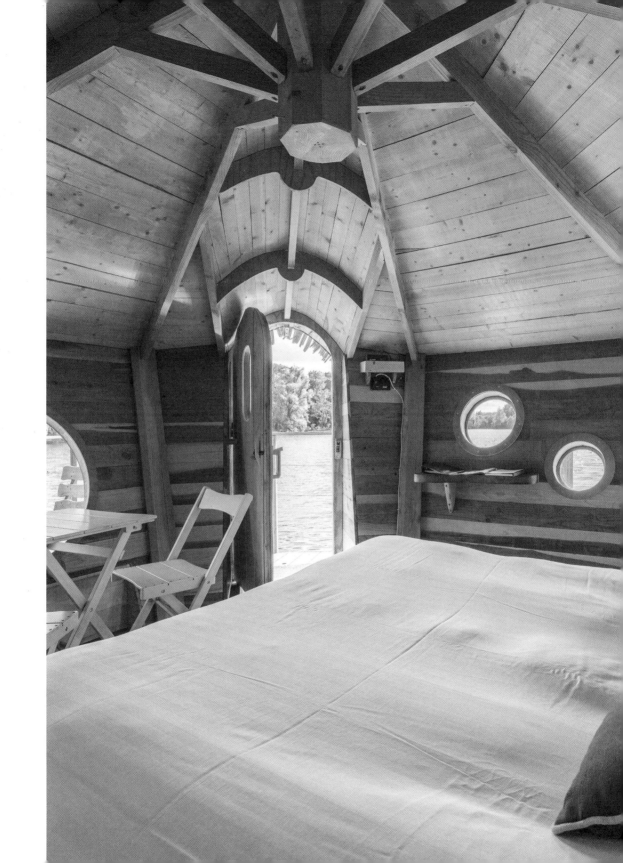

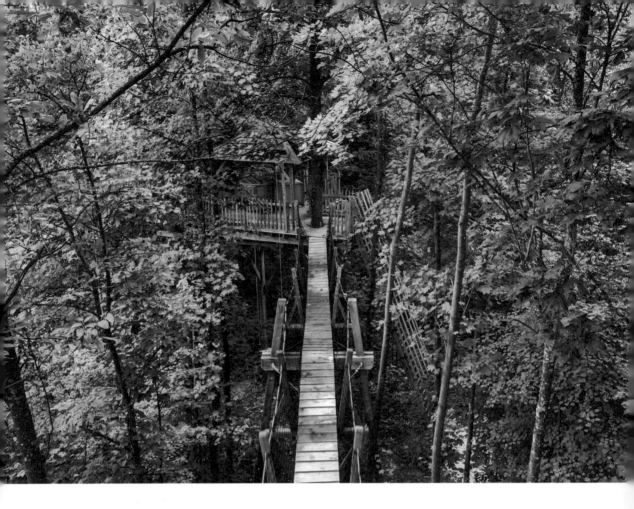

Coucoo
Grands Chênes
Raray, France

CONTRIBUTED BY
Gaspard de Moustier and
Emmanuel de la Bédoyère

PHOTOS BY Atelier LAVIT

Built upon a hundred-year-old
oak tree, this bird's nest of a
treehouse is perched 42 feet
above the ground and features
a 98-foot rope bridge that leads
to a private Nordic bath.

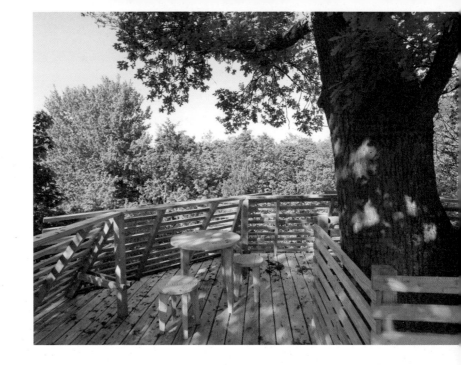

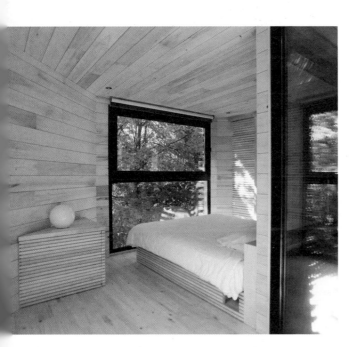

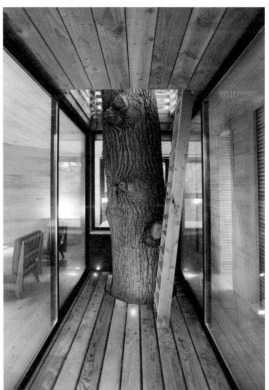

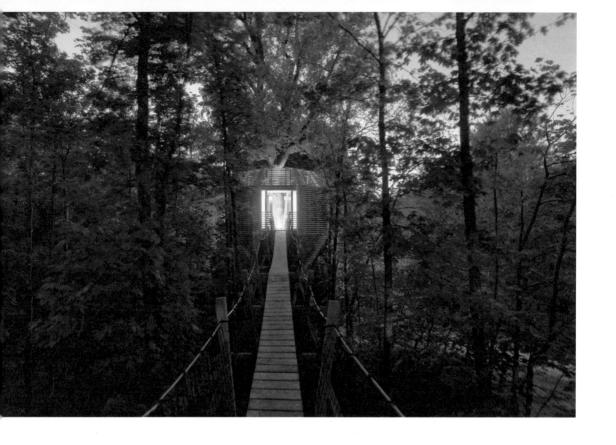

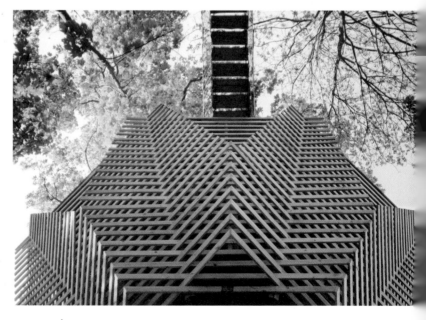

FOLLOWING PAGE

The Gingerbread House
Mt. Baldy, California

CONTRIBUTED BY Mariah Jochai

PHOTO BY Kyle Jochai

Construction of the Gingerbread House began in 1934 by George Kayser, a Hollywood set designer. Shortly after finishing the shell of the structure, he abandoned the project and the cabin sat in neglect for nearly 30 years. In 1975 Mariah's parents purchased the cabin from Kayser's widow and rebuilt it over four years. All of the interior woodwork was done by her father, Daven Gray, and much of the wood was salvaged from local barns and grove houses. Remnant walls of another structure on the property were refaced in stone by Daven to create an outdoor gathering space (shown on following page).

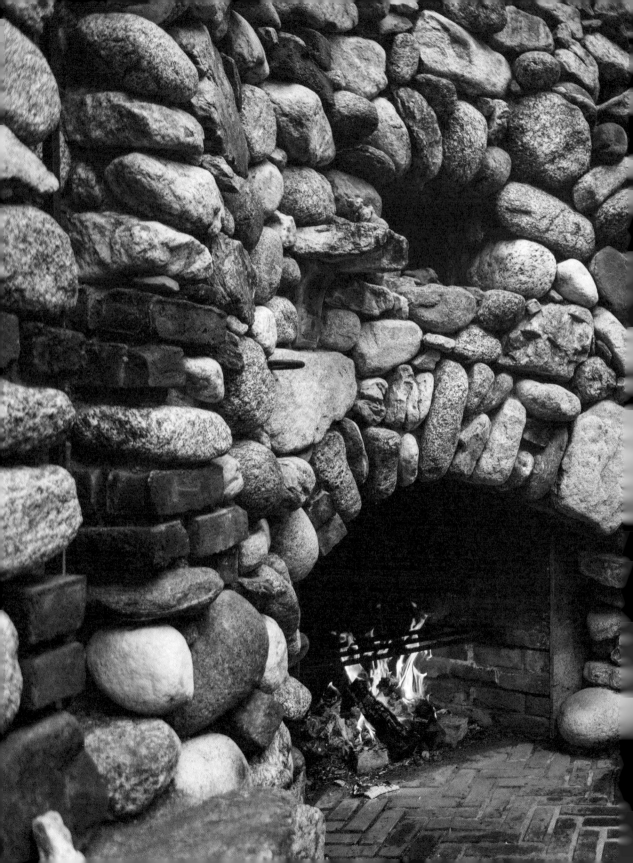

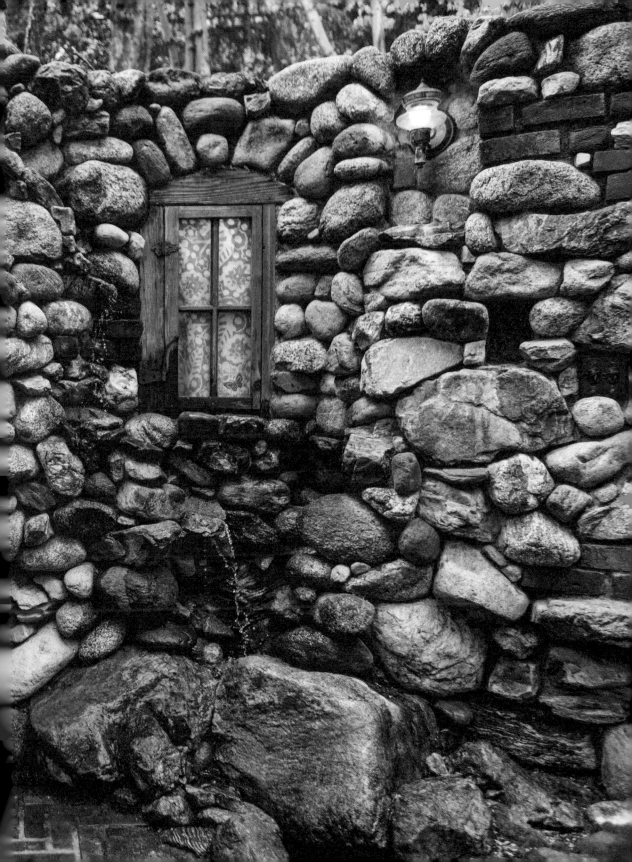

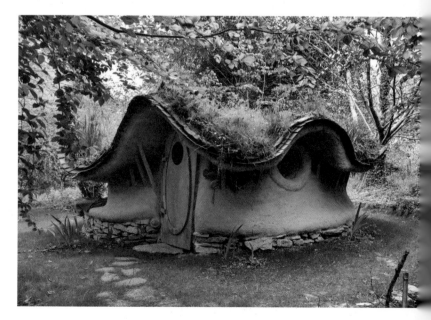

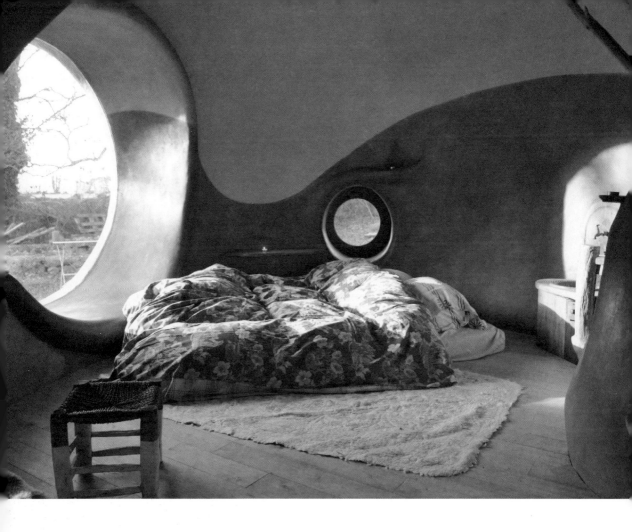

Love Shack
Melgven, France

CONTRIBUTED BY Brice Mathey

The Love Shack is a tiny clay hut hidden in the woods of northwestern France. Named after the B-52s song, the shack was created by Brice Mathey, who says, "Clay work brings naturally some love between builders and nature." Mathey used clay, straw, and bamboo for the structure, ferns for the floor, and a rubber roof covered with grass. The project began as a singular effort, but Mathey says it quickly became "a social thing." He recently finished his sixth.

Cabin 14½
Odell, New Hampshire

CONTRIBUTED BY Heidi Jewell

Set in New Hampshire's Great North Woods, this family cabin was built in 1945 by three brothers after they returned from World War II. The brothers, Granville, Bill, and John Jewell, have all passed, but their children and grandchildren still enjoy its isolation and the trade-off it necessitates: electricity and running water are swapped for fresh mountain air, a six-burner stove, and casting a line from the dock. At night, the swaying pine trees and pitch-black loft offer the best of kind deep sleep.

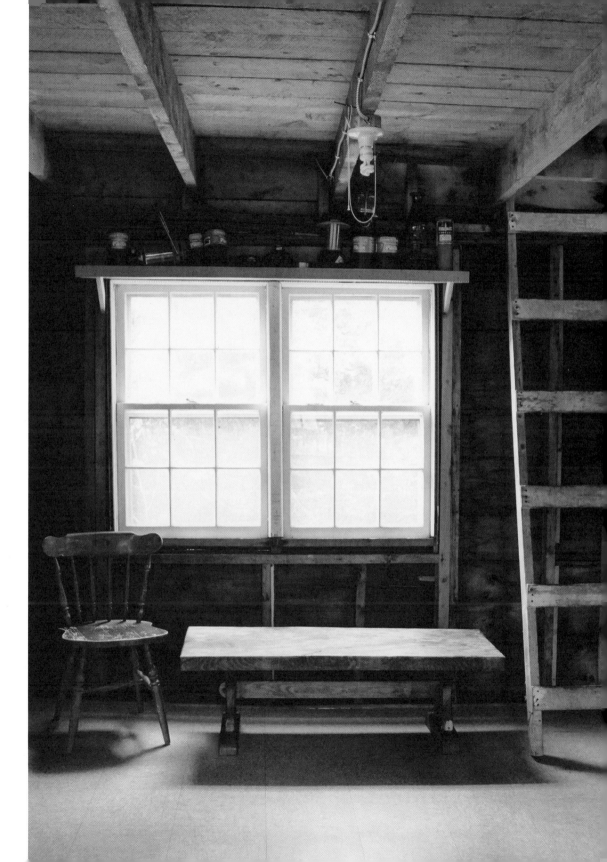

Tragata

Contributed by **Pantelis Pipergias Analytis**

Photographs by **Marianna Xyntaraki,
Merle Sudbrock**

Pantelis Pipergias Analytis grew up on the Ionian island of Kefalonia. His family lived in the four-thousand-person town of Lixouri, but Pantelis spent much of his time 5 miles north, at the tip of Argostoli Gulf, where his maternal grandparents owned a 74-acre farm. He was particularly close to his grandfather, Dimitris. Dimitris taught his grandson beekeeping, and Pantelis often worked alongside him, harvesting wine grapes in the summer and olives in the fall. "He was like a second father to me," says Pantelis.

When Pantelis was ten, he moved to Athens, on the Greek mainland, where his mother had moved after his parents divorced. Several years later, he and his mom returned to Kefalonia, where he finished high school. But then, in 2005, he left again—this time alone, to study in France. When Dimitris became ill that November, Pantelis drove home to Greece to be with him in his final days in an Athens hospital, where his grandfather died. Pantelis eventually inherited half of Dimitris's property, Koriani Farm.

Over the past decade, Pantelis has traveled the world, living in Italy, Japan, and the United States. He spent years in Berlin, where he studied for his PhD in psychology, worked on documentary films, and lived in a communal apartment with seven other students. The German capital is, he says, "the place after Kefalonia that feels most like home." Though

The lower panels open to allow for versatile views of the landscape. There's a second platform beneath the floor that can be used for storage.

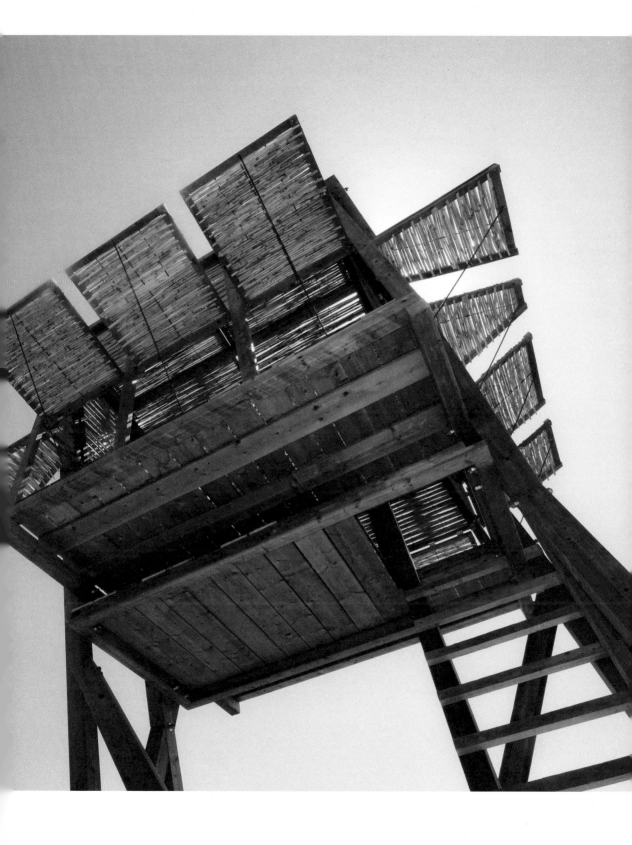

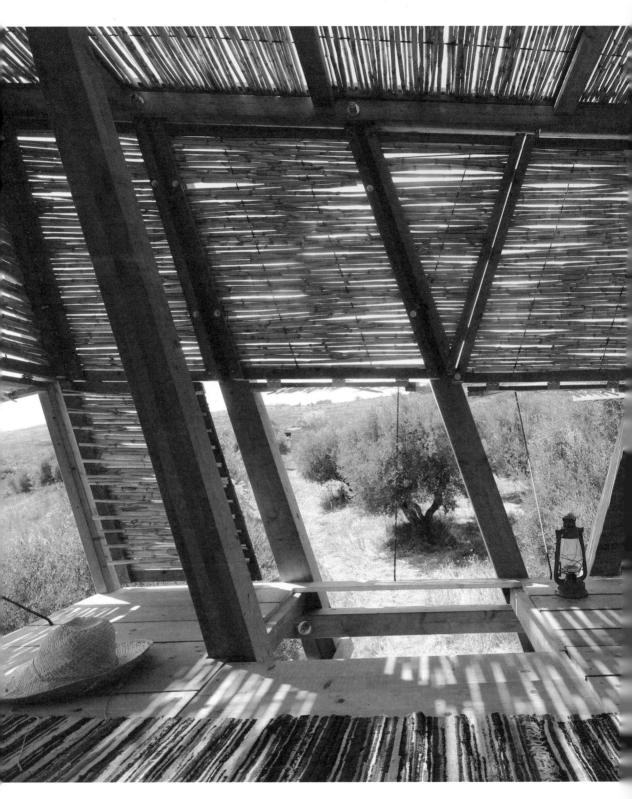

TRAGATA

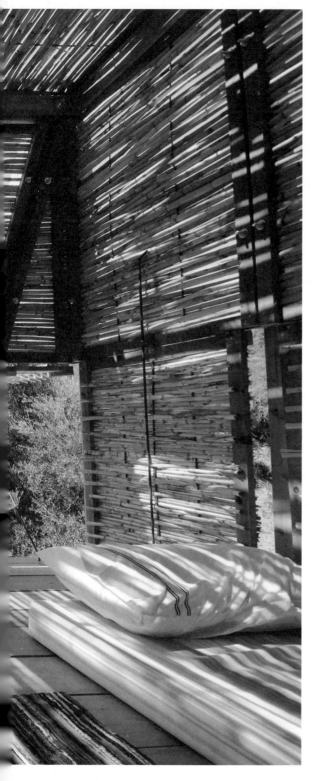

his degree is in psychology, Pantelis's interests are broad-reaching, and his work focuses on decision-making, both "in the real world," he explains, and online. "I don't think that anybody could predict that I would turn into an academic twenty years ago," he says. He's now an assistant professor at the Danish Institute for Advanced Study.

After his grandfather's death, Pantelis returned to Kefalonia most summers, visiting family and friends and even, in 2013, staging an art exhibit there. Then, in January and February of 2014, two large earthquakes hit the island, destroying many of the historic structures on Koriani Farm. The quakes "were an absolute emotional low," says Pantelis. At the same time, the damage motivated him "to rebuild and to develop a vision for the place," he says.

He gathered several friends—a group that would swell to some twenty-two people from six countries—and asked them to join him in creating an international community on the land. "The vision," says Pantelis, "is for the farm to be a place to meet mighty travelers who go out and explore the world and return to the farm to share the stories and create."

Pantelis and his grandfather had discussed potential uses for the family farm beyond its traditional crops. But as Pantelis saw more of the world and encountered different approaches to communal living—from WWOOFing in Latin America to Israeli kibbutzim to German cohousing projects and Beaver Brook in upstate New York—his vision for Koriani Farm came into focus.

In the summer of 2016, Pantelis traveled to Kefalonia with the Berlin-based architect collective Studio Genua—a group of friends and architecture students who were eager to "build something rather than studying," says Merle Südbrock, one of Pantelis's former

The reed-filled frames guarantee ventilation and reflect the purpose of the traditional *tragata*, airy places to rest during the hot Kefalonian summer.

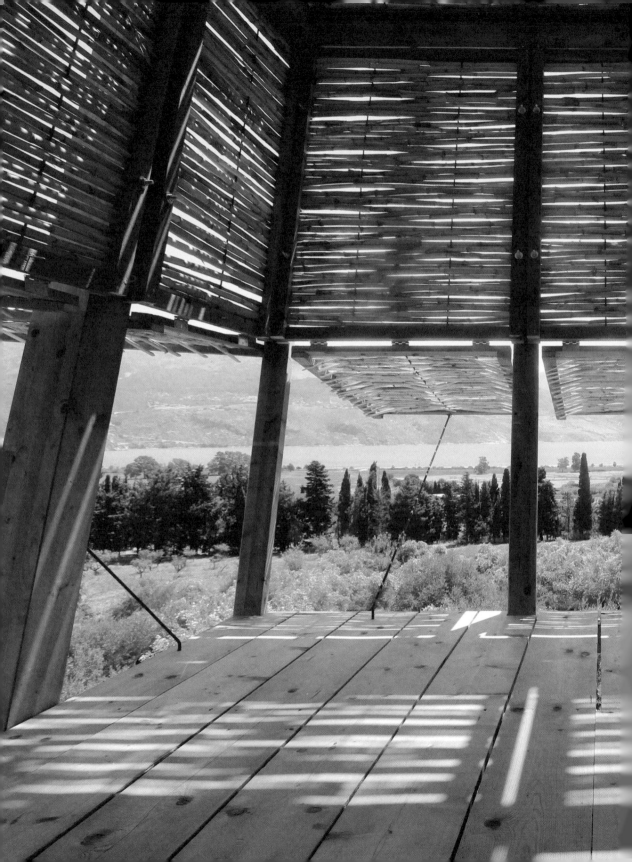

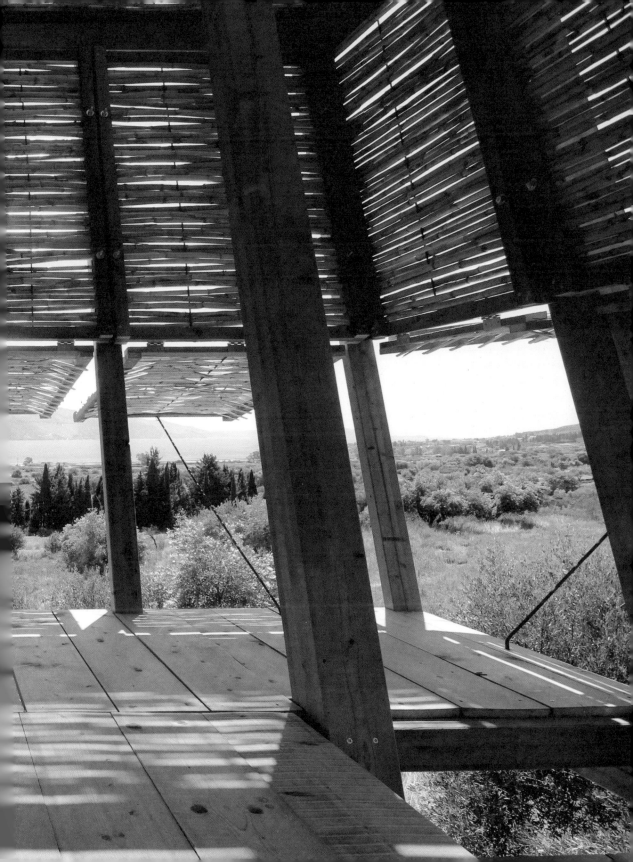

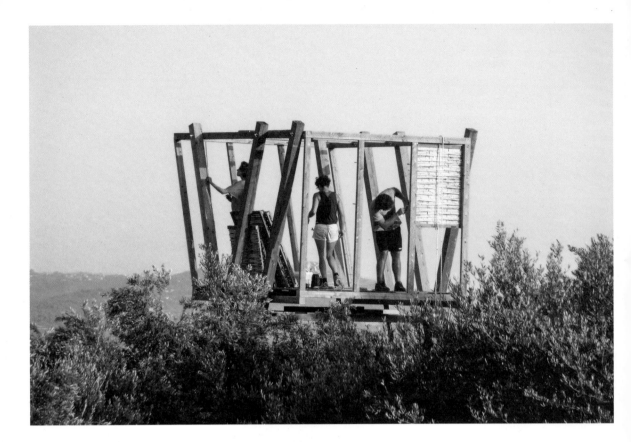

The *tragata* hovers above the olive orchard. Once the main structure was stable, Marina, Merle, and Stefano started to place the first panels on it.

R Merle and Marina mount the panels. After experimenting with different framing and weaving techniques over several days, they finally got it right. The panels were then removed for the wet and windy Kefalonian winter.

OPPOSITE Situated among the olive trees, *tragata* are not only a place to hide from the sun but a hermitage— a place to retreat, think, and relax.

PREVIOUS The eastern and southern panels are framing Argostoli bay and the Thinia mountains. Its 9-square-meter platform can sleep four or five people.

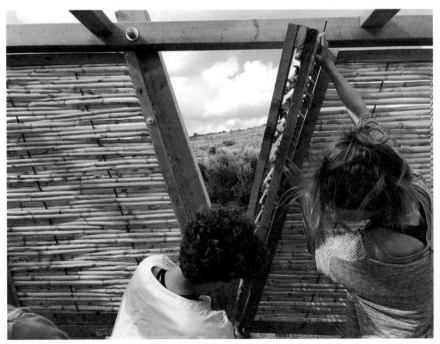

TRAGATA

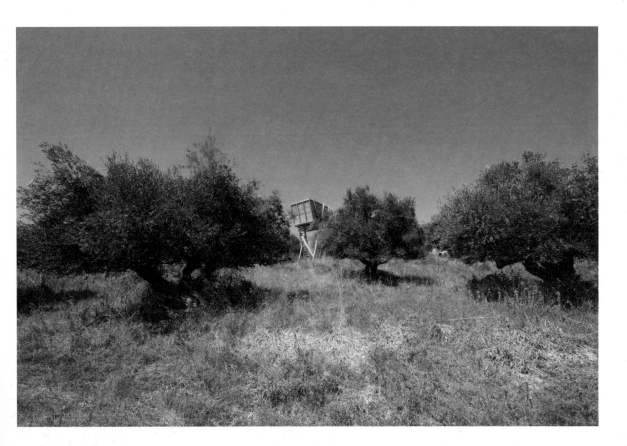

roommates, who led the project. Initially, Pantelis hoped to have the group build a house on the land. But committing to a location and design, plus navigating the notorious Greek planning bureaucracy, felt like too big of a first step.

When Studio Genua visited the farm, the collective studied its landscape of white stone and blue sea and discussed potential projects. They walked the land, says Merle, and heard stories and learned its history, "from ancient Greece to pirates who lived in a bay." In sharing the property with his friends, Pantelis reflected on his grandfather telling him about *tragatas*—traditional treehouse-like structures that floated above the fruit and olive trees in Ionian orchards. He had a faint recollection of Dimitris describing how he and his siblings would take refuge from the heat in their shade while they worked the land. "It was kind of a little bit vague in my memory," says Pantelis, "just reverberating since my grandpa died."

As a first project for Pantelis's communal farm, the *tragata* seemed ideal. It could be built affordably and quickly—the group could gather for only two weeks—while adding a modern dimension to Pantelis's family's heritage on the island.

But because the *tragata* tradition had been supplanted by more modern, permanent structures on the island, Pantelis had only a rough image of one in his mind. And because hardly anything has been written about these outbuildings, he didn't have much to work with in terms of a starting point for a design. All he knew, really, was that they had been built of local cypress and had provided a very basic, open-air shelter—a refuge.

Pantelis reached out to the Greek architecture collective Hiboux for its insights. And that fall, Merle and two other members of Studio Genua traveled to Athens, where, over several days, the two groups—from Germany and from Greece—played with models. The resulting design was a contemporary take on a traditional Ionian treehouse, with a permanent frame encased by seasonal panels made of local reeds. "My input was minimal," Pantelis says. He credits the team of architects and the project's master carpenter from Germany, Clemens Linnenschmidt.

In August of 2017, members of both collectives—

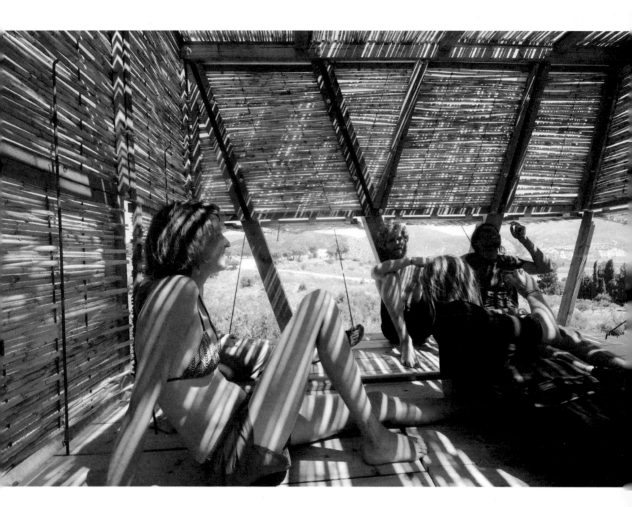

along with friends from around the world—returned to the island to build the *tragata*. Initially, the Greek collective had wanted to hire workers to do the construction. But Merle and Studio Genua were eager to use their hands. "We said, 'No, we will build it on our own!'" says Merle with a laugh. "We somehow convinced them."

Traditional *tragatas* were made of cypress, but were only built to last a couple of years. To improve the *tragata's* longevity, they imported spruce beams to serve as the *tragata's* base. The exterior panels were made of reeds harvested from Koriani's creek, stripped and woven by hand. That laborious task could be accomplished only during the early mornings and evenings, when the group wasn't being assailed by the sun. So Pantelis and his friends and collaborators woke at 6 a.m. to maximize the time they could work

outdoors before a midday siesta became necessary. All twenty-two of them stayed in a house on the property with Pantelis's grandmother, Eleni, who, in her early eighties, still lives in nearby Lixouri and still frequents the farm. "When she's there," Pantelis says, "she's the boss."

Since Dimitris died, Eleni has kept up the place, planting trees and building stone walls. "She has herself put a lot of labor there," says Pantelis, "so I am sure she found it rewarding that so many people can benefit from these labors."

For two weeks, Eleni's house was full of young people. They slept everywhere, from mattresses Eleni set up on floors to hammocks to tents. And everyone had a job, from the jester, as Pantelis describes Maher Salameh, a Palestinian architect who "kept our spirits up," to the Dutch anthropologist Herbert Ploegman, who "became our documentary filmmaker." The result is an airy fort above

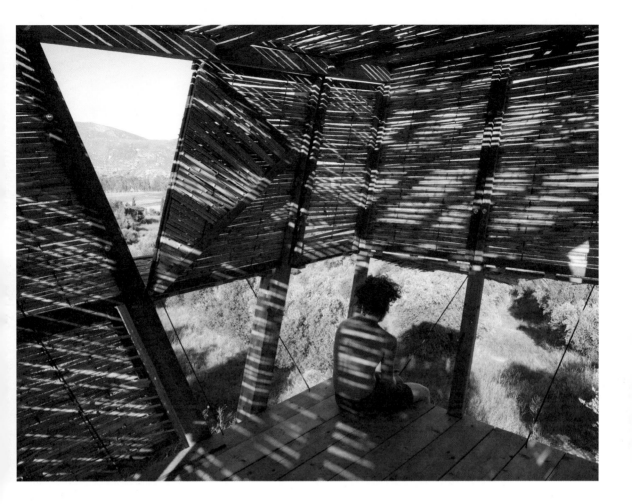

Clemens can finally exhale. He was
a carpenter before he turned into an
architect, and he spearheaded the
construction. Without his expertise the
project wouldn't have been possible.

OPPOSITE After two weeks of hard
work, Merle, Clemens, Pantelis, and
Louise lie back and relish the soft light
inside the *tragata*.

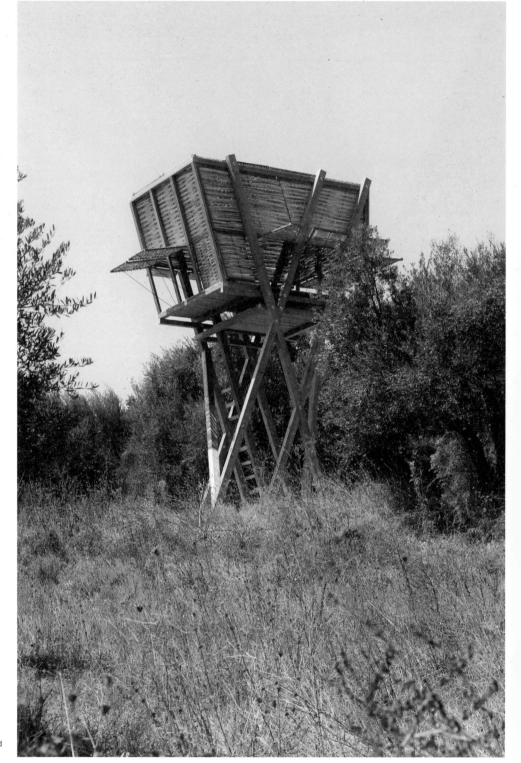

In contrast to traditional *tragatas*, which were built from perpendicular cypress logs, beams on Pantelis's modern version are positioned diagonally.

TRAGATA

the leaves, shaded from the sun, yet receptive to the salty breeze off the gulf. Pantelis didn't insist on much, says Merle, but his *tragata* had to have a view of the water.

Pantelis and his community are now planning what's next for Koriani Farm. In order to do anything, they'll have to expand the farm's irrigation system. Dimitris had dug channels to divert a small creek that runs through the farm, and those channels water the existing crops: almonds and oranges, pears and apples, lemons and apricots, pomegranates and figs. Now Pantelis is researching ways to water additional crops from a spring on the land, including herbs like lavender, thyme, and oregano, which grow wild on the island.

Pantelis acknowledges that his big idea for the farm—creating an international community—won't happen overnight. "The timeline of how it will materialize is still

uncertain," he says. "Building the *tragata* was a first wild experiment in that direction. More than anything, we built memories and strong bonds between us."

So what would Dimitris think of Pantelis's vision for Koriani? "He would be certainly happy to see the place reactivated," says Pantelis. "But I am not sure he would fully approve." Pantelis thinks his grandfather may have envisioned a family-run project on the farm. Of course, there is more than one way to build a family—and Pantelis has found his.

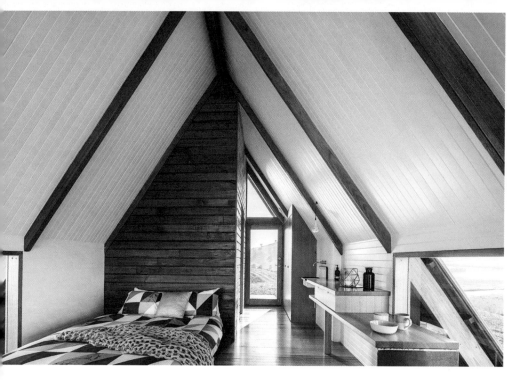

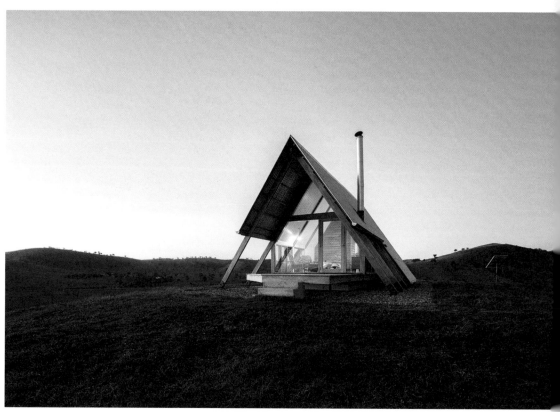

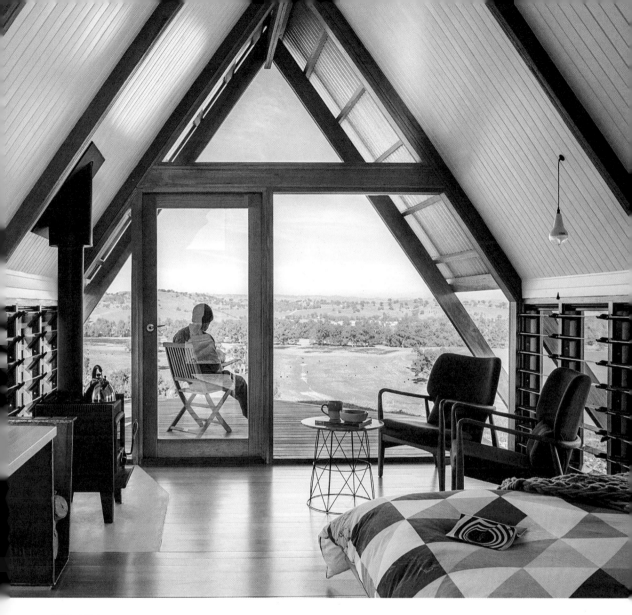

JR's Hut
at Kimo Estate
Gundagai, Australia

CONTRIBUTED BY David Ferguson

PHOTOS BY Hilary Bradford

JR's hut sits on a hill overlooking
the Australian bush. Designed
as an overnight digital detox
spot for city dwellers, this
off-grid "glamping" cabin was
built by David Ferguson on his
family's 7,000-acre cattle and
sheep farm in New South Wales.

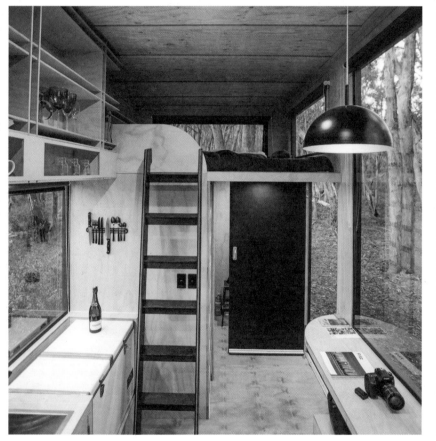

Jude
Adelaide Hills, Australia

CONTRIBUTED BY CABN

Located in South Australia,
and built with natural timber,
Jude is off-grid and designed
to merge a minimalist interior
with the outdoors.

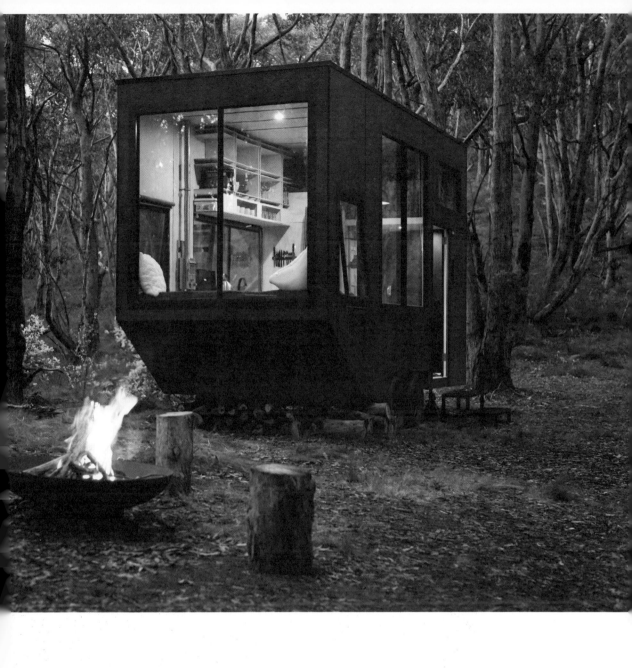

McGovern Residence
Pomeroy, Washington

CONTRIBUTED BY Sven Holt

Sven and his partner have been restoring the home his grandparents built during the back-to-the-land movement in the 1970s.

Enlisting family and friends for help, the McGoverns harvested logs from Umatilla National Forest and salvaged materials from construction jobs, demolition sites, and second-hand stores. In addition to the main cabin, Bill and Evelyn McGovern built a root cellar, a potting shed, a guest room, and a Quonset hut.

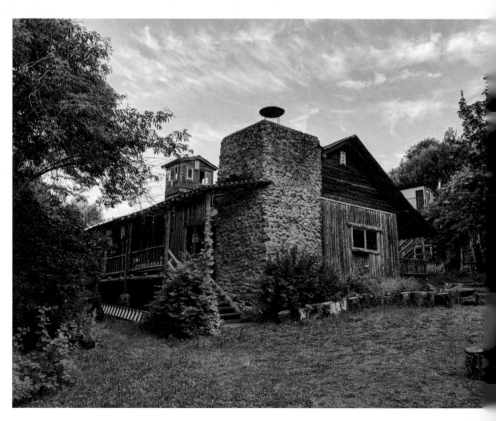

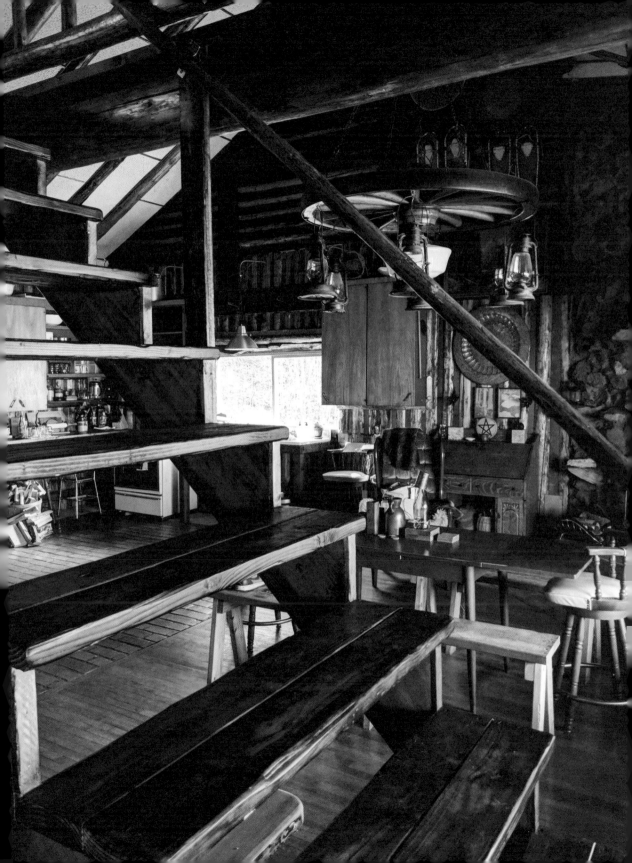

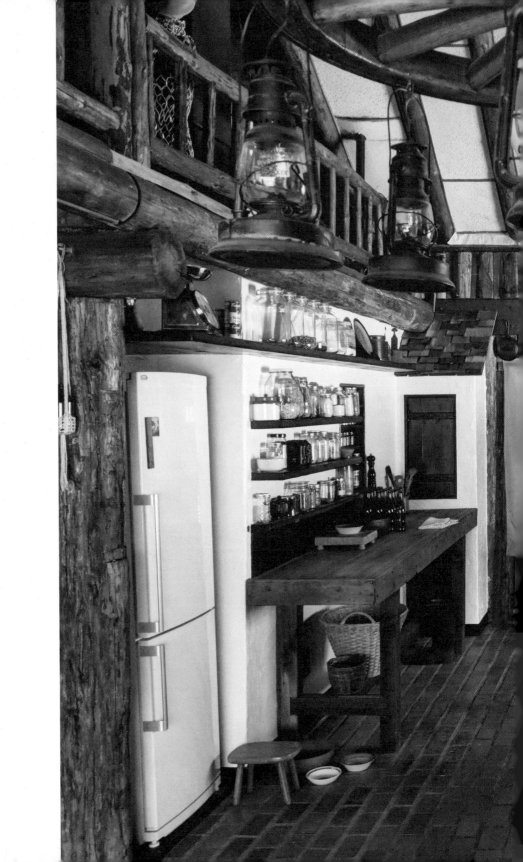

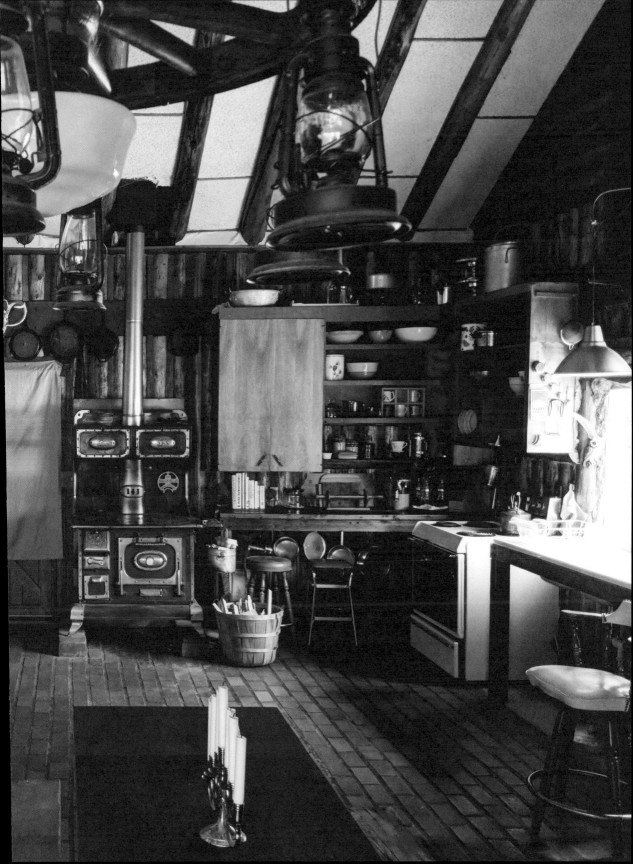

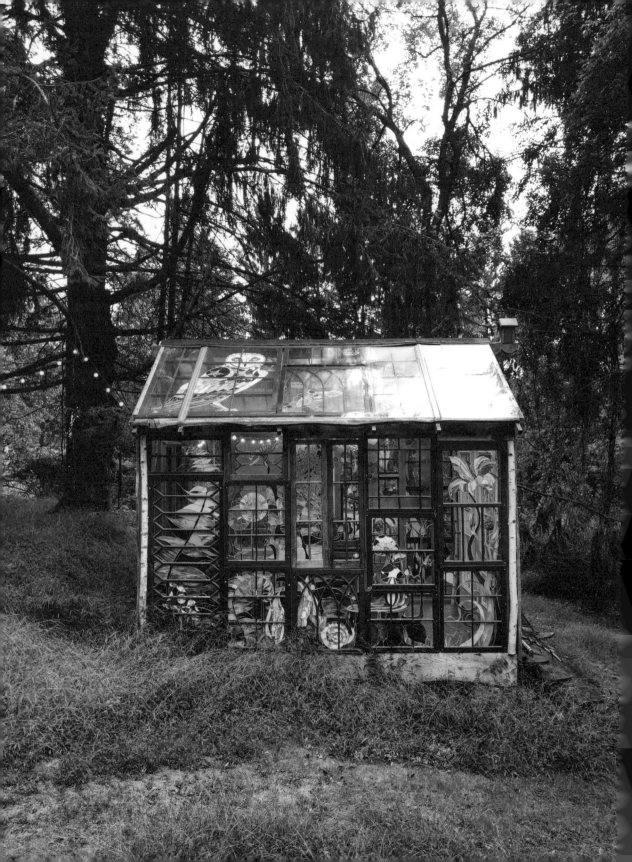

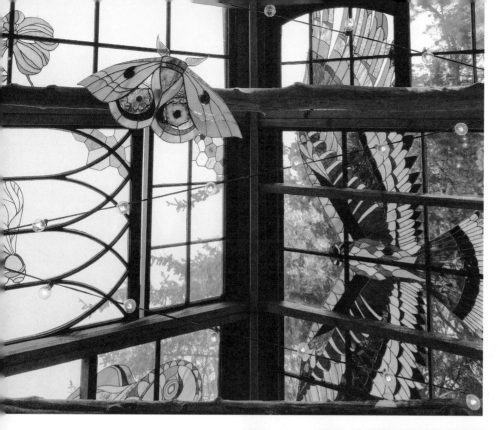

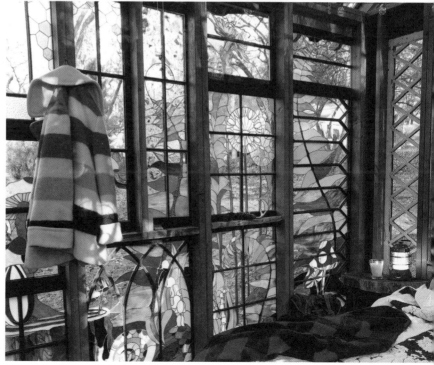

The Glass Cabin
Sparta, New Jersey

CONTRIBUTED BY
Neile Cooper

This tiny cabin is constructed entirely of stained-glass windows. Built as an art-making space offering complete creative freedom, the structure is clad entirely in reclaimed window frames filled with nature-inspired stained glass.

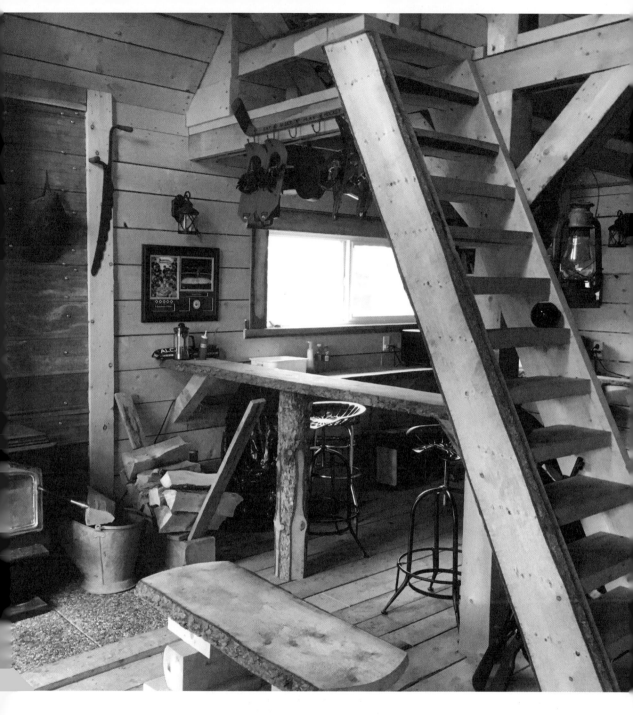

Jason's Cabin
Alberta, Canada

CONTRIBUTED BY Jason Prins

Built as an escape from city life, Jason's Cabin is located in Central Alberta and constructed with 50-year-old materials—shop-metal cladding and barn and coral wood salvaged from an old farm. The interior is finished with wood from spruce trees that owner Jason Prins cut himself.

189

Fjellro
Drammensmarka, Norway

CONTRIBUTED BY
Dag Erlend Lohne Mohn

PHOTOS BY Frøyset NorskeHjem

Dag Erlend Lohne Mohn found his cabin a few years ago in a decrepit state. Located outside the Norwegian port city of Drammen, the place was abandoned, with holes in the roof and rotted logs. Still, with its notched round timber and elegant construction, the cabin was beautiful.

And it came with a powerful story: built in the 1930s, it housed anti-Nazi resistance fighters during World War II and the German occupation. Plus, Dag was convinced it could

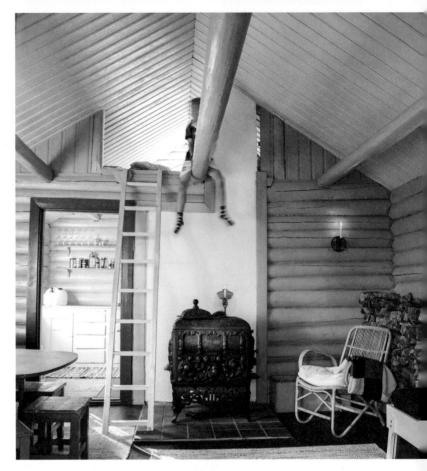

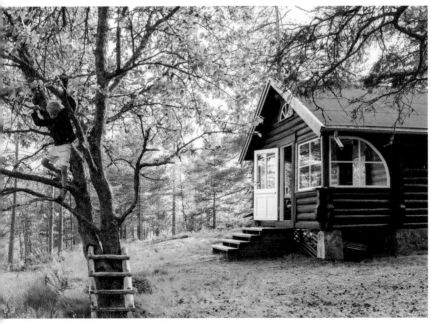

be saved. After tracking down the owner and settling on a sale price, Dag began a two-year restoration process. Using traditional tools and materials, he did most of the work himself, using logs harvested from the property and linen-seed paint for maximum breathability. Beautiful old cast-iron ovens were added to the living room and kitchen. Now, he uses it for family trips, as a home office, or for late-night mountain bike adventures—a resurrection, Dag says, that's nothing short of amazing. "It was about to die. About to turn into soil," he says. "I saved it."

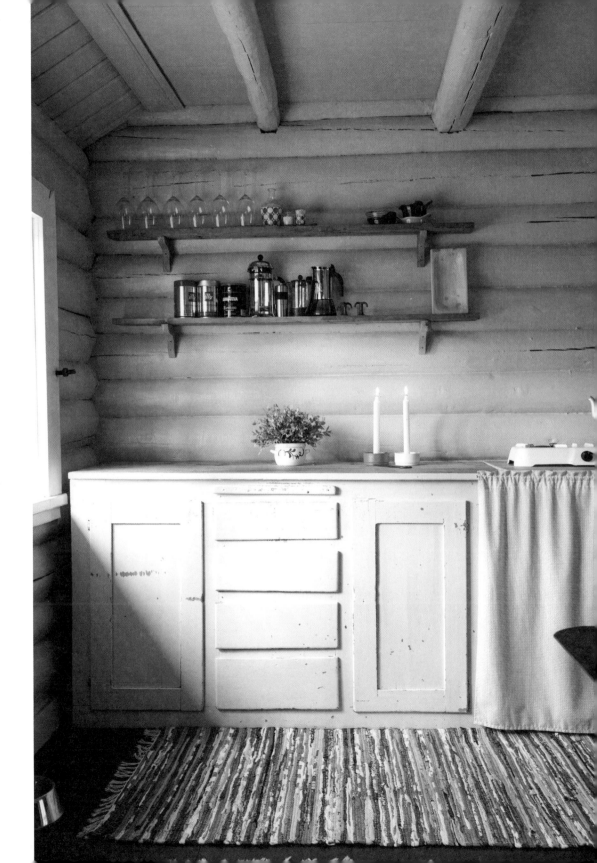

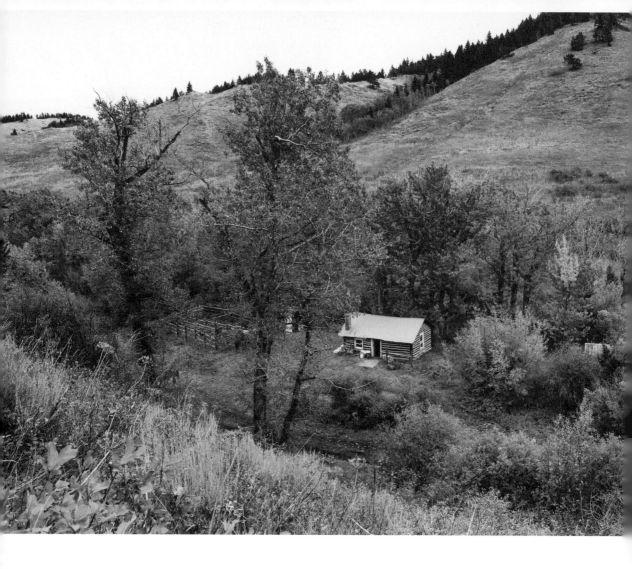

Shonkin Cowcamp Bunkhouse

Highwood Mountains, Montana

CONTRIBUTED BY Brian Liu

PHOTOS BY Liu/ToolboxDC

The Shonkin Cowcamp bunkhouse is in the Highwood Mountains of north-central Montana. Built roughly a century ago, this one-room log cabin is used by eight cowboys during their annual cattle roundup on 50,000 acres of forestland. Filmmaker Brian Liu traveled there for seven years to capture the dying American tradition for the documentary *Only Roundup Remains*.

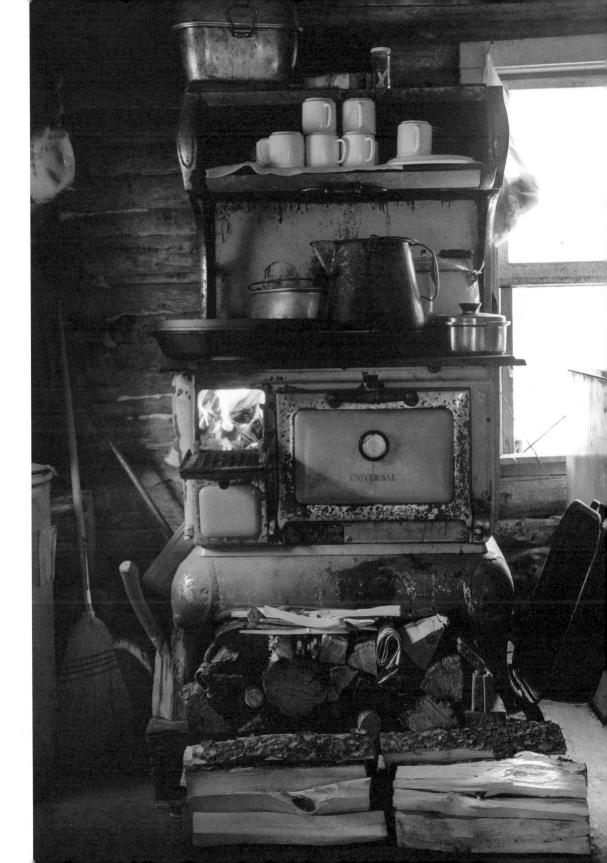

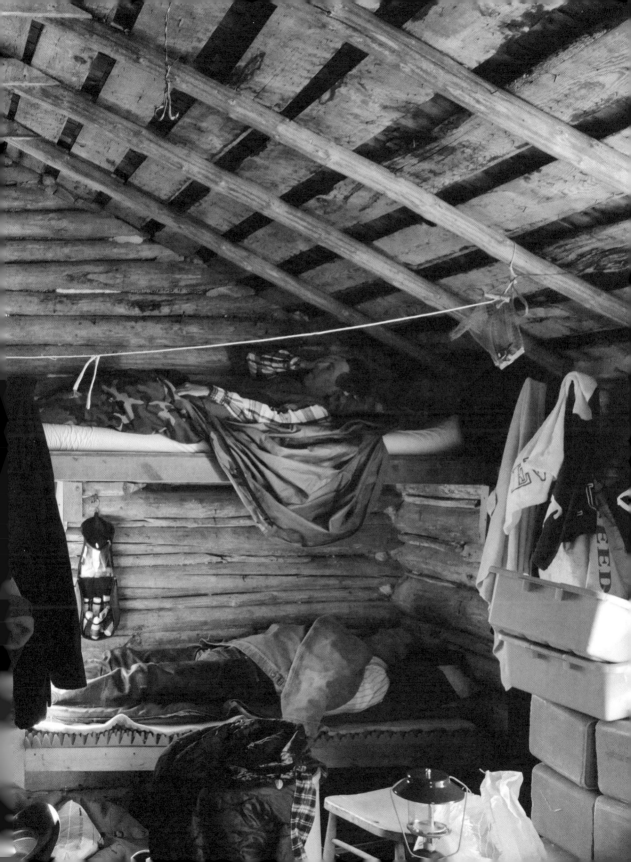

Hillside Homestead

Contributed by **Jenna Pollard**

Photographs by
Jenna Pollard, Kathy Pollard

Jenna Pollard has "a wild heart and a gypsy soul." But despite her nature, she is deeply rooted in the prairies of South Dakota. Her great-great-grandparents emigrated from Ireland and Sweden in the late 1880s, and their farm outside the tiny town of Kimball has been handed down matrilineally—from mother to daughter—ever since. Jenna's mother inherited the land from her mother, and someday, when her mother is gone, Jenna will inherit the land as well.

Despite the family's long history on the windy northern prairies, Kimball hasn't always felt like an obvious home for Jenna, a self-described "young, single, liberal, gay woman." It took a moment of heartbreak—when she was twenty-six, living in Minnesota and facing the end of a six-year relationship—to bring her back. Jenna and her partner had been living in an off-grid community, DreamAcres Farm, where they'd hoped to build a house together. When their relationship ended and their plan fell through, Jenna's desire for a homestead of her own only intensified. "My vision for a cabin was written and drawn across hundreds of sheets of paper and had even manifested in several 3-D models made from cardboard boxes," says Jenna. "I needed something productive to do with my hands and to take my mind off of the pain I was feeling."

Jenna initially shopped for her own property in

A year after beginning, the cabin is complete, with a porch and lean-to storage area, and metal siding and triangular supports to block wind. The red sliding-door hardware came from Jenna's grandpa's toolshed.

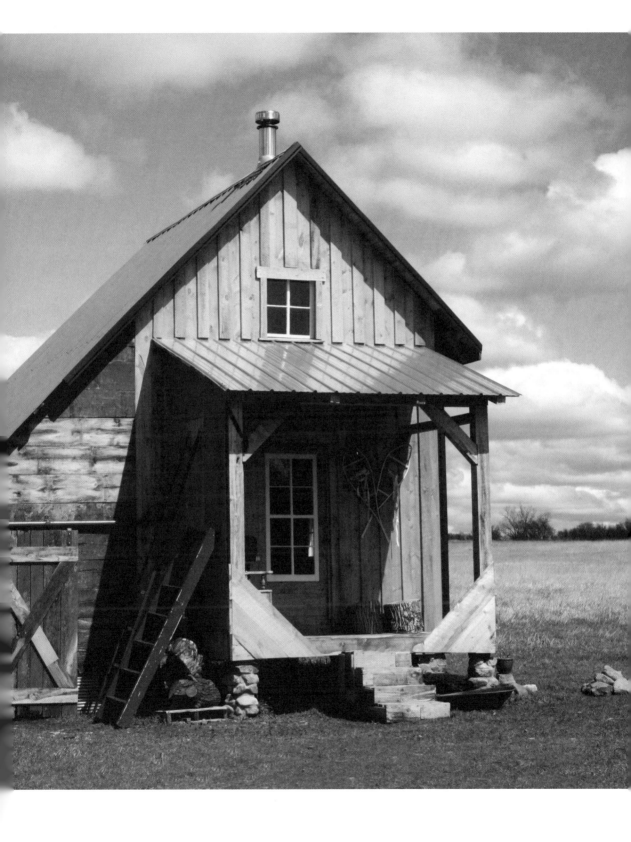

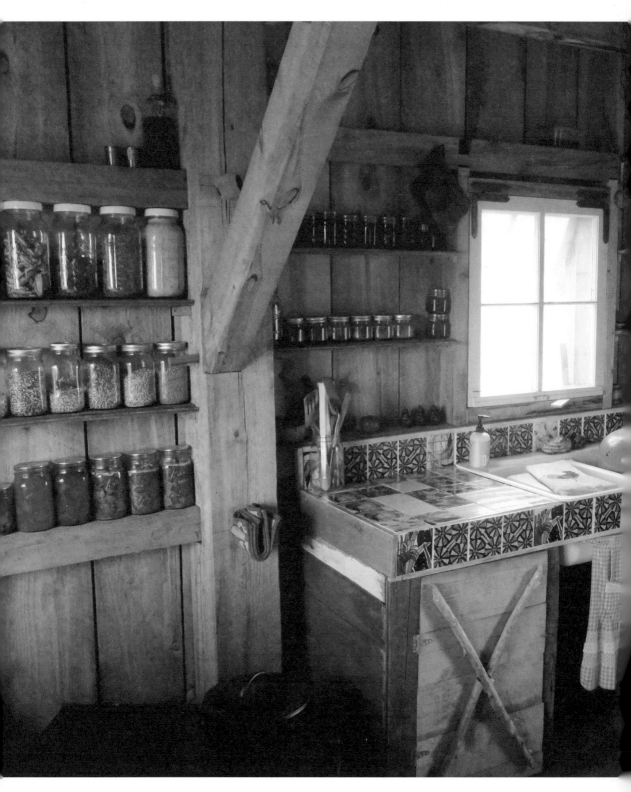

HILLSIDE HOMESTEAD

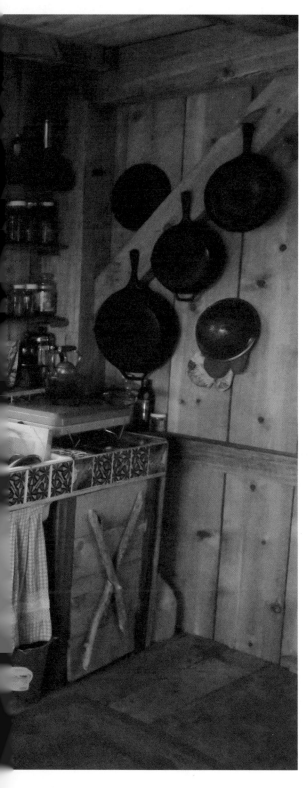

Minnesota, but the cost of land was prohibitive. Then her mom suggested that she build a cabin on the family tract where Jenna had grown up, and which she would someday inherit. The parcel is 86 acres of wild, sparsely populated prairie land—a fraction of the original family homestead, which has been divided through the generations. It's fully fenced but has no trees or structures. There's not another home in sight.

To build her cabin, Jenna spent six weeks tent camping on her family's land. First, she asked her mom to walk the property and stand where she felt the cabin should go; that is where Jenna would build. "I feel a lot of respect for the tradition of women owning this piece of land," says Jenna, "and having my mom choose where the cabin should go felt like a way for me to show respect for her ownership of the land and her history there."

Then she ordered 24,000 pounds of Black Hills ponderosa pine from a local sawmill. She saved money by buying the wood undried and rough-sawn—as minimally processed as you can get it, she says, without "buying the tree and milling it yourself." She avoided delivery costs by borrowing a truck and trailer from her dad's work and hauling it herself. The lumber was especially affordable because at the time, there was a pine beetle infestation that led to a glut of lumber and drove down the price. The wood is stained blue from a fungus carried on the beetle's legs. When Jenna bought the wood, the staining was viewed as a blemish. But now, "denim wood," as it's come to be known, is sought-after for its distinctive character.

The lumber that made up the frame, rafters, roof, decking, siding, floors, porch, and outhouse cost Jenna just $2,900. The entire cabin came to just under $7,000 total. Jenna built everything herself. Having learned the technique from her mentors who

The kitchen is a blend of old and new, with her grandmother's apron, cast-iron pans, glass jars for bulk storage, recycled tiles, wood from nearby barns and sheds, and a two-burner gas stove.

worked at DreamAcres Farm in Wykoff, Minnesota, and Wild Rose Timberworks in Decorah, Iowa, Jenna spent a month and a half laying and chiseling timbers in the traditional timber-frame style. The cabin, which she named Hillside Homestead, is just 12 by 16 feet. It is built entirely of wooden timbers and pegs. Not a single metal screw, bolt, or fastener holds the frame together. When the frame was complete, Jenna gathered a group of fifteen friends and neighbors on the summer solstice; together they raised her cabin.

"It was easily one of the most empowering and moving experiences of my life," says Jenna.

Then Jenna used metal nails, for the first time, to attach sheathing—a protective covering also made of ponderosa pine—to the frame before adding the roof and letting the frame settle for a couple of months. She splurged, she says, on traditional square-shaped nails that work with the grain of the wood instead of tearing or compressing it. Finally, she installed flooring and siding and hung hundred-year-old windows. Still, by the beginning of the winter of 2015, the cabin remained a work in progress. As the dramatic South Dakota weather shifted, season to season, Jenna followed its lead. She added insulation and a wood-stove in the winter; she built an outhouse in the spring.

Erecting the frame was such a momentous accomplishment that each step afterward felt minor in comparison, Jenna wrote in a blog she maintained about her experience. She spent weeks sleeping in the cabin's loft when it was still open to the elements. "I was hesitant with each piece of siding I added, knowing that I would miss the beauty of the timber frame visible from the outside," she writes. "Now that nighttime temperatures are dropping, though, I'm thankful for my siding, and my windows, and my

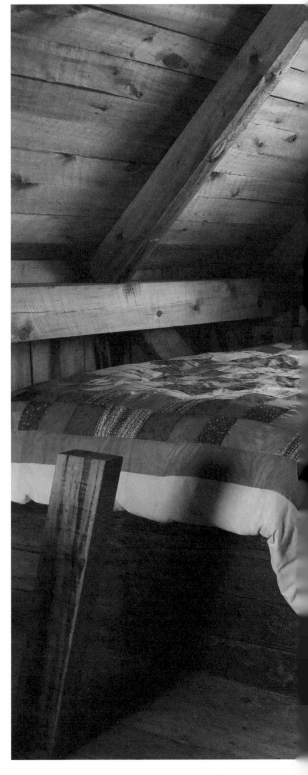

Jenna designed the loft windows to face east at bed height. She wakes to the sun rising at eye level. The bed is made from pallets, and the duvet cover is a quilt her grandmother made but never finished.

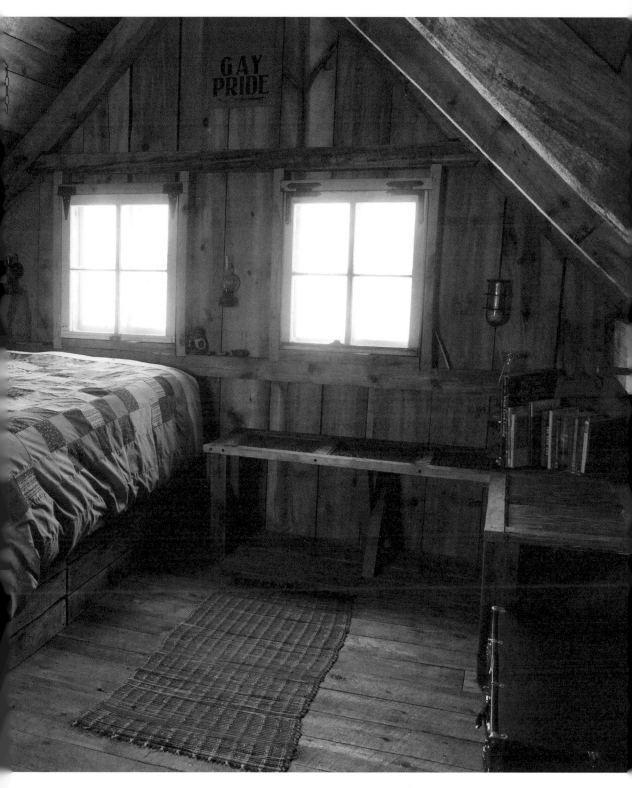

HILLSIDE HOMESTEAD

front door. I know that soon I'll be especially thankful for my woodstove."

Two things Jenna decided to do without: electricity and indoor plumbing. Instead, she added a water tower to allow for gravity-fed showers and committed to introducing improvements gradually, in keeping with her vision of the cabin as like a step "back in time."

But South Dakota is a challenging environment. The weather in the central part of the state is extreme. It's hot, dry, and windy most of the summer, and during the spring and fall, heavy rains make the dirt road to the cabin impassable by vehicle. (The soil is clay and sand, so it becomes extremely slippery when it rains. Locals call it "gumbo" because of its thick, stew-like texture.) When that happens, Jenna has to walk the last half mile home. In the winter, blizzards are frequent and intense. "The wind defines the landscape," says Jenna, who oriented the cabin on the landscape so that it would best withstand the area's forceful flat-line winds and tornadoes.

But there are deeper factors that complicate Jenna's

To save the time of premeasuring the roof decking to an exact length, Jenna cut them after nailing them on. She used a generator to operate power tools and wore a rock-climbing harness on the steep-pitch roof.

ʀ Jenna was almost always barefoot during the construction of the cabin; it provided better balance and grip, and felt freer.

relationship to the place where her family has lived for 150 years. Jenna is an extrovert, but she's struggled to find close friends in Kimball. Though she has generous and "incredibly kind" neighbors, she says, her desire to be around people like herself is a challenge in a place that has about seven hundred people, several bars, a bank, a grocery store, a post office, a hardware store, and little else. "The ball is in my court to develop my community," says Jenna. "'Don't ask, don't tell' is a pretty prevalent mantra in the area," she adds, "right alongside 'You do you, I'll do me.' I love the community and most often find myself at the local Smokin' Mule—formerly the Back 40, formerly Clint's Antiques—enjoying a pint of beer and listening to live music on the weekends."

This coming summer, Jenna will spend as much time as she can living in and working on her Hillside Homestead. She plans to plant trees, improve her water collection system, and build tent platforms so that friends and volunteers from WWOOF—World-Wide Opportunities on Organic Farms—have a place to stay when they visit. Still, Jenna acknowledges that the transition back to life on the prairie can take time. "It took a few days for me to readjust to the intensity of life on the open grassland," she wrote on her blog. "But slowly, as windy days gave way to warm sunny days with a slight spring breeze, I felt the telltale tingles in my toes: I'm falling in love with South Dakota again."

Prepping for winter winds, Jenna and two volunteers removed the siding and wrapped the cabin in tarpaper, added foam sheets, one-inch boards for airspace, and a final layer of board-and-batten siding.

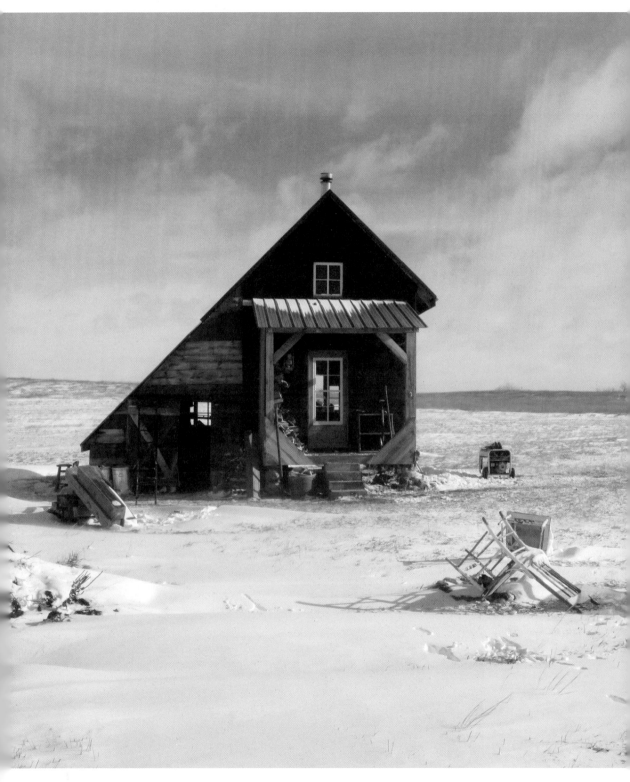

HILLSIDE HOMESTEAD

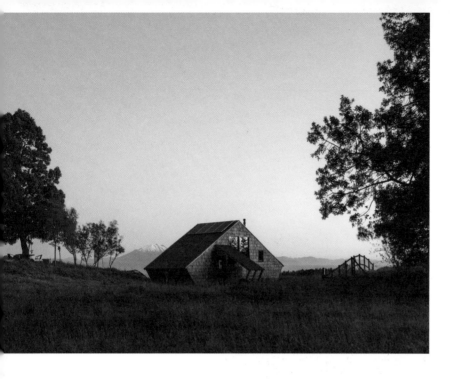

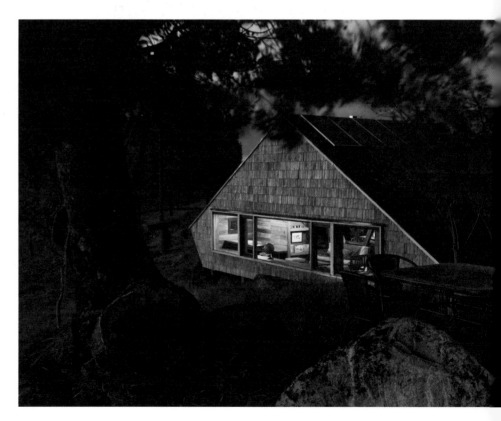

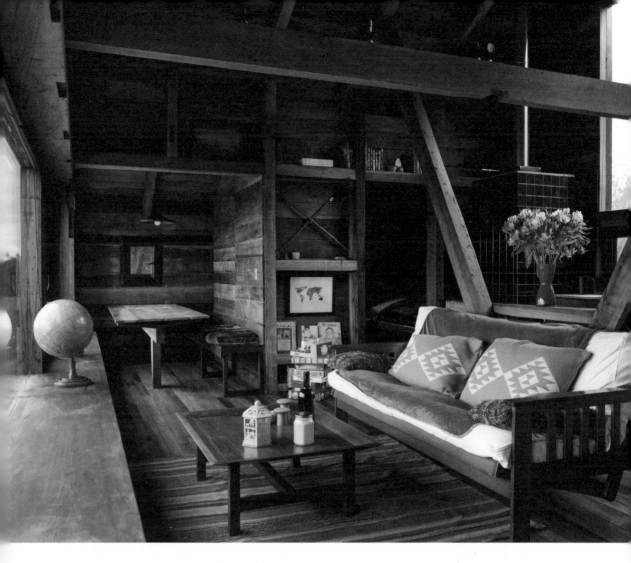

Cabaña Venado
Frutillar, Chile

CONTRIBUTED BY Nicolas del Rio
/ Del Rio Arquitectos Asociados

PHOTOS BY Felipe Camus

This fully off-grid cabin was built in
the North Patagonia Lake District
of Chile. The wood was reclaimed
entirely from old structures, with
the shingles supplied by an old
barn and the beams and planks
from a decaying house. Water
is harvested from the rain, solar
panels provide electricity, and the
heating comes from a masonry
stove that requires just one load of
logs per day.

The Pond House
The Catskills, New York

CONTRIBUTED BY
Peter Hussey

PHOTOS BY Monique Crabb,
Katrine Hildebrandt

The Pond House, in New York's
Catskills Mountains, began as
a college project among two
teenage friends in 2001. But
over the years, as Peter Hussey
and Gerrit Gibbs grew older
and got married, their off-
grid straw-bale experiment
became a family commitment.
Inspired by the natural building
movement and architectural
luminaries like Christopher
Alexander and Lloyd Kahn,
Peter and Gerrit used locally
harvested and milled rough-cut
hemlock for the framing and
salvaged building materials

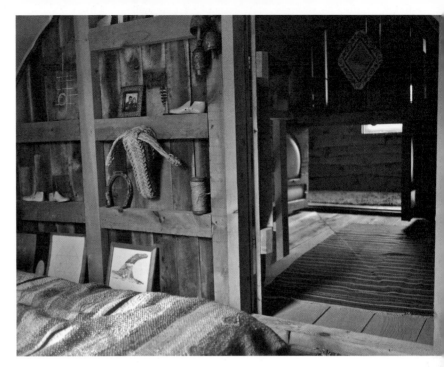

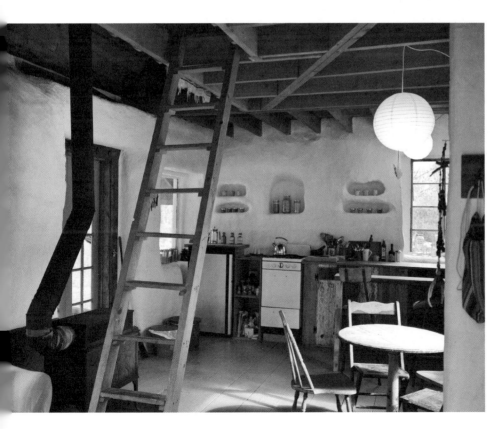

for the windows and doors. Straw bales from a nearby farm became the insulated walls; they were finished with plaster and a white lime wash.

The cabin has evolved over the years, with new guests: the pair's mentor, Clark Sanders, and his wife, Andrea, whose daughter married Gerrit, moved in after the pair left. The Pond House also saw new modifications and additions: an outdoor shower and kitchen, and textiles gathered from far-flung locations, courtesy of Clark and Andrea. Though the families are scattered across the Northeast, they continue to use it as a retreat for themselves and their children.

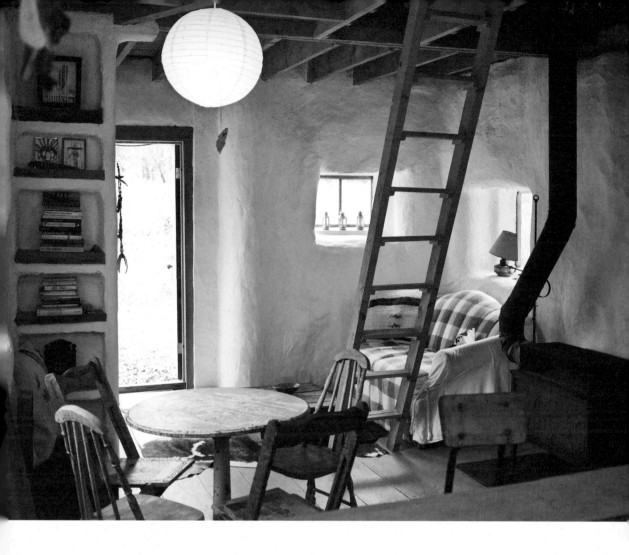

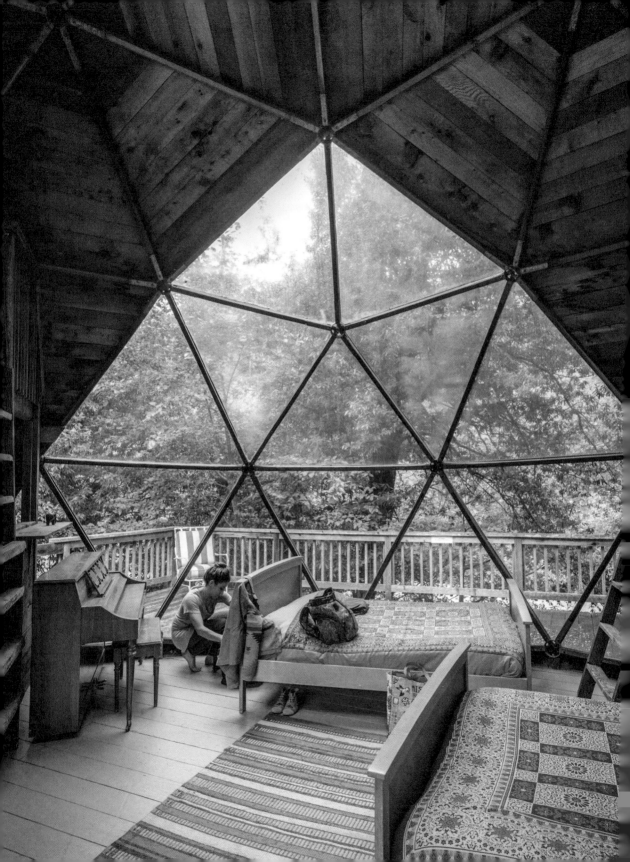

Oz Farm
Point Arena, California

CONTRIBUTED BY Marina Edwards

PHOTO BY Brian Vogelgesang

Located in a remote area of Northern California, this geodesic dome is built on an organic farm near the Pacific Ocean. It has a potbelly stove, two lofted bunks, a kitchen and dining area, and a bed beneath a dreamy geodesic window.

FOLLOWING PAGE

Marge Barge
Golden, British Columbia

CONTRIBUTED BY David Ratzlaff

PHOTO BY Dave Best

Originally built as a cabin on land, David had to act quickly when informed the water levels were soon going to change on Kinbasket Lake. On the advice of local loggers, he built a log barge in one week before the water level rose.

Christened Marge Barge in honor of David's wife, Margaret Ruth, the floating cabin is fully off-grid. David, Margaret, and their grandkids enjoy the barge year-round, as a summer retreat and for ice fishing in the winter.

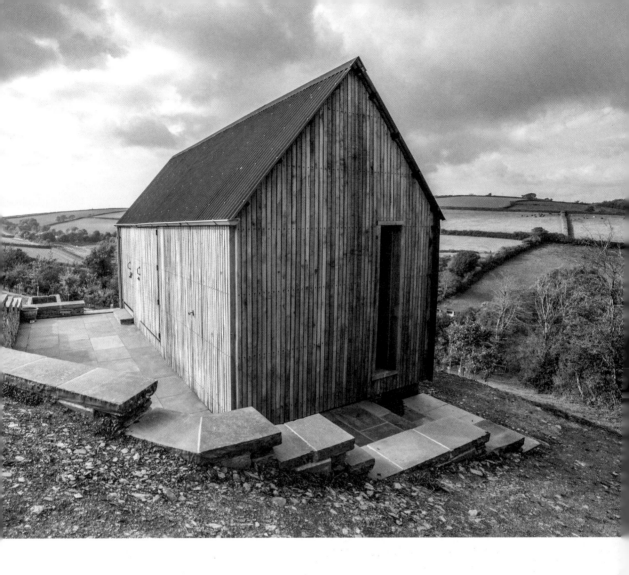

Woodcutters Refuge
South Devon, England

CONTRIBUTED BY Lifespace Cabins

PHOTOS BY Dan Dayment

Woodcutters Refuge is located on a 300-acre estate in southwest England. Built to blend into its rural setting while remaining protected from the weather, the bespoke cabin has double-glazed Crittall windows, Corten corrugated-steel sheets, custom-designed latches and handles, and yacht rigging to operate specially crafted shutters.

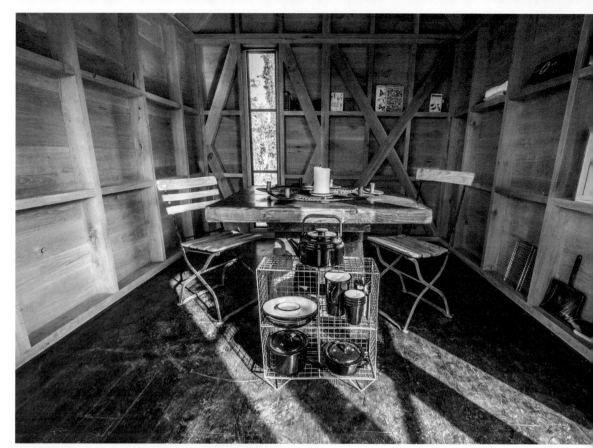

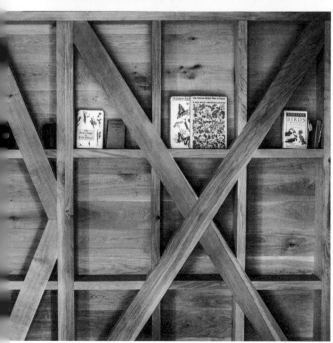

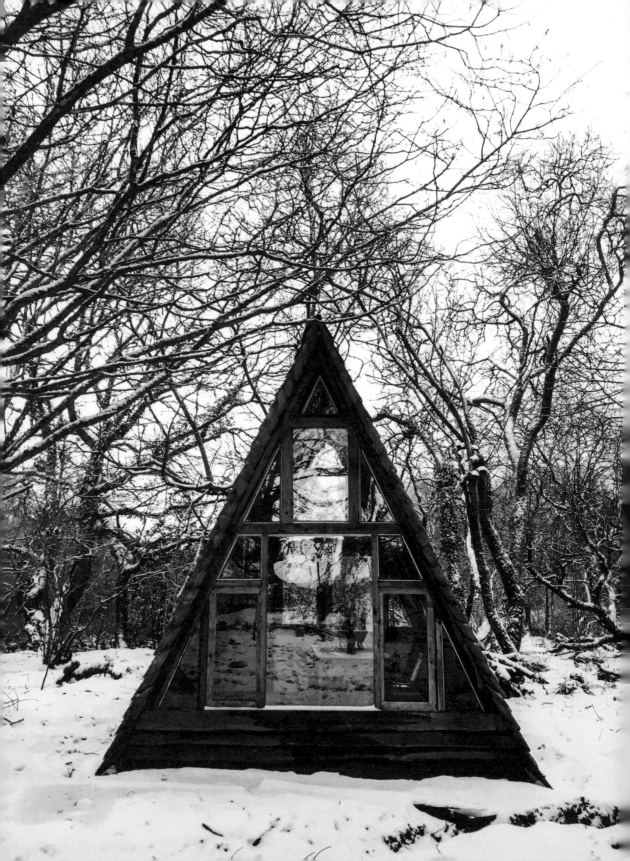

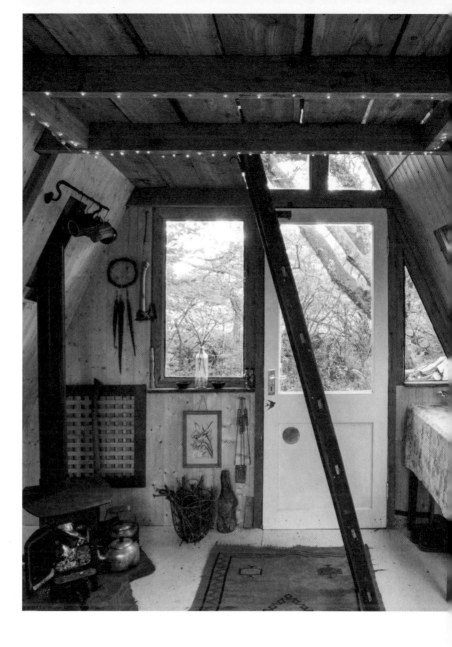

Reclaimed A-frame
Pembrokeshire, England

CONTRIBUTED BY Peter Haskett and Siobhan Alexandra

Siobhan and Peter built their cabin in the Welsh countryside slowly, and for just £2,000—or about $2,600.

The pair wanted to enjoy the nature they love, but they didn't want to be hemmed in by a mortgage. So they took a year and a half, salvaging glass from a double-glazing firm and wood from a home renovation project; they also used locally sourced Welsh larch. The result is a place for "literal slow living and slow cooking," Alexandra says. There's a loft bedroom accessible by ladder, a living room and a kitchen with a log burner, and large windows for ample views of the surrounding "fairy-tale-like woodland"— mossy covered oak, hazel, and willow trees, and a variety of birds, bats, foxes, toads, frogs, and oil beetles.

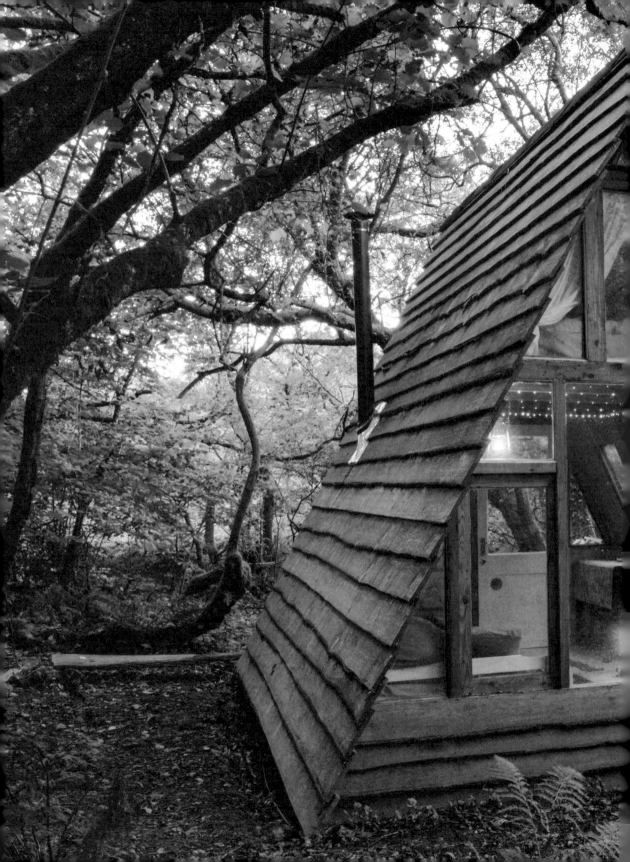

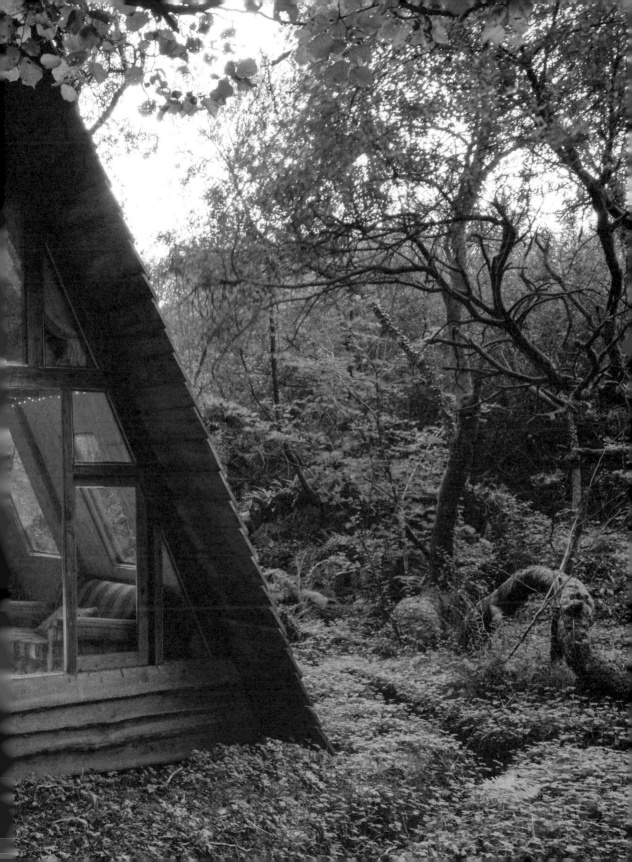

Fall River Ranch
Fall River Valley, California

CONTRIBUTED BY
BCV Architecture + Interiors

PHOTOS BY Bruce Damonte

The Fall River Cabin is located in a remote agricultural region of Northern California. Built of rough-cut Douglas fir and cedar, and vertical-grain Douglas fir plywood, this 1,300-square-foot cabin was designed for several families to stay together.

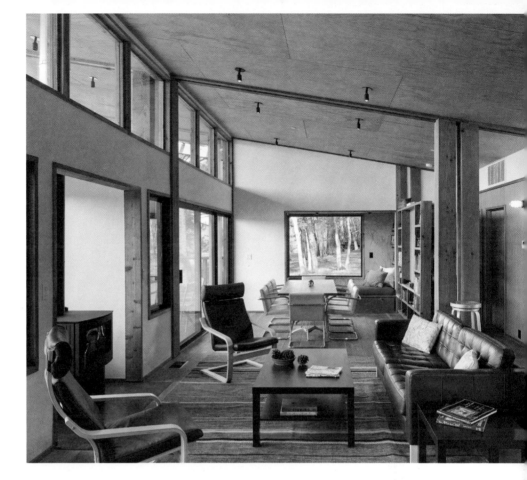

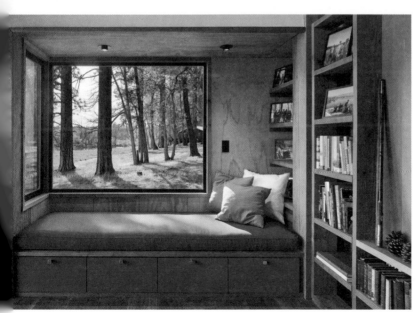

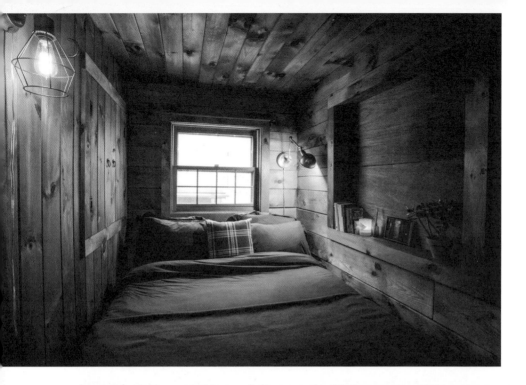

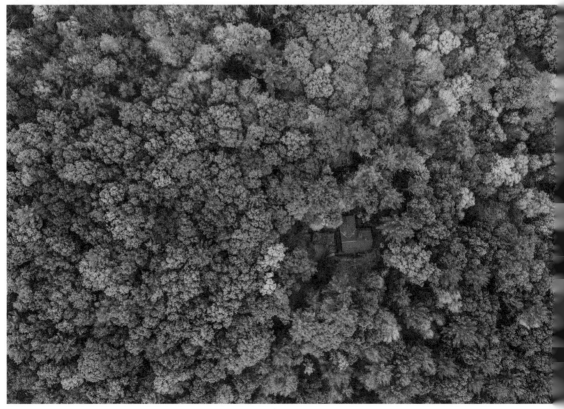

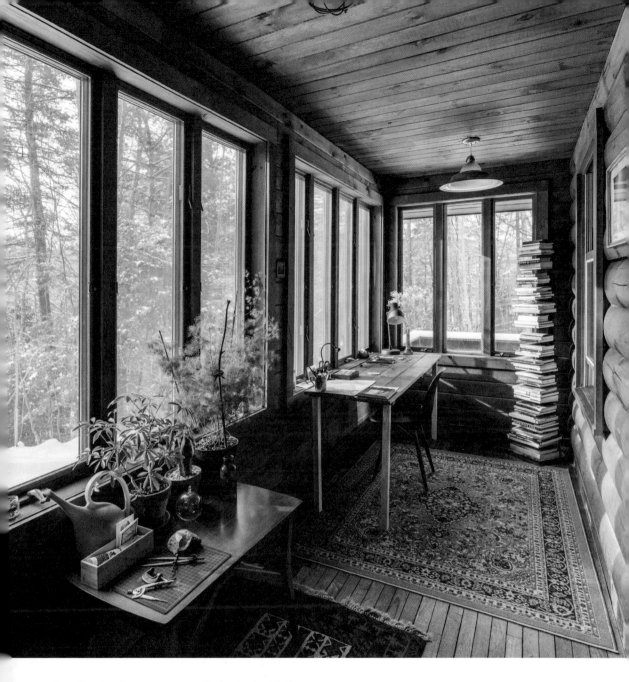

Lumberland Log Cabin
Lumberland, New York

CONTRIBUTED BY Noah Kalina

The Lumberland Cabin was built in 1986 as a one-room hunting cabin on a secluded 5-acre parcel near the Delaware River. The log structure now has a bedroom and a solarium/reading room, making it the perfect spot for catching up on a book and writing.

Bird Box

Contributed by **Damian Maynard**

Photographs by **Mark Hawdon**

Damian Maynard came from a modest background. He's the son of a single mom without "many coins in the pot," as he puts it, but early on he displayed talent as a builder and woodworker who applied his skills to ambitious project models. As a young man, he manned the workshop at Brighton University, where he taught architecture students about the technical aspects of their future profession.

In Brighton, a resort town on England's south coast, Damian met Jim Wilson. The two became colleagues, then friends and birding buddies. Damian and Jim shared both a passion for design and a love of "reveling in the art of being complete nerds by sitting in a bird hide," says Damian. Over the years they spent bird-watching together, the friends began to fantasize about building a giant, human-sized bird box in the woods.

To explain his fascination with birds, Damian shared an anecdote. One day, he says, he watched a crow take a frozen apple from a tree, fly to the nearest chimney, and place the apple on top. "Five minutes later," Damian says, "apple strudel! Clever buggers."

From her home in Devon, in southwest England, Damian's mom would drive him and his two sisters to the countryside, where they would take picnics into the "wilds," play in the surf along the coast, and explore rock pools. They moved around, but always

Winter, 2017. Full moon. Subzero temperatures. Waiting for the wood burner to be installed.

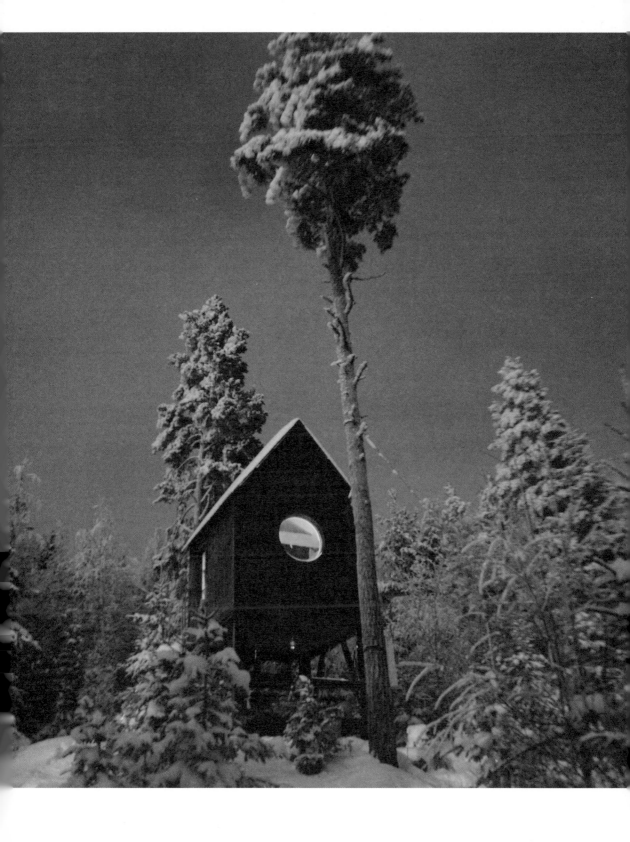

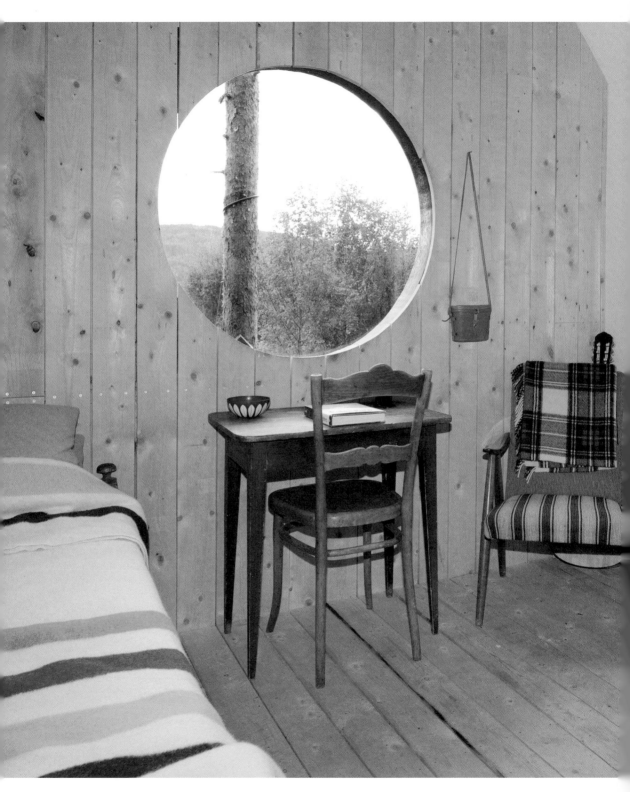

BIRD BOX

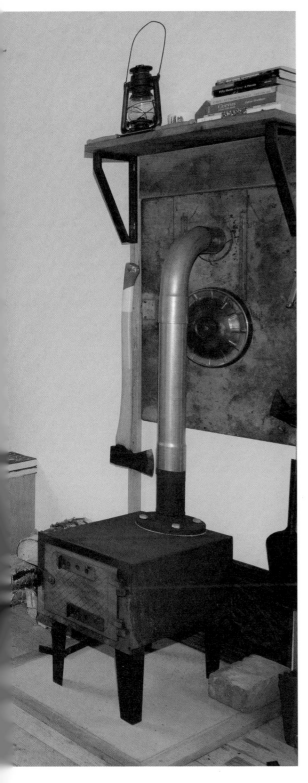

ended up in places with beautiful countryside, Damian says. It's "something I always needed, and still do."

For a period during his rootless childhood, Damian lived next door to an artist and dreamer who became a good friend and mentor. The neighbor inspired Damian—a working-class kid—to paint, to pursue his passion for nature, and to be creative. But it wasn't until later, while studying and working in Brighton, that Damian's creativity and love of birds began to come together.

It was also there that Damian met Lena, a visiting student of interior architecture, who, in "typical Viking tradition," he says, stole him away to her home country of Norway. ("Turned out quite nice, to be fair," Damian assures.)

Moving with Lena to Oslo in 2011, Damian found a new countryside to explore. Her family owned a farm in Hadeland, an hour north of the city, surrounded by thousands of acres of pine forest. The property, which had been in the family for at least three hundred years and was previously used for growing potatoes and barley and breeding foxes for fur, was where Damian finally found a home for the cabin he and Jim had envisioned years before.

Lena was content to let Damian "bugger off into the woods every weekend," he says, "to basically be a self-indulgent kid." Damian recalls offering Lena a compromise when the couple left the UK: if "I leave my country, my family, my friends, you let me build a massive bird box in the forest." Looking back, he jokes, "What could be fairer?"

It took Damian eighteen months to build his long-imagined bird box. During that time, Jim visited for a few weeks here and there. Mostly, though, it was Damian alone, working away on weekends and during long Norwegian summer nights, when the daylight

Daybed to the left. Untreated Norwegian spruce wall and flooring. Looking west.

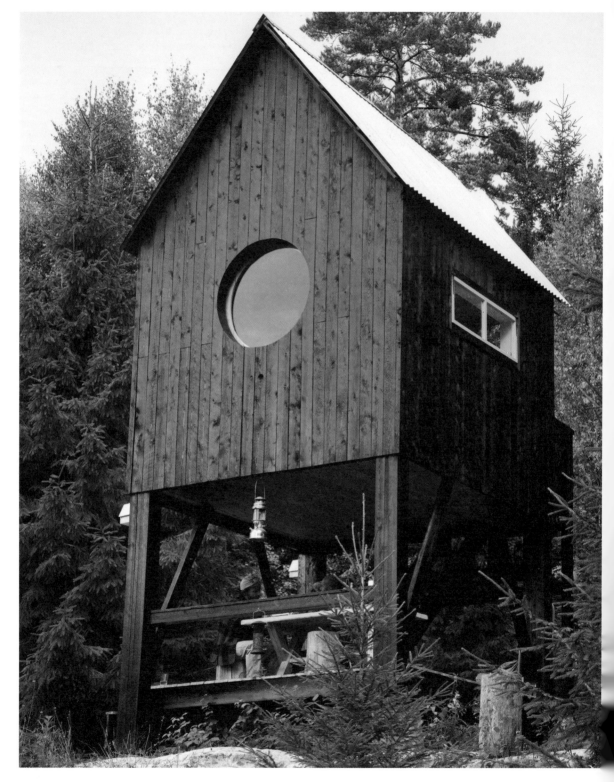

Cabin creators Damian Maynard and Jim Wilson
enjoying the shade under the Birdbox.

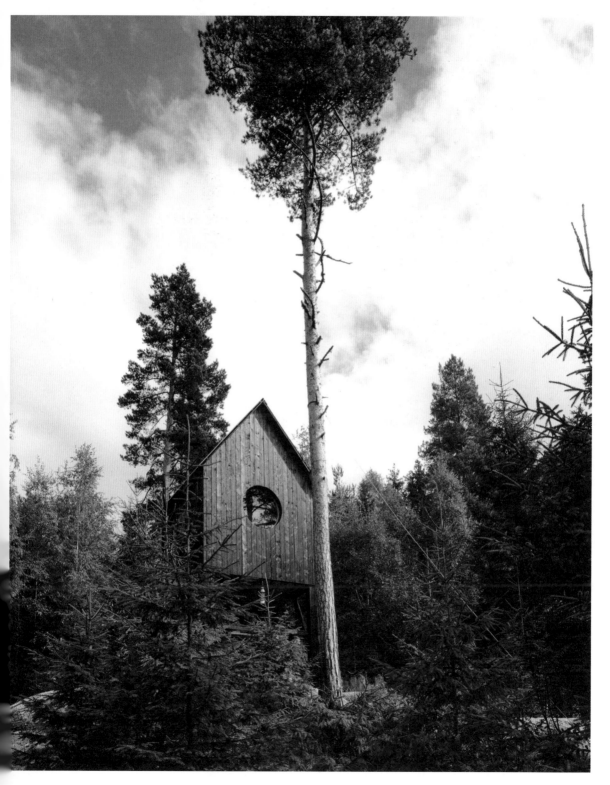

BIRD BOX

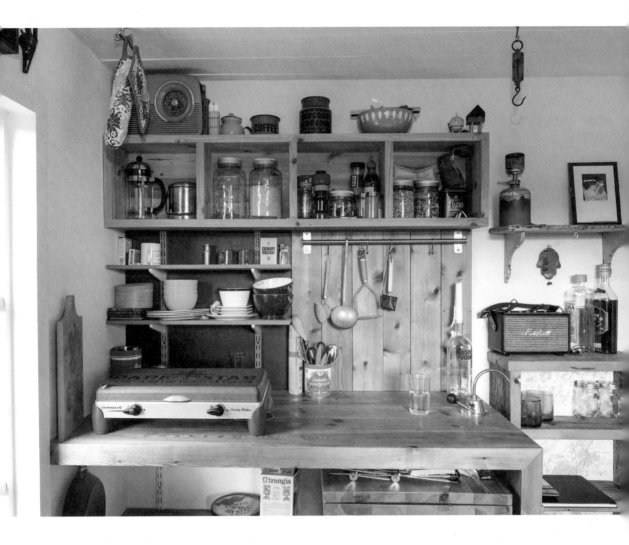

Cabin kitchen. Made from recycled timber and old wine boxes.

OPPOSITE Swedish army tent stove with a truck exhaust repurposed as a chimney.

lingers well into the evening. Lena's stepfather, Hans, helped haul heavy objects using an ancient Ford tractor, and Lena chipped in when she could.

Damian's original vision was a treehouse, but design and engineering limitations led him to seek out a spot with a bedrock of millennia-old granite that's "not going anywhere." He then fixed four anchoring points to the granite and attached the cabin's four laminated timber-and-steel legs to the rock. Making sure the base of the cabin was level and straight on the uneven stone was the project's most significant challenge. "Getting that first stage correct was vital," says Damian.

At the same time, Damian was striving to have as little environmental impact as possible. Fortunately, a three-century-old farm has plenty of materials lying around for

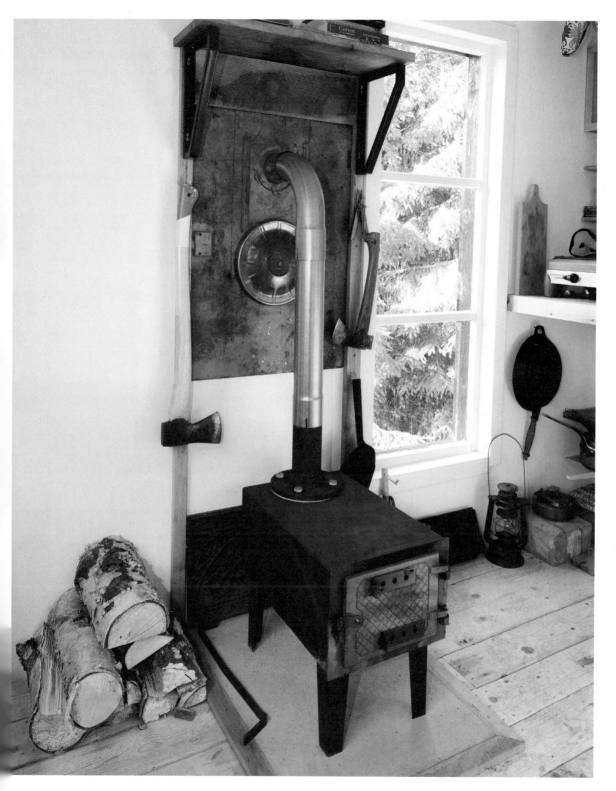

BIRD BOX

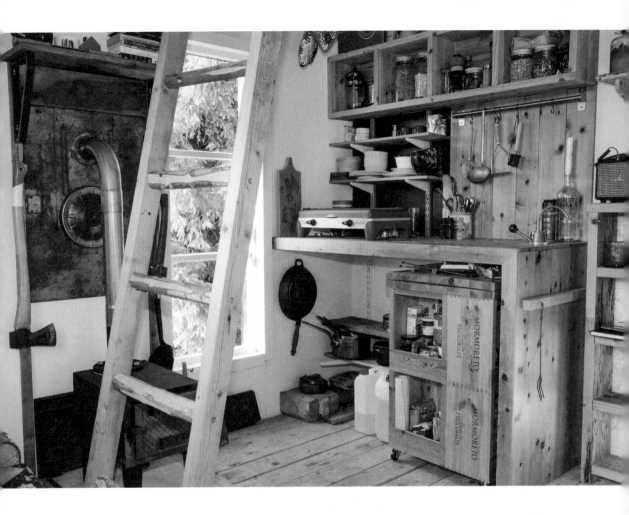

Ladder to loft bed in front, wood burner to the left.

R Seating deck under cabin for sleeping outside in summer.

OPPOSITE Loft bed with framed view over the woods to the east.

BIRD BOX

repurposing. Though the bird box's main body was built from conventional materials—plywood, Norwegian spruce cladding, and Rockwool insulation—for the inside, Damian relied heavily on recycled objects and accents. He fitted a vintage Swedish army stove with a truck's exhaust pipe for a flue and turned wooden wine crates, salvaged from Oslo's Gardermoen airport, into shelves and cupboards. For flooring, he used pine planks and boards from a demolished farmhouse. He reused old windows, and for a chair, he bolted an old steel seat from a potato-sorting machine to a tree stump. What couldn't be built of recycled materials, like the bird box's cladding, Damian sourced locally.

But building a cabin in the far northern latitudes of Norway has its challenges. Damian worked through two Norwegian winters, when temperatures could get down to well below zero. "When it is negative twenty-five degrees [Celsius], it's not advisable to put your lukewarm, tacky

hands on the rungs of a frozen ladder," says Damian. "You learn fast."

Fixing wrinkly tin sheets onto the 55-degree sloped roof 23 feet off the ground posed another—and more unexpected—danger. Norway isn't known for its sweltering summers, but the year that Damian was hanging the tin roof was the country's hottest on record. "Being blinded by the reflection is one thing," says Damian, "but sitting astride the ridge with shorts on is another."

But in the end, completing the project was its own reward. Damian especially loves the bird box's round window, which he took special care to design so that the outer edge of the glass was flush with the exterior cladding—"like a washing machine," he says with delight.

Still, Damian acknowledges that there's plenty of

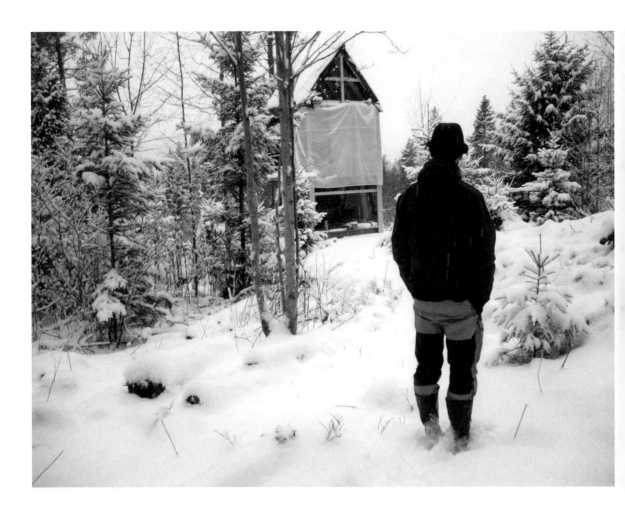

Main framework goes up during
the winter of February 2014.

OPPOSITE Looking out toward the
neighbors and the fjord below.

room for improvement. "I will probably go for years chang-
ing things," he says. "More or less everything in the cabin
has been made on average three times." But for Damian,
that process seems to be part of the joy of the project.
"I have learnt something throughout the build," he says,
"and that is patience."

"Think, ponder, resolve," he says, adding, "Ponder
again, maybe again, *then* make."

Though the cabin is off the grid, Damian especially
likes to visit it at night, when the woods are peaceful. He
climbs the stairs with a flashlight, lights the candles and
lanterns, and starts a fire in the woodstove. Then, he says,
"I just have to step outside sometimes and look up at the
old girl and thank the stars she's still standing."

Damian's cabin isn't his permanent home. But like a
bird box for a migrating bird, it has helped him feel settled
in his adopted country.

BIRD BOX

Bath House
Great Western, Australia

CONTRIBUTED BY ARKit Architecture

This prefabricated cabin sits on 20 acres of bushland near Grampians National Park in Victoria, Australia. It has a living space, an outdoor deck, and a sauna.

The designers behind it, ARKit, have sought to keep its environmental footprint minimal: it collects its own water and uses on-site wood for heat.

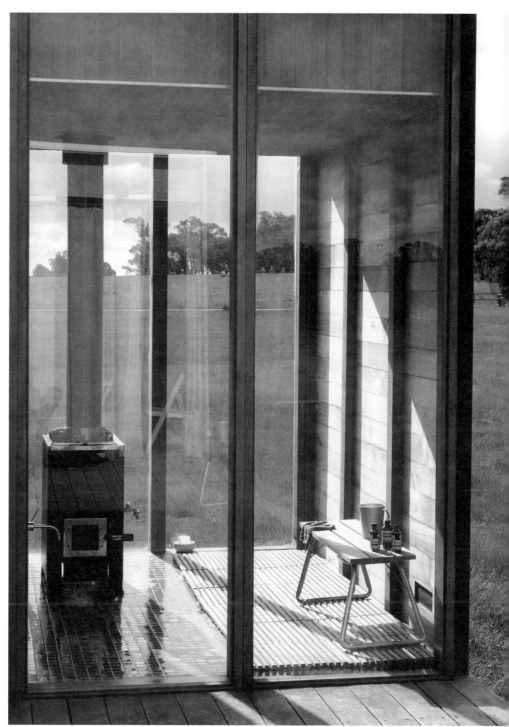

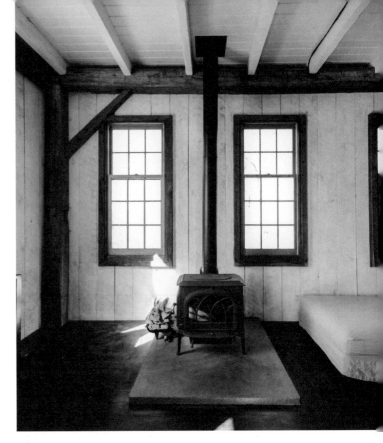

Hemlock Hill Barn
Callicoon, New York

CONTRIBUTED BY
Kasia and Matt Murphy

PHOTOS BY Peter Crosby

Set on 14.5 acres in Callicoon, New York, the Hemlock Hill Barn was built in 1998 with hand-hewn beams and raw cut pine. Kasia and Matt Murphy bought the cabin in 2016 and set to work renovating it. With the help of a local carpenter, the fashion designer and film/TV producer from Brooklyn tore down walls, sanded and whitewashed those that remained, turned a shop into a master bedroom, and restained the floors, among other things.

Matt oversaw the landscaping, carving new paths, laying stones, and trimming vines and shrubs that had enveloped the two largest trees on the property, an old ash and a giant willow; on the latter, an antique swing now sways from its branches.

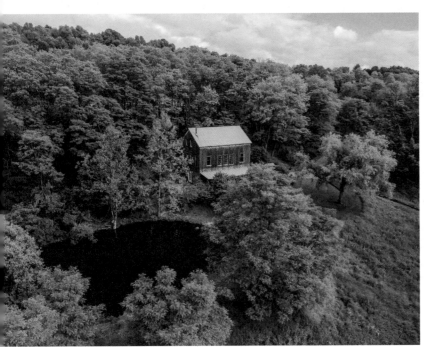

240

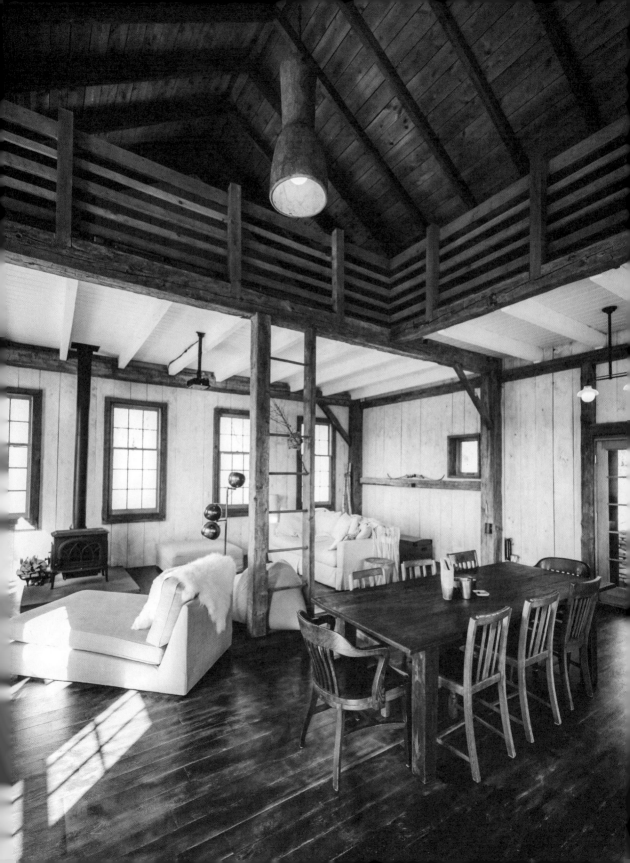

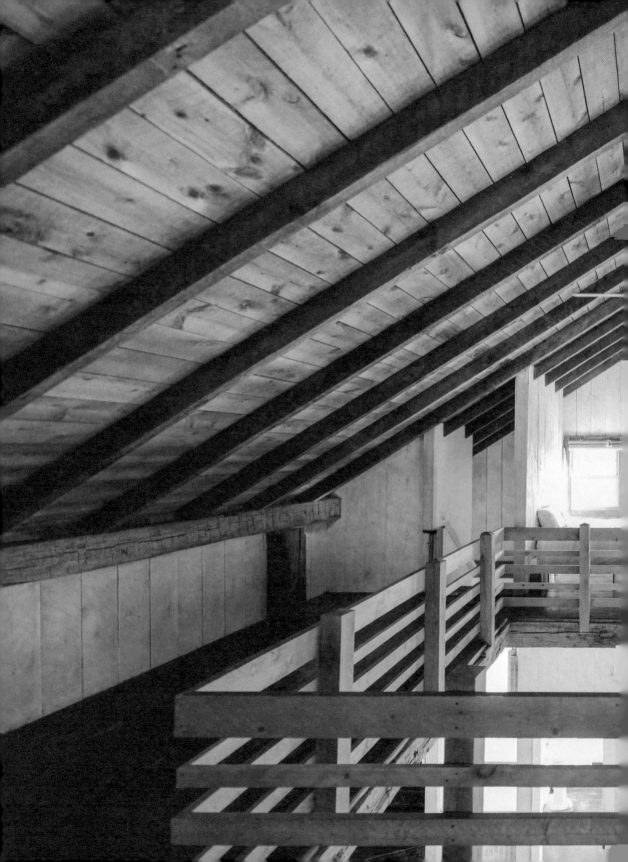

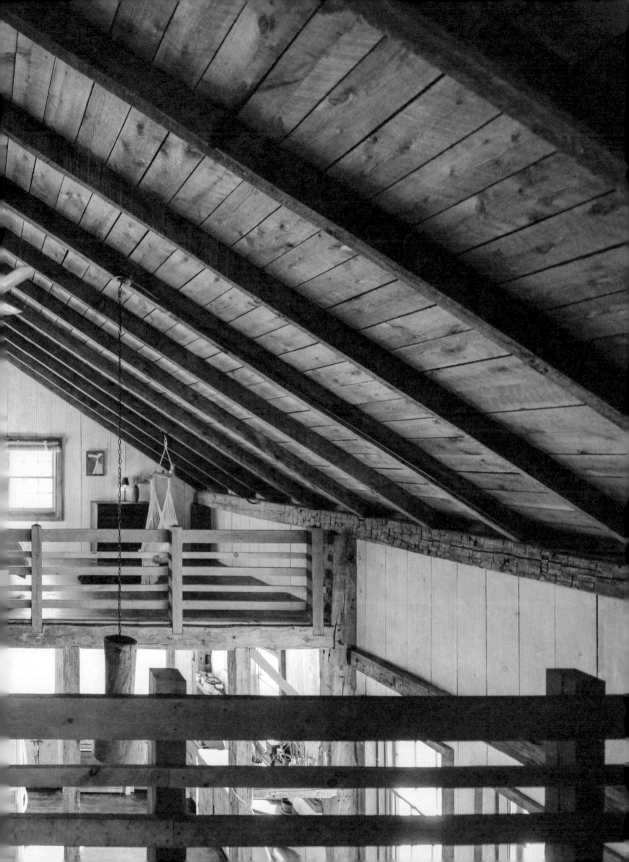

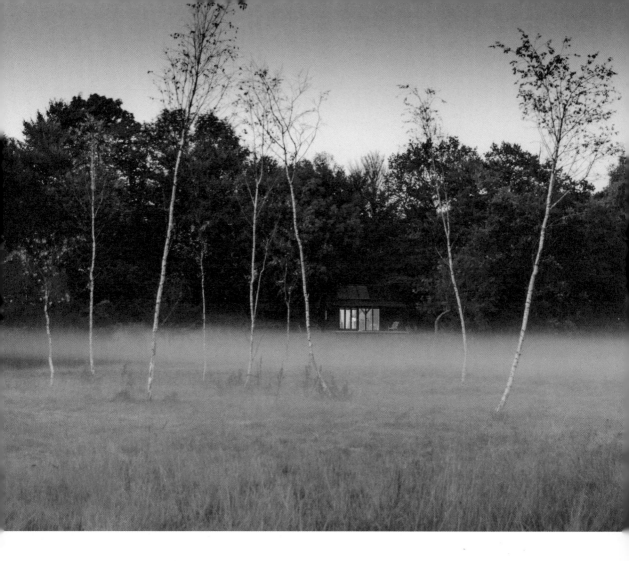

Rupert's Oak Cabin
Devon, England

CONTRIBUTED BY Out of the Valley

In southwest England, this 259-square-foot oak structure sits quietly in the landscape. Designed and built by cabin-maker Rupert McKelvie to be used as his own home, with a weight of eight tons, the cabin was assembled off-site and transported by tractor.

The frame is made from green oak that slowly dries and darkens with time. The cabin has solar power, and is heated by a convection wood stove.

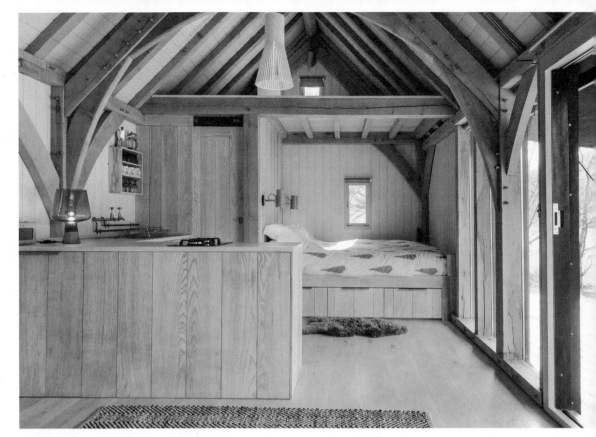

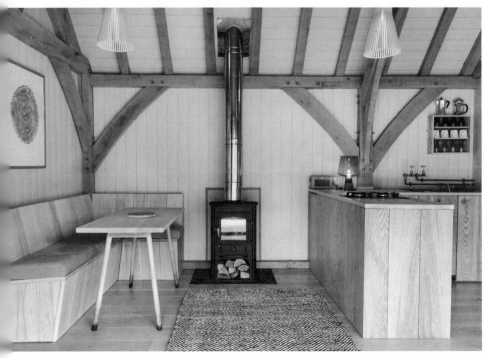

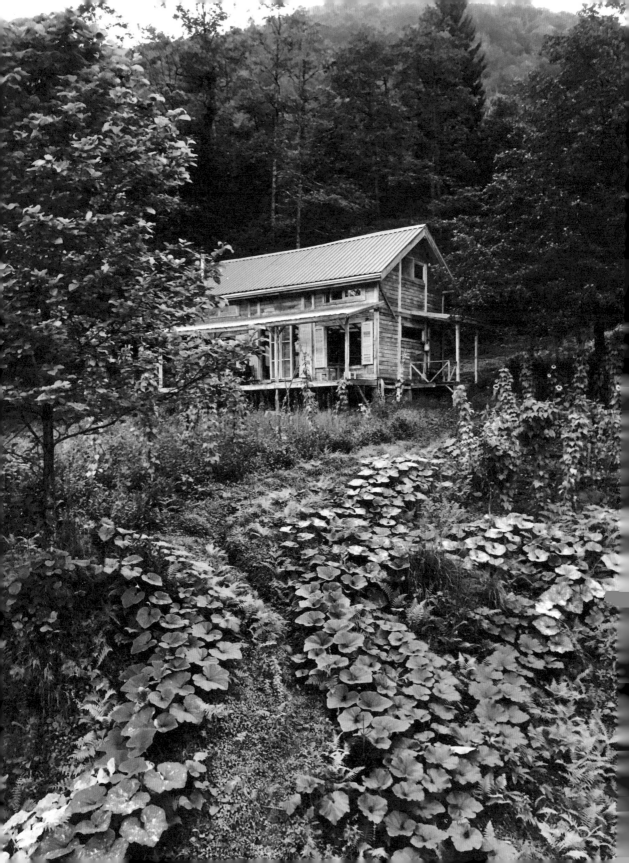

Moyy Mini Cabin
Camlihemsin, Turkey

CONTRIBUTED BY Özlem Erol

PHOTOS BY Yasemin Taşkın

Located in a village in Turkey's Black Sea region, this 484-square-foot cabin is built in the traditional style—entirely of chestnut wood. Its owner, Özlem Erol, moved to the village of Camlihemsin from Istanbul in 2009 with the idea of renovating the family home. When some relatives refused to approve her plan, she moved on to Plan B: building a new home from scratch.

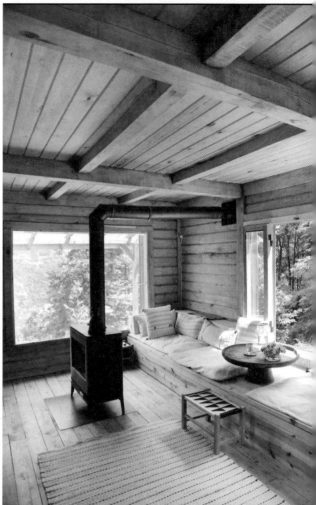

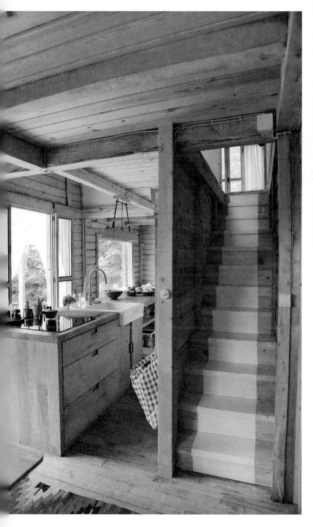

But chestnut construction is a lengthy process. After the wood is cut, it needs to be dried for a couple of years. "Nobody has this patience and respect anymore, so I had lots of difficulties to find the builders or workmen to make the house," she says, adding: "It was a tough challenge to tell a bunch of men workers what they should do in a really patriarchal cultural zone as a woman." But Erol persisted, the cabin was built, and she couldn't be happier.

Quail Springs Earthenhouse

Los Padres National Forest, California

CONTRIBUTED BY
Sasha Rabin and John Orcutt

EXTERIOR PHOTO BY
Ryan Spaulding

INTERIOR PHOTOS BY
Adam Battaglia

Natural-building instructors Sasha Rabin and John Orcutt live year-round in an earthen home at Quail Springs Permaculture in Southern California's high desert.

The mass of the materials keeps the cabin comfortable even in freezing temperatures, though Sasha and John say nothing beats crafting in front of the fireplace. The kitchen is encircled with windows, providing passive solar heating and grand views of the canyon. The cabin's loft, meanwhile, is surrounded by operable windows and is the warmest spot in the house during the winter, as well as one of the coolest in summer.

Built using a variety of earthen building techniques, the house contains materials, including clay and sand, that were harvested from the 450 acres that Quail Springs responsibly stewards in Los Padres National Forest. Sasha and John feel that teaching and building with earth provides the perfect balance between creativity, environmental ethics, and community.

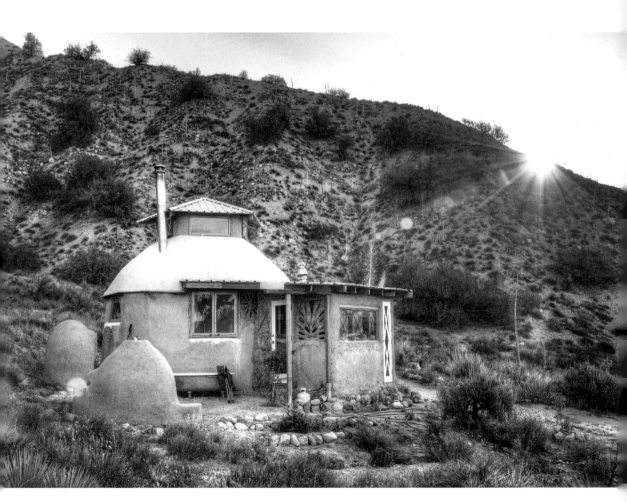

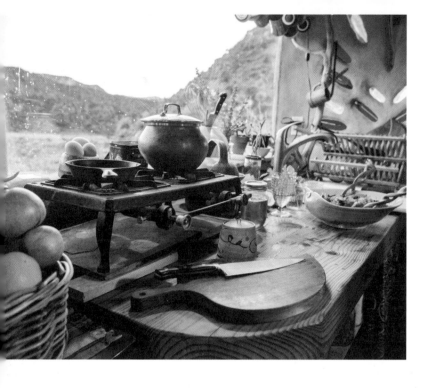

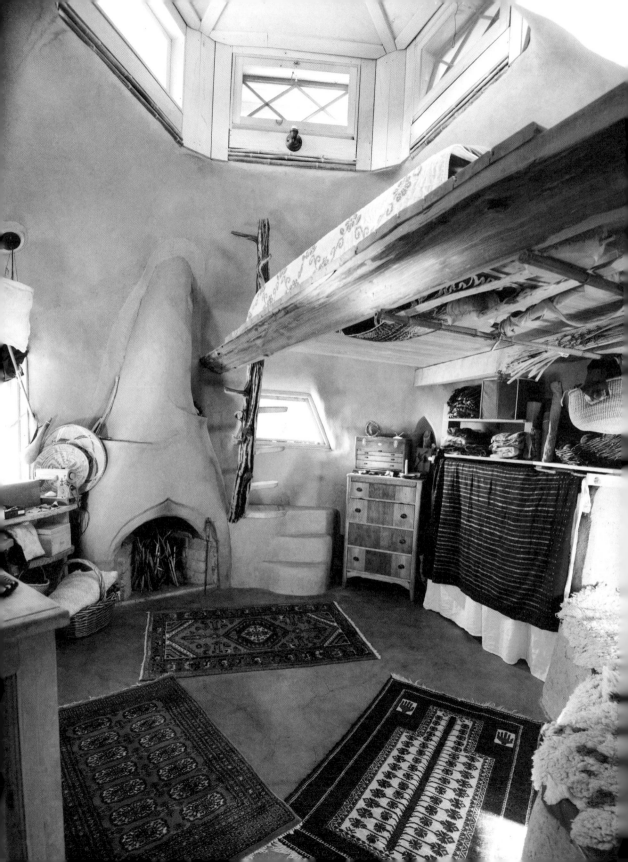

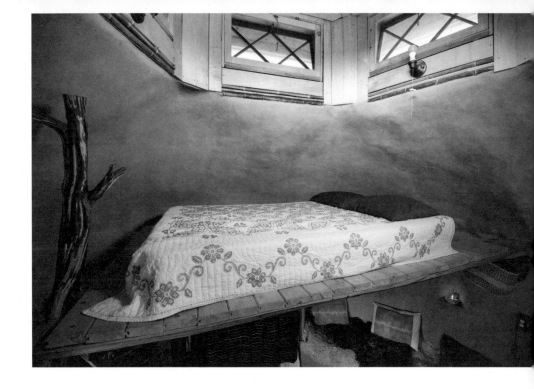

I Am a Monument
Csórömfölde, Hungary

CONTRIBUTED BY Josep Garriga
and OfficeShophouse

PHOTOS BY Tamas Bujnovszky

Set in the forest of rural Hungary, this cabin was built as part of a summer school program organized by the Budapest-based design studio Hello Wood. It was one of six installations that were designed to be movable, livable, and environmentally friendly.

This stilt house was built on top of a previous abandoned project and embraces an architectural philosophy that says that a building is never finished. The student architects honored the history of the existing structure by adding their own ideas to it while respecting its existing features.

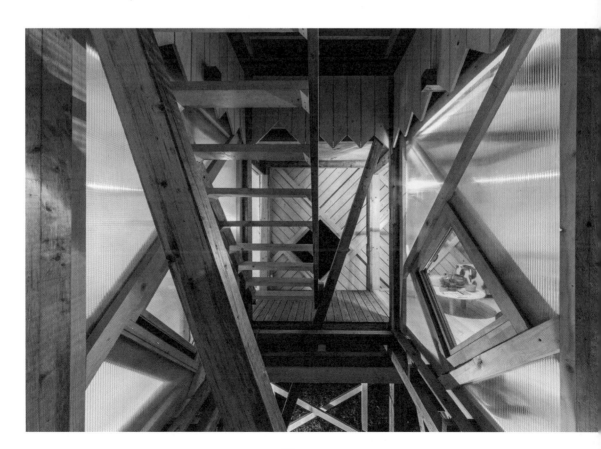

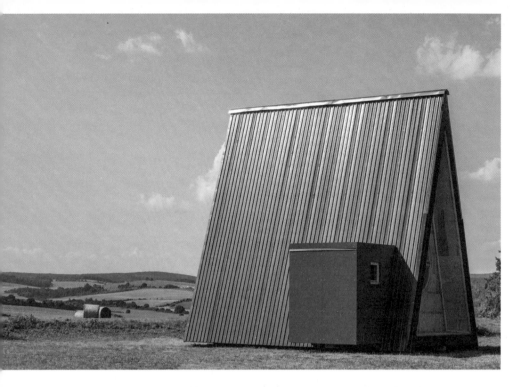

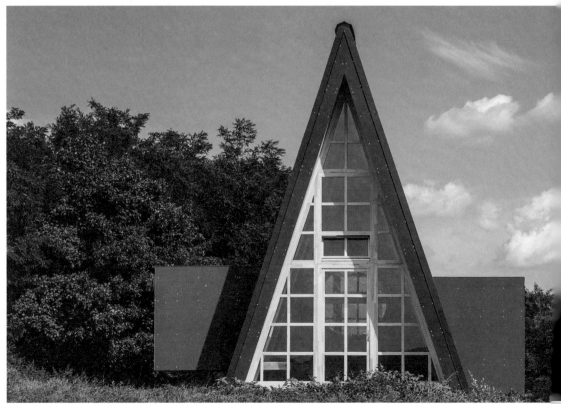

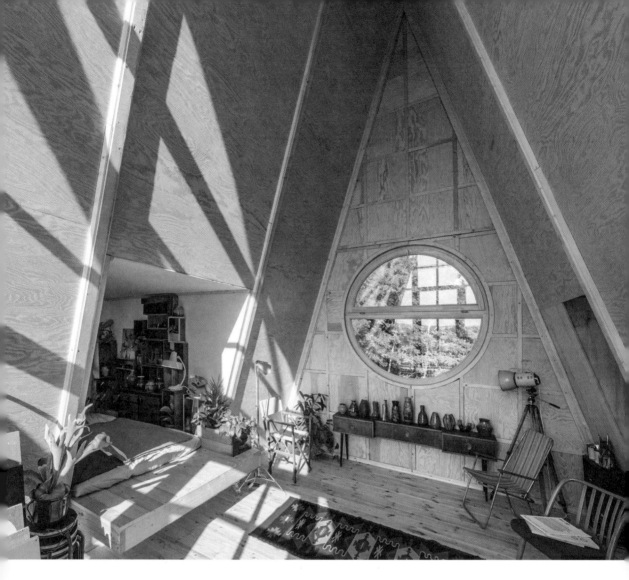

Grand Cabin Club
Csóromfölde, Hungary

CONTRIBUTED BY Hello Wood
International Summer School

Another Hello Wood experiment, this traditional A-frame cabin was inspired by Czech-style mountain lodges. Designed as a clubhouse, it distinguishes itself from a "lonely retreat" by being a place designed for socializing. Its nostalgic shape is familiar to Central Europeans, but the Grand Cabin Club has been updated to include large windows that look out over the surrounding landscape. Built of prefabricated, made-to-measure wooden panels, it can sleep eight people in its two "sleeping boxes," which are connected to the outside of the cabin. Its main area—a common space unbroken by walls or doors—blurs the line between community and private space.

Casa Tiny

Contributed by **Claudio Sodi**

Photographs by **Camila Cossio**

Aránzazu de Ariño did not know any architects when she was growing up in Mexico City's Herradura neighborhood, a middle-class barrio on the hilly fringes of Mexico's messy, beautiful, sprawling capital. Both of her parents were doctors, and she planned to pursue a career in the sciences. But as she was applying to college, Aránzazu (who goes by Aranza) veered from her planned path. Instead of seeking a degree in physics, she applied—"impulsively," she says—to an architecture program at one of Latin America's most prestigious institutions, Universidad Iberoamericana. "I loved literature. I loved philosophy. I loved art," says Aranza. "It clicked that I would need something that was also nurturing some sort of creative side."

In architecture school, Aranza, a self-described perfectionist, was so intensely focused on her studies that she lost touch with friends. But when she graduated in 2014, she reconnected with people she hadn't seen in years, including Claudio Sodi, an artist and theater producer.

Claudio comes from a prominent Mexico City family. His older brother is Bosco Sodi, an internationally known contemporary artist, while his mother is a famous telenovela actress and his father a chemical engineer with a PhD. As a kid, Claudio visited museums with his dad. He loved art, he says, and felt a "direct heritage from my mother's career." That

The concrete work at Casa Tiny makes use of the skills of local craftsmen.

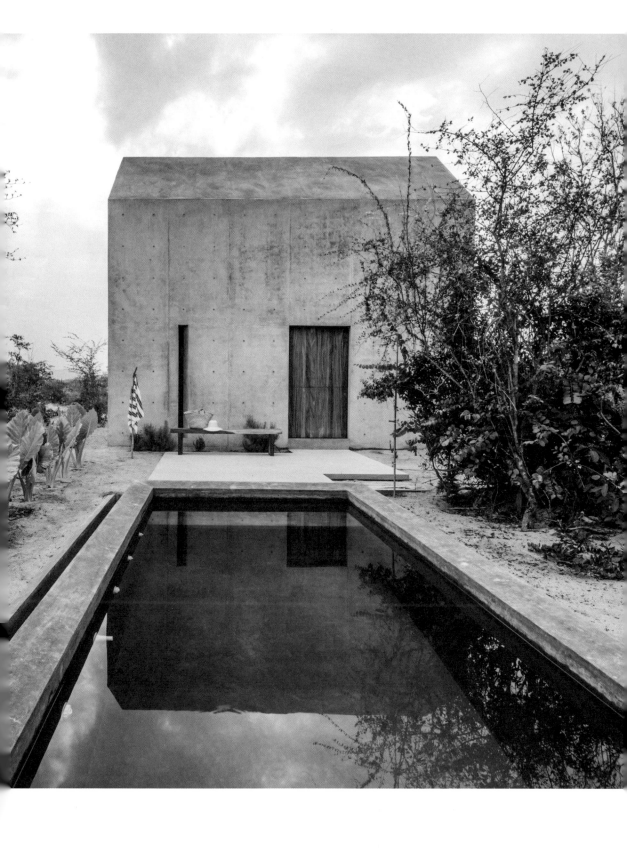

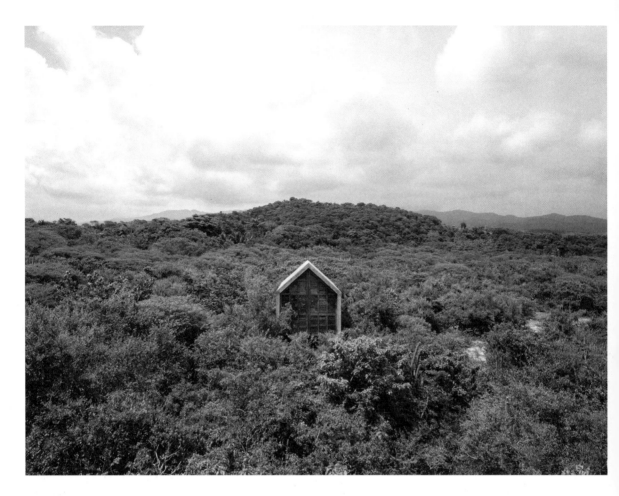

fascination took him far from home, to Barcelona, where he studied filmmaking.

When Aranza and Claudio reconnected in 2014, he was back in Mexico after four years abroad and was reacclimating to the capital, a distinctly intoxicating, overwhelming metropolis of twenty million people. His brother Bosco had recently started a program outside Puerto Escondido, a beach town in Oaxaca that their family had visited since Claudio was a child.

It was an exciting time. Bosco's art foundation, Casa Wabi, had enlisted Pritzker Prize–winning Japanese architect Tadao Ando to design its anchor foundation building. Other celebrated architects had committed to designing a henhouse, a clay work-shop, a greenhouse, a composter, and other beautiful but fundamentally functional structures. (Casa Wabi borrows its name from *wabi-sabi,* a philosophy "focused on the acceptance of the ephemeral and the imperfect," according to the center.) Claudio bought a plot of undeveloped jungle nearby.

At around this time, Claudio picked up a copy of Henry David Thoreau's *Walden; or, Life in the Woods.* The book's philosophy of minimal living spoke to Claudio, and he fantasized about a cabin of his own. He wanted to create a place to "get a different rhythm," he says. "To relax and refocus."

While reading *Walden* and falling in love with Thoreau's vision, Claudio was also falling in love with Aranza. When Claudio decided to build a cabin on his Oaxacan property, it was natural that he asked her—a talented young architect —to design it.

Aranza was just twenty-five at the time, and though she had worked at a prominent Mexico City architecture firm and spent time on construction sites, Claudio's house would be the first project she would oversee from vision through completion.

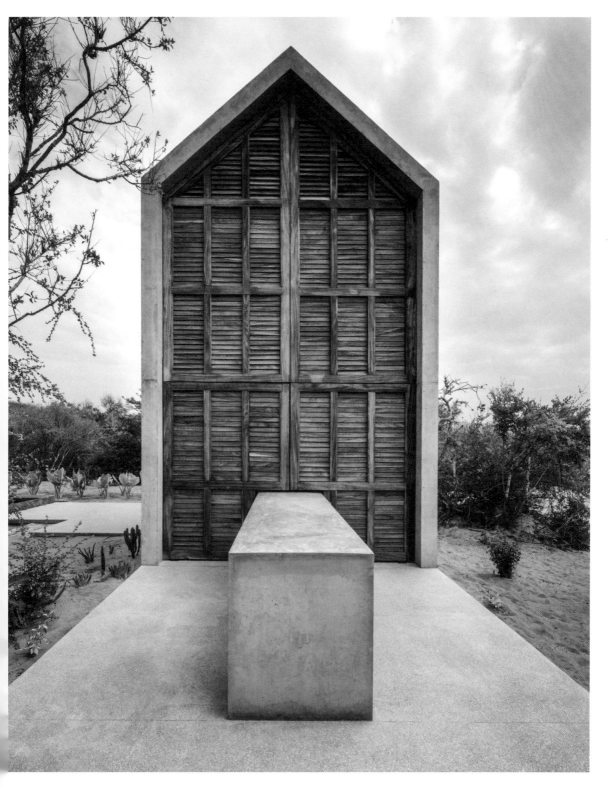

Casa Tiny sits in a jungle of copal trees and dry tropical forest. The house, with its pool and terraces, is an archipelago in a sea of green.

CASA TINY

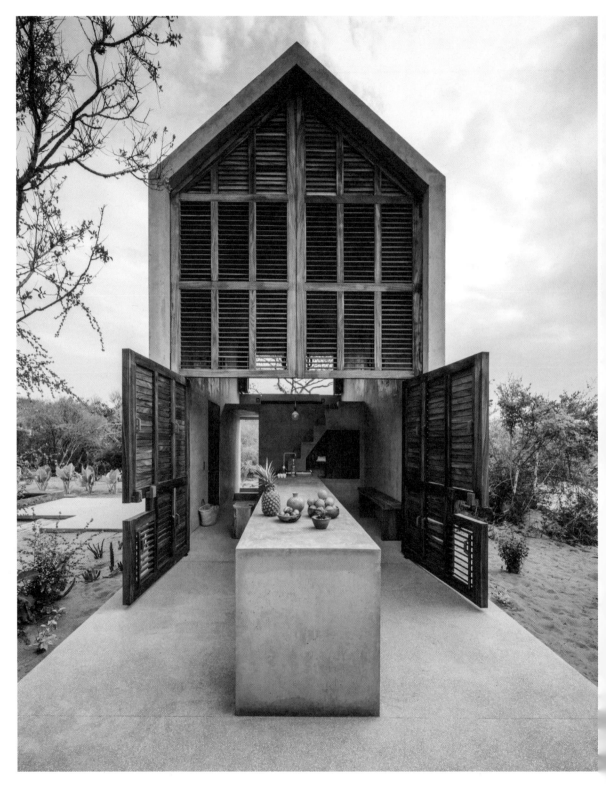

CASA TINY

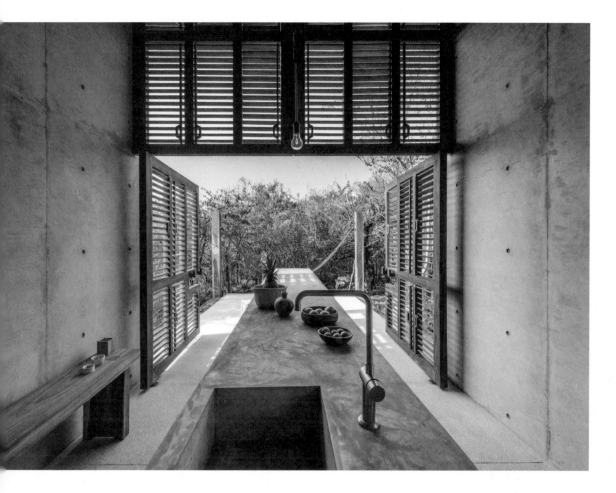

Counterintuitively, Aranza chose to impose constraints on herself. "When I'm given absolute freedom, I sometimes have this fear of the blank page," she says. She decided on the house's modest dimensions and materials. It was built of just two things: concrete and a local wood, *parota*. Aranza and Claudio named the cabin Casa Tiny.

Casa Tiny's design was rooted in Claudio's desire for "a secure space to escape and slow down." But its modest scale also responded to a reality: he and Aranza were a young couple, and both were self-employed. He was on a budget. (Claudio estimates that the cabin cost about $40,000.)

The house took eight months to build. Aranza traveled back and forth between Oaxaca and Mexico City, overseeing a team of workers, including a master mason, José, who had been on the Casa Wabi project. Her choice to use concrete came, in large part, from the fact that locals had been trained to do this challenging, exacting work. She saw

The long table relates life indoors and outdoors, where cooking, eating, and having a good time can be shared with friends.

OPPOSITE Casa Tiny is not hermetic. It is meant to open up to the landscape and encourage a life lived in the outdoors.

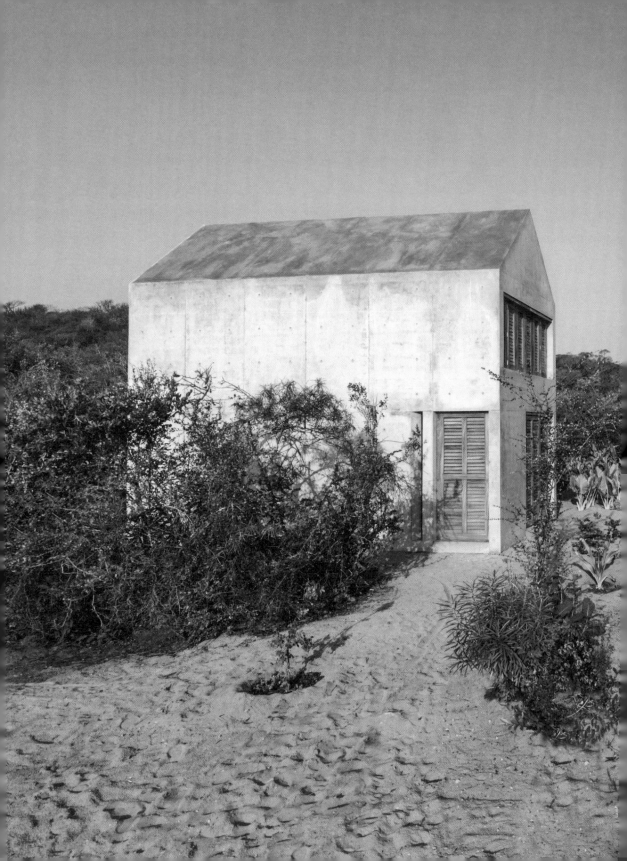

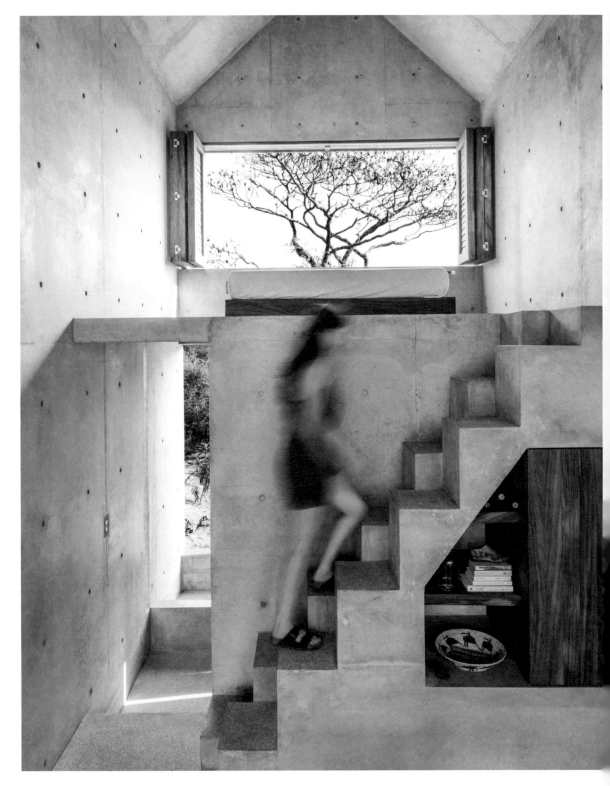

CASA TINY

A concrete hopscotch stair game leads you
to the sleeping area.

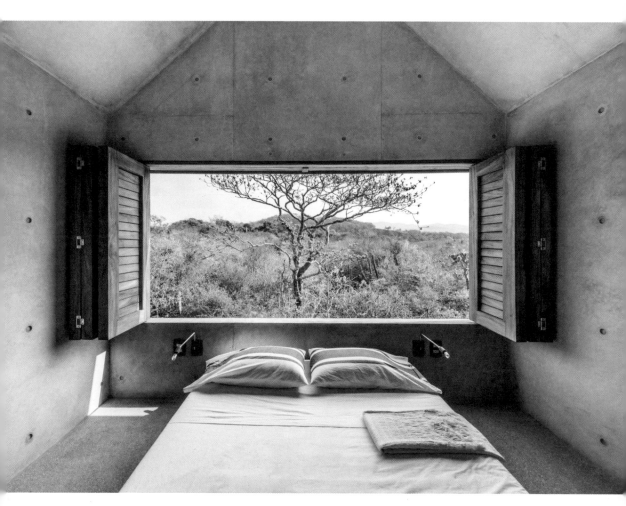

their expertise as being as much of a local resource as any material. But being a woman—especially a young woman, and an outsider to Oaxaca—in charge of the project was challenging. "I would spend my days surrounded by twenty men in the middle of nowhere, trying to have my voice be heard and have them do things the way I wanted."

At times when "things were not being done right," says Aranza, "I would have to insist on that." Her insistence was not always welcome. At the same time, she was "learning from their experience and understanding that they knew how to do their craft," she says. It was a process of building mutual trust.

As Claudio and Aranza worked on the cabin, they grew closer. For Aranza, who believes that architecture is "a form of conversation," designing for Claudio meant thinking deeply about "the philosophy, the way of life that we wanted for the house," she says. "When you

design a house for somebody, [it] is really almost like designing a tailored suit for them," she says. "That is very intimate."

Inside, Casa Tiny is almost entirely unadorned. It has no cell phone signal or Internet access. Because the concrete forms the house's focal pieces—its stairway, terrace, and main dining table—the two-person cabin has almost no furniture. Only a handful of objects decorate the interior. Among them: Claudio's and Aranza's collected copies of *Walden*—in Spanish, English, German, Chinese, and Japanese. The cabin's main aim, it seems, is to lure you outside. "Aranza played very intelligently with space," says Claudio.

Now Aranza is back in school, working on a dual master's degree in urban design and design studies at Harvard University, where she is in her third and final year. But when she's home in Mexico, she and

There is nothing like waking up with the windows open to the ever-changing landscape of the Oaxaca coast.

Aranza de Ariño, architect, and
Claudio Sodi, owner, found each
other through dreams of a simple life.

OPPOSITE Clean lines, cooled air,
no mirror.

Claudio spend as much time at Casa Tiny as possible.

Aranza designed the house for Claudio, but it is now
hers as well. She's able to watch Casa Tiny become lived-in
and be part of its evolution. When she was designing
it, she "thought the house was a kind of archipelago—a
little island in this sea of vegetation." Now, during the dry
season, she sees the way the bushy jungle loses its green,
becoming "this art landscape with pops of yellow." And
during the rainy season, she sees how "everything just
comes to life," she says, "and it's so crazy how fertile the
area is."

As Aranza and Claudio's life together has continued,
their archipelago has evolved as well. They've built
another terrace, a short distance from the house, for doing
yoga; they've added a pizza oven, which they tucked into
the vegetation. As the jungle has encroached on their

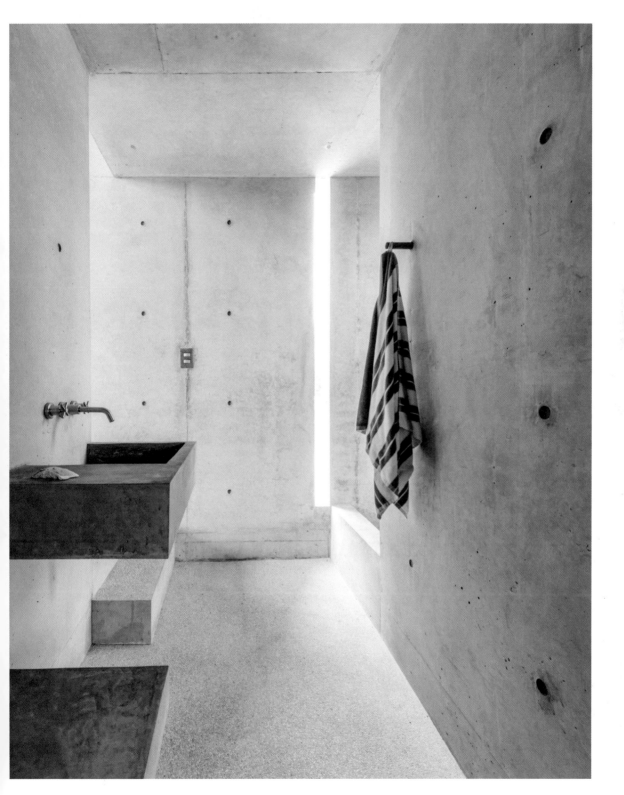

CASA TINY

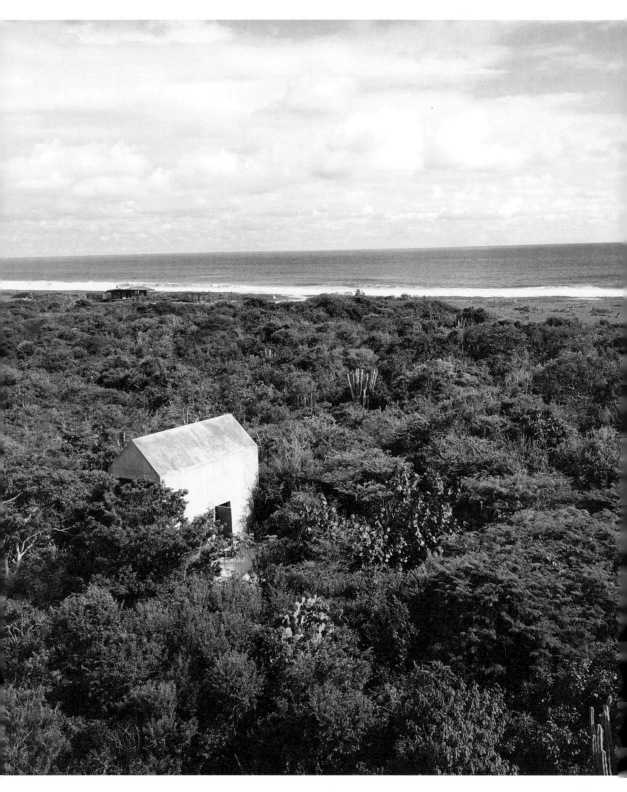

CASA TINY

cabin, it has created a natural shade for the hammock. And over the years, Casa Tiny's long concrete table has hosted friends and family.

Casa Tiny was designed as a two-person escape. But instead of being an isolated retreat, it has become a gathering place: "space for experience, rather than space for things." Aranza says, "We love *sobremesa*"— the postmeal time when people settle in to converse, drink, savor dessert. "It's very Mexican." At Casa Tiny's table, cooking and working, playing and eating, become "interrelated," she says. "The idea behind the house is so powerful," says Claudio, that it "moves you to enjoy life and nature in a completely different way."

Because of the dense, bushy jungle, Casa Tiny doesn't have an ocean view. But you can hear the Pacific from its secluded location.

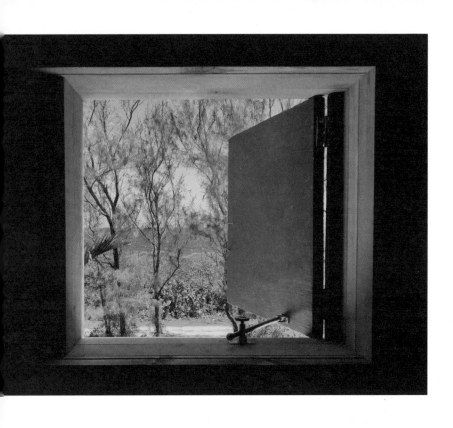

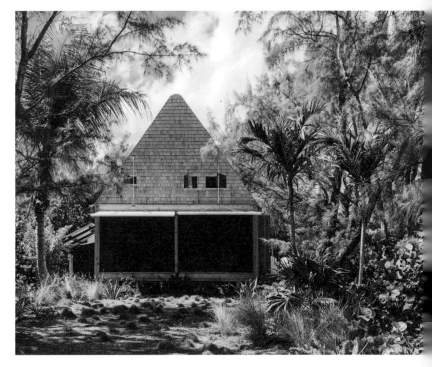

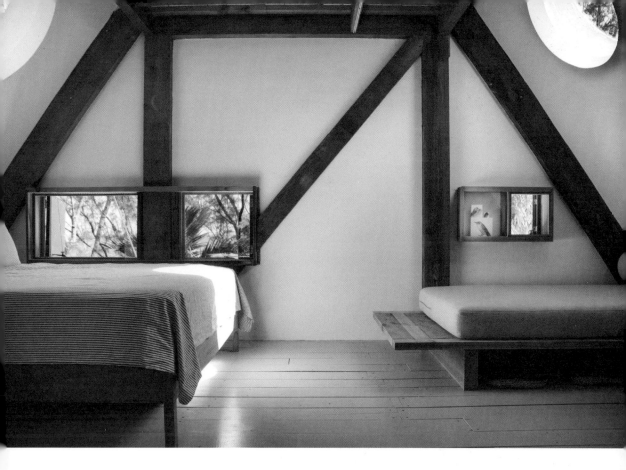

Brillhut
Eleuthera, Bahamas

CONTRIBUTED BY
Brillhart Architecture

Melissa and Jake Brillhart built this 14′ × 22′ × 30′ hut in their backyard in Miami. They then dismantled it, flat-packed it in a 40-yard container, and shipped it to the Bahamas via cargo ship. In Eleuthera Island, the couple reassembled the cabin themselves onsite. They built everything from the foundation to the flaps, including the kitchen cabinets and furniture.

The couple wanted their Bahamian cabin, Brillhut, to have a contemporary design while also being contextual and familiar. They borrowed from regional architectural styles by referencing both the gabled cottages of nearby Harbour Island and the Creole-style cabinet-loggia, an open area with a room, or "cabinet," at each corner.

Screened on three sides, the downstairs is both *loggia* and living space. It has views of sea grape and pine trees and the Atlantic beyond. Upstairs, the sleeping areas have skylights above the beds that orient views toward the night sky, and small picture windows—at eye level of the beds—that offer ventilation and framed daytime views of the blue horizon. The cabin's materials, western red cedar and cedar shingles, blend into the landscape. Operable flaps, made of lightweight fiberglass and foam-insulated panels, can be manually operated by a single person using a pulley system. When open, these flaps provide shade and rain protection for the interior and create a covered outdoor space for the deck. When closed, the panels offer structural stability, security, and protection against the elements.

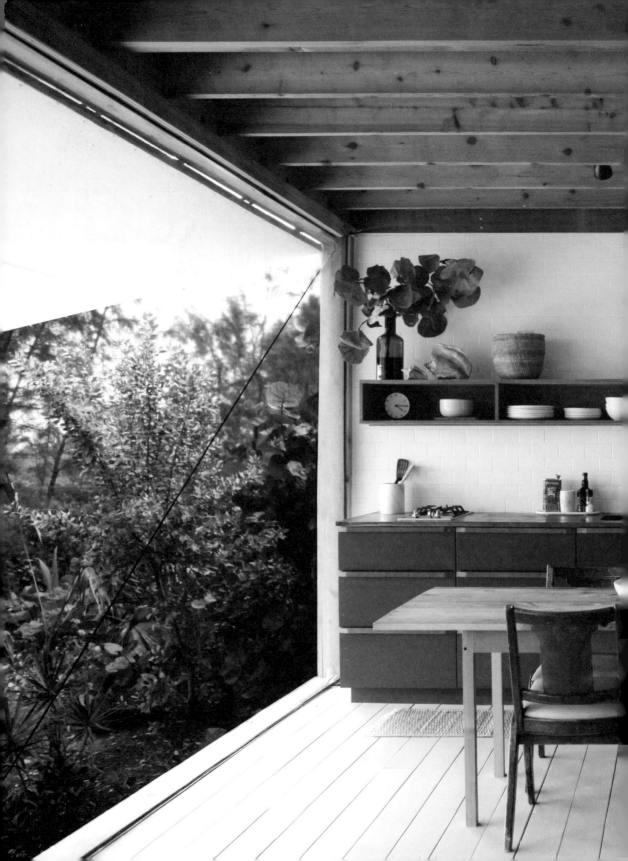

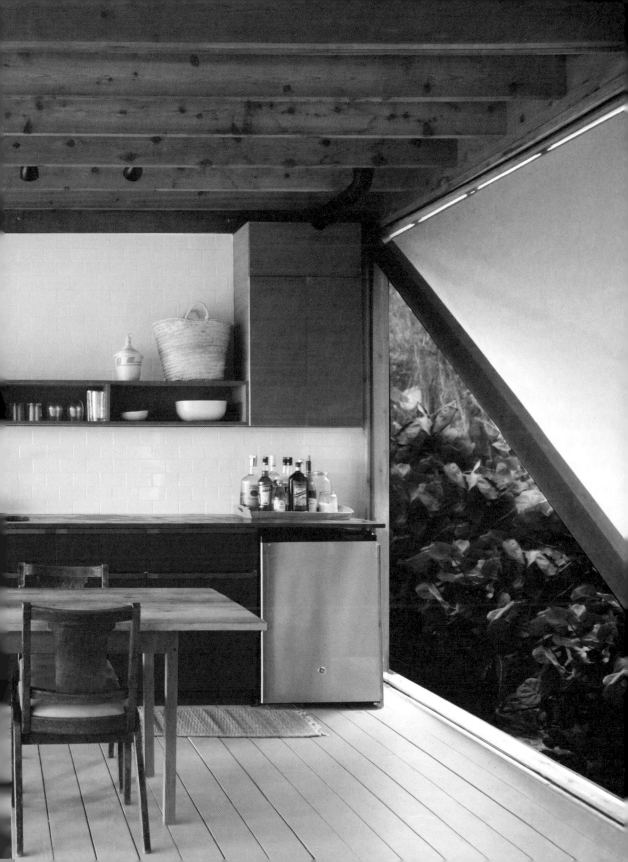

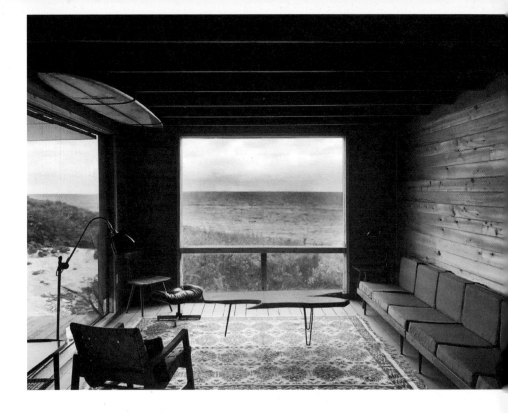

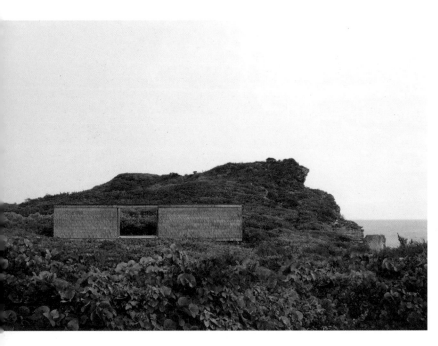

Thatch House
Eleuthera, Bahamas

CONTRIBUTED BY
Brillhart Architecture

INTERIOR PHOTOS BY
Mark Ingraham

This tiny outpost and surf camp overlooks Eleuthera's wild Atlantic coastline. Just 600 square feet, the tiny retreat was designed for Kate and Mark Ingraham and their daughter.

Inspired by Cape Cod's experimental Hatch House, it is constructed with western red cedar and thatch. It features outdoor decks that dissolve into the landscape, ocean views, and a long porch to enjoy the weather while remaining protected from the wind and spray blowing in off the ocean.

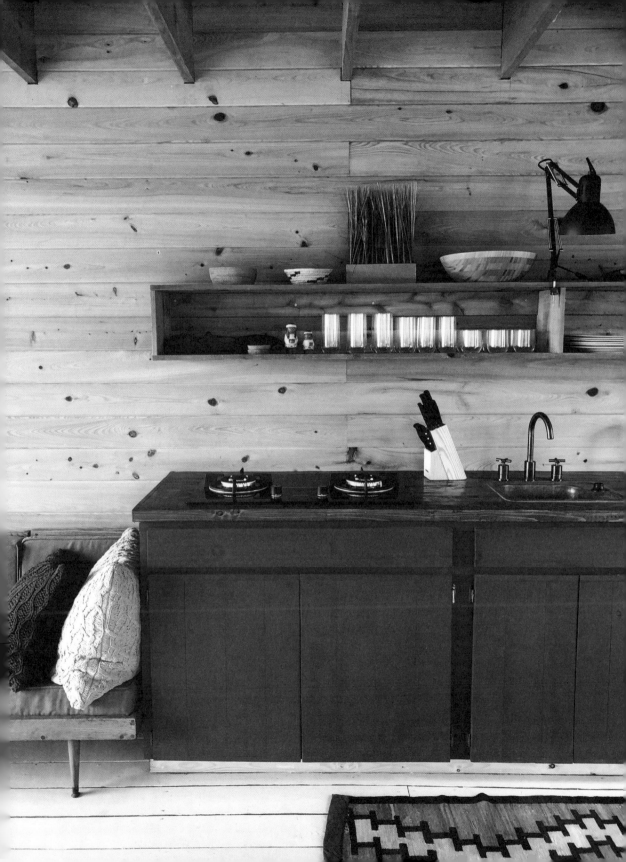

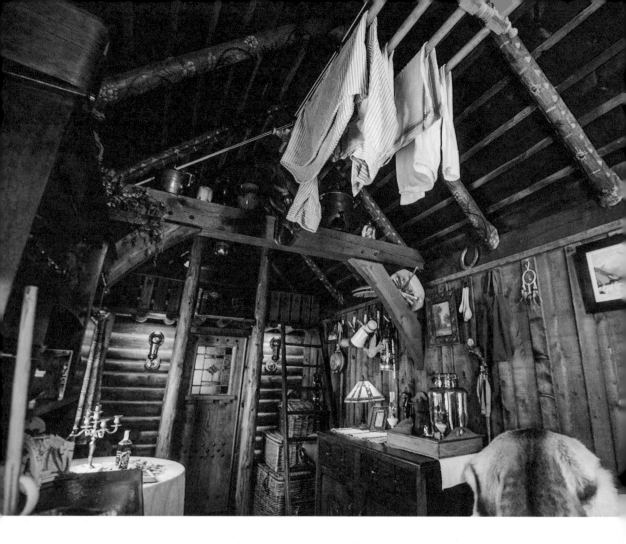

Talliston House & Gardens
Great Dunmow, England

CONTRIBUTED BY John Trevillian

PHOTOS BY
Gavin Conlan Photography

This cabin is among 13 themed
rooms at the Talliston, an ordinary
detached house in Essex, England,
that was transformed into an
"extraordinary labyrinth of
locations from different times and
places, so that not a single square
centimeter of the original house
remains," as its mission statement
puts it. The cabin is meant to
evoke the Cree hunting grounds of
Saskatchewan, Canada.

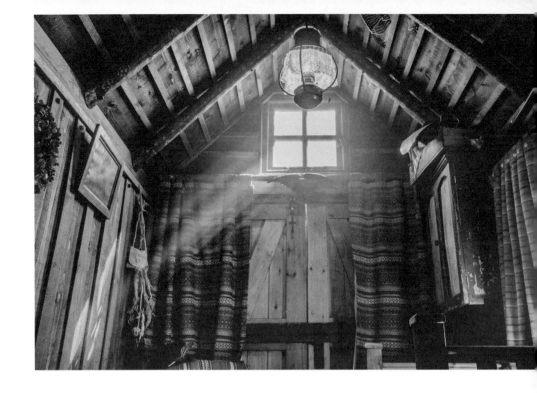

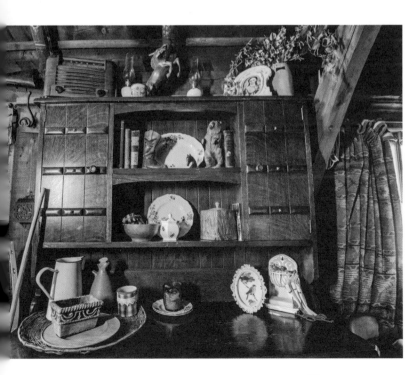

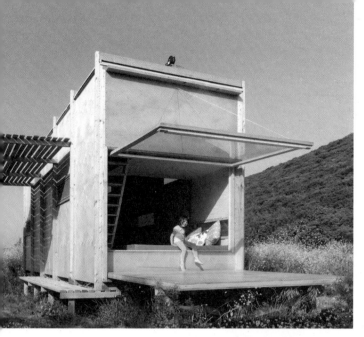

Cabin on the Border
Edirne, Turkey

CONTRIBUTED BY SO? Architecture / Sevince Bayrak, Oral Göktaş

Located in a village on the Turkish-Greek border, Cabin on the Border faces weather conditions that vary dramatically depending on the season. On warm, rainy afternoons, its polycarbonate window becomes a canopy to lie under and watch the sky over a plywood façade that can be transformed into a terrace. On a stormy night, both the window and the façade are closed, and the cabin—constructed entirely from insulated, laminated wood—becomes like a sailboat in the ocean. This happens manually, since the cabin is off-grid.

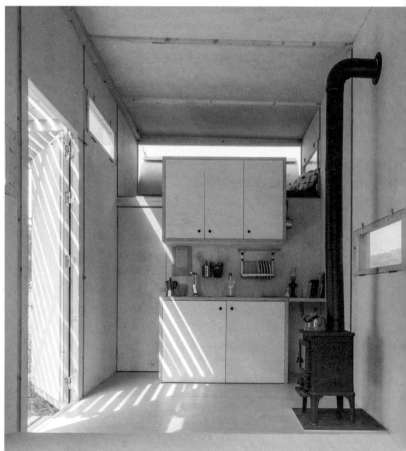

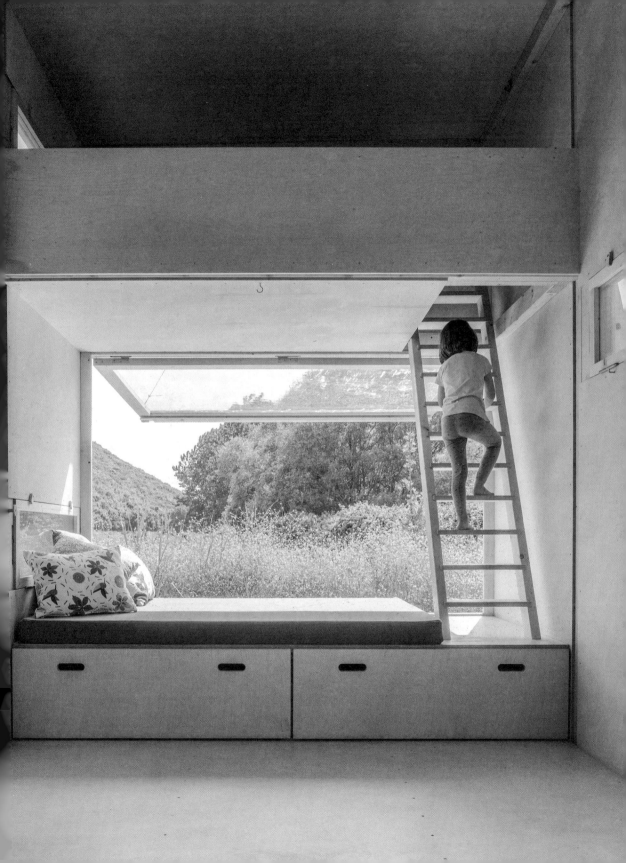

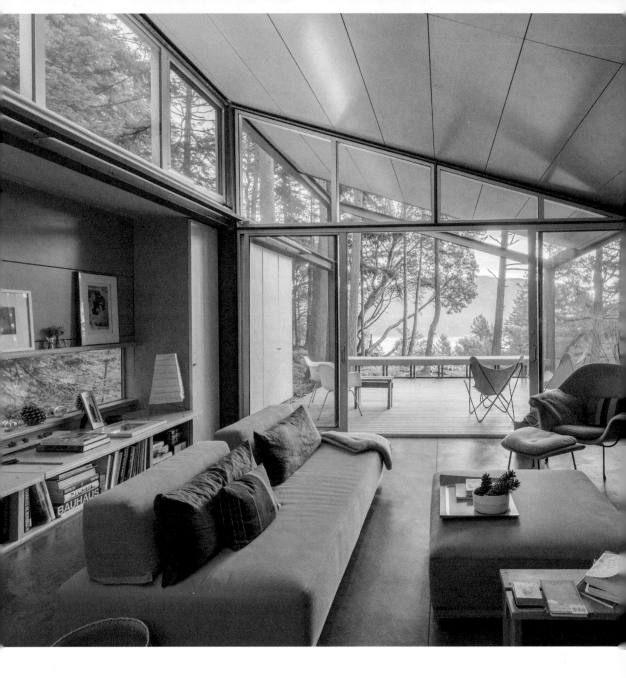

Walker-Pope Cabin
Orcas Island, Washington

CONTRIBUTED BY Gordon Walker

PHOTOS BY Andrew van Leeuwen

This steel-framed structure is set in the San Juan Islands of Washington State. David Shore Construction built the cabin with one of its owners, Gordon Walker, in 2006 with a prefabricated kit of parts that was trucked to the site and,

once assembled, includes an outdoor terrace, concrete radiant-heated floors, a simple shed roof, and a variety of living spaces.

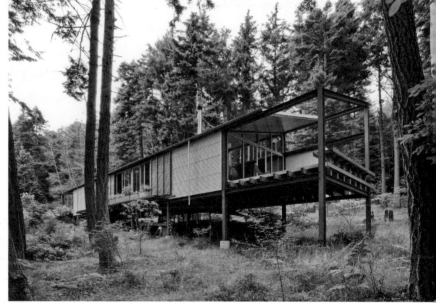

Croft Lodge Studio
Bircher Common, England

CONTRIBUTED BY David Connor

PHOTOS BY Jim Stephenson,

ABOVE David Connor

When Croft Lodge Studio was built atop a dilapidated, centuries-old cottage, the ruins were carefully preserved—and not just their rotten timbers and crumbling bricks, but dead ivy, old birds' nests, cobwebs, and dust.

Over this decaying structure builders placed a modern shell: a steel frame with timber, strand board, a waterproof membrane, and black corrugated iron. Solar panels provide electricity; heat comes from two wood-burning stoves. During the summer, a glycol-filled pipe placed under the corrugated iron acts as a hot water system.

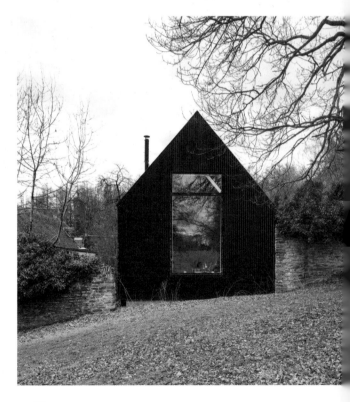

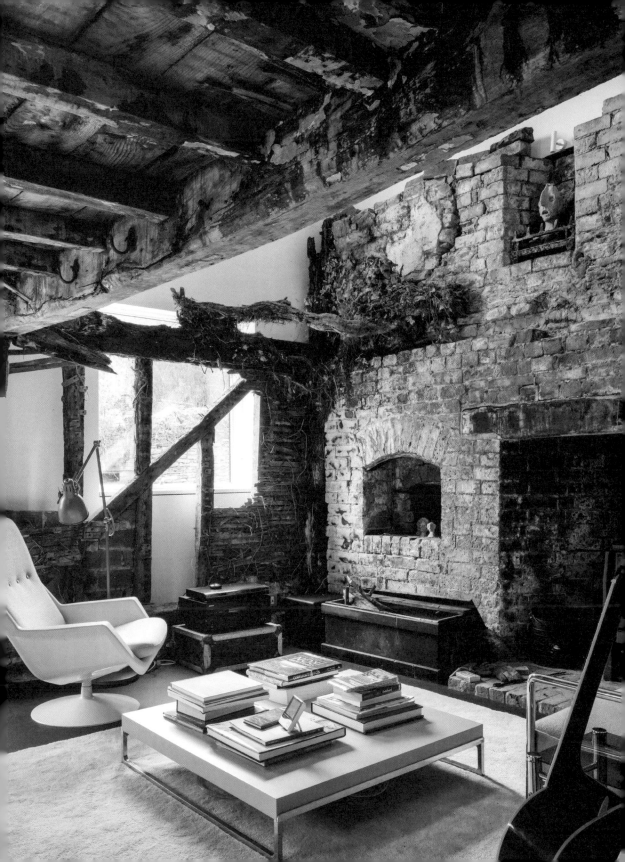

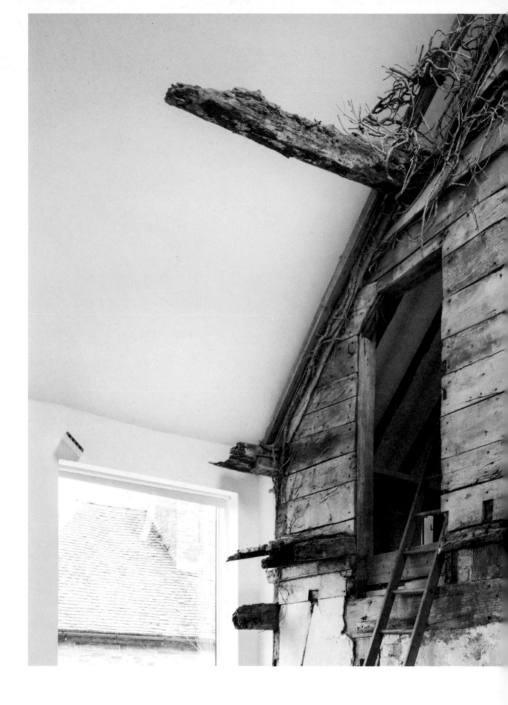

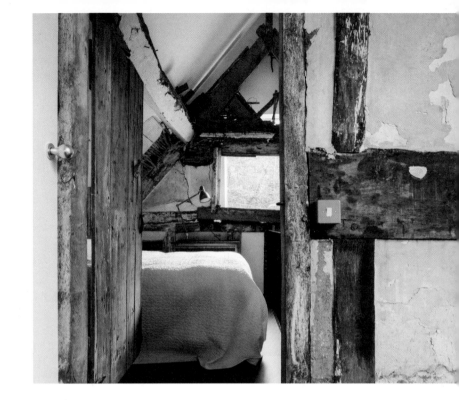

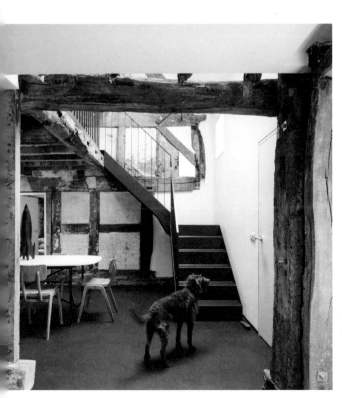

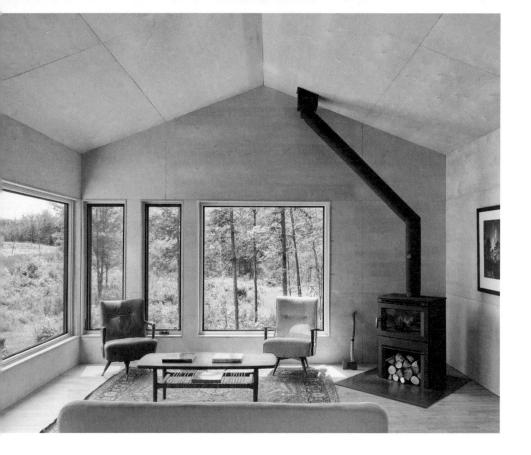

Land House
Meaford, Ontario

CONTRIBUTED BY WORKS OFFICE
of Brian O'Brian Architect

PHOTOS BY Shai Gil

Just outside Georgian Bay, in Meaford, Ontario, the Land House is a spare wooden container in the Ontario woods. Set beside a winding ravine and wetlands, this year-round cottage takes its shape from the traditional gabled dogtrot familiar to the American South, with a roof of corrugated steel and an exterior of silver-gray, untreated tongue-and-groove cedar boards. The interior is built entirely of plywood and white oak. On one side of a breezeway are the sleeping areas; the living space is on the other. The centerpiece of the Land House is a 16-square-foot opening that doubles as an outdoor living room and provides an intimate connection to the environment.

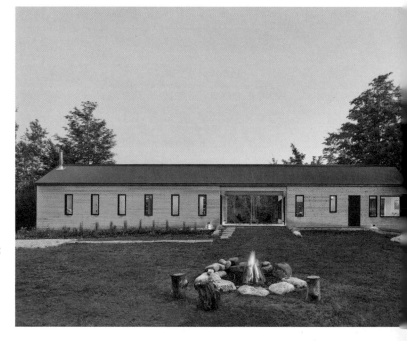

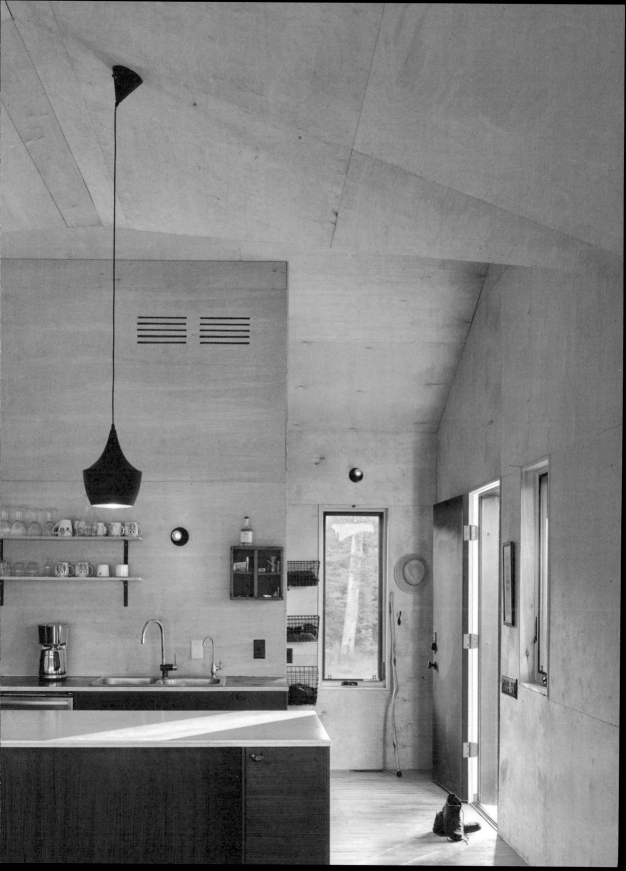

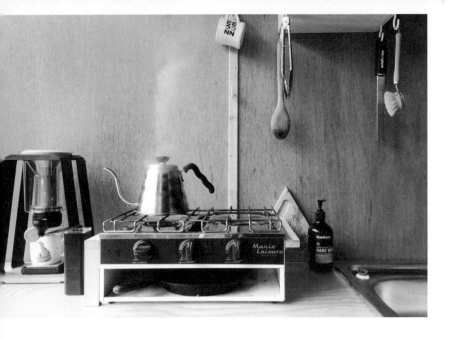

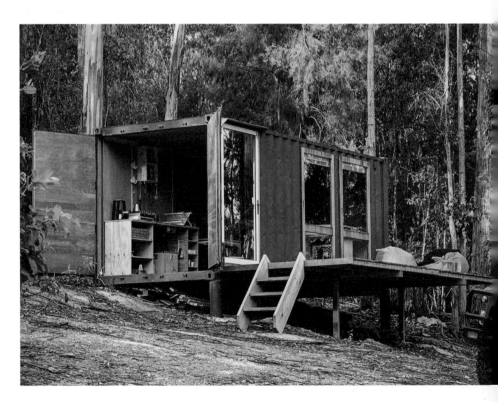

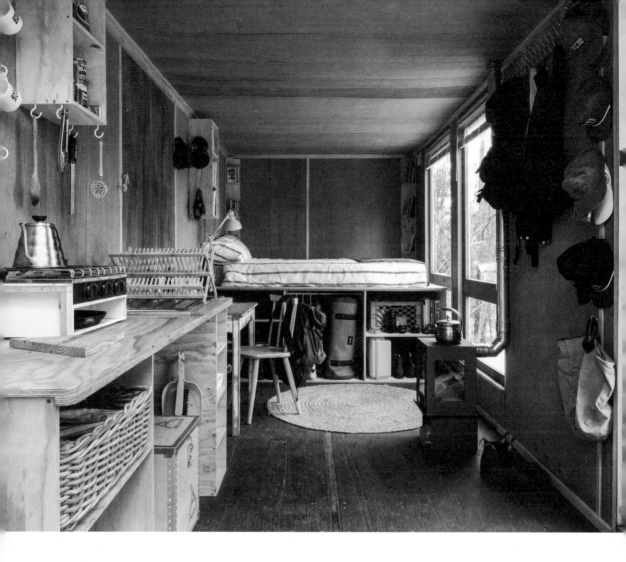

Container Surf Shack
Tasmania, Australia

CONTRIBUTED BY
Nick Jaffe and Sarah Glover

From 2006 to 2009, Nick sailed solo in 26-foot boat across the Atlantic and Pacific Oceans. After buying land in Tasmania with this shipping container, which had previously been used for storage, already on it, he hired a crane operator to move it onto its own corner of the property, where he used recycled materials, plenty of plywood, and a lot of time spent grinding and welding, to build this container surf shack. Having sailed thousands of miles alone at sea, he often lies awake at night watching the stars, wondering how many storms this particular shipping container has seen.

Fire Lookout

Contributed by **Kristie Mae Wolfe**

Photographs by **Mike Sanders,
Matthias Barker, Robert Garlow**

Before building her first home, Kristie Mae Wolfe spent nearly a year driving around the country in an oversize fiberglass potato on wheels—Idaho's official potato truck—as a spokesperson giving interviews, hosting potato-centric events, and celebrating her home state's most famous crop. But this blip on her resume barely stands out in Kristie's life story.

In high school, Kristie wanted to be an entrepreneur. But rather than graduate and go to business school, she dropped out. "My sixteen-year-old self thought, You go to college so you can get a job, and you go to high school to get into a college, but I'm going to own my own business, so why don't I get my life started?" she says. "Not perfect logic, but it worked out for me."

Kristie was the fourth of six kids in a family in which her father was a teacher and her mom stayed home, and there was never enough money or space. So Kristie's mom, Sharon, became handy with construction. They lived in fixer-uppers, and while the kids were at school, Sharon would tear down walls, install tile, and pour sidewalks. "My mom is a little restless," says Kristie, "so it definitely was an outlet for her."

Kristie inherited her mom's building bug. Even in the pre-Internet days, when learning how to tackle an ambitious home-improvement project was full of

A woodstove with a viewing window was installed so guests could watch the fire. The original woodstove now heats the sauna.

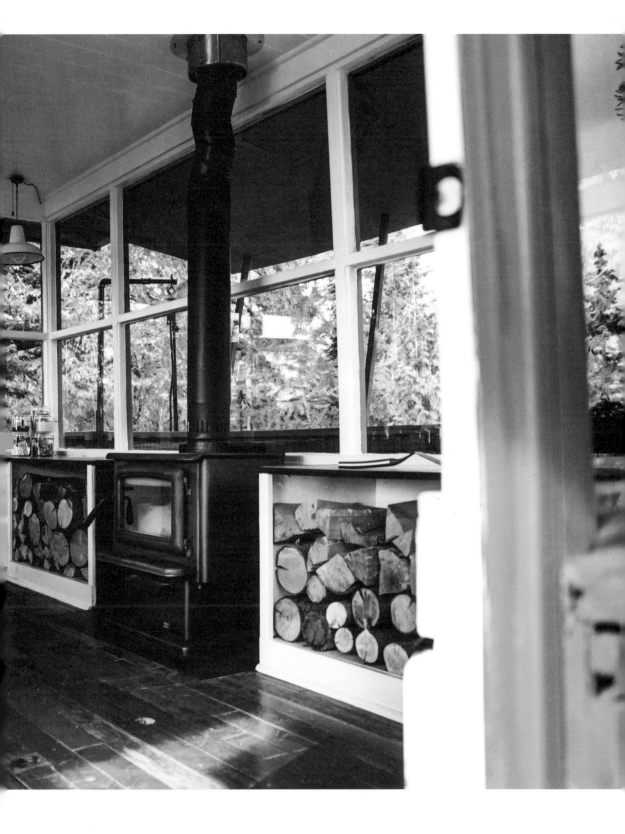

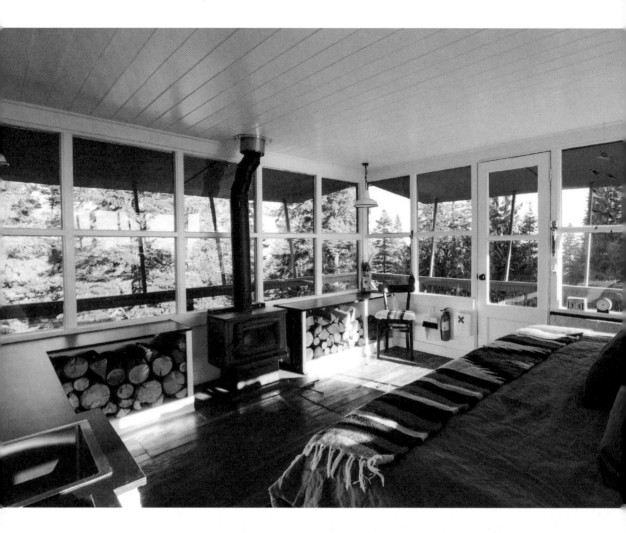

The door and fireplace were originally in the cab's corners, but Kristie felt that moving them to the center of the room offered greater visual symmetry.

OPPOSITE The items in the nightstand were carefully selected. They include books that are either about the outdoors or written by an Idaho author, a handful of games, and a weather log for guests to record the conditions during their stay. Because the lookout is off-grid, Kristie placed solar lights in the cab's corners and affixed antique enamel shades to each to give them character.

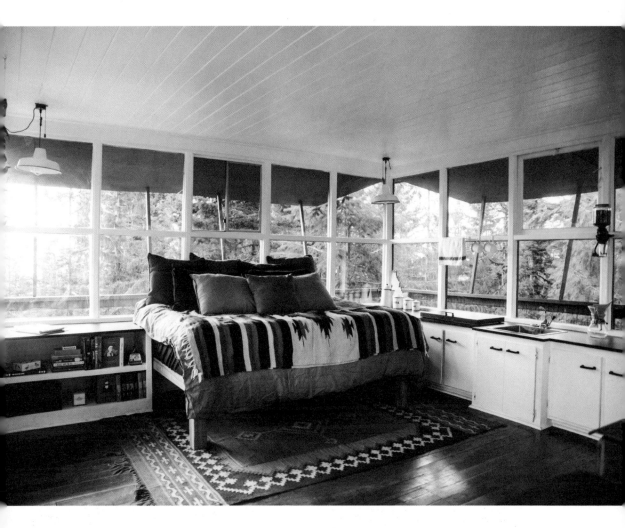

painstaking trial and error, Kristie's parents let her "do crazy things to their houses," she says. She had interest, she insists, but "no talent."

Kristie's willingness to throw herself into something new has translated into a philosophy of experimentation and "living deliberately." She will do things like apply on a whim to speak before a crowd of hundreds. Or post a video of herself working on off-grid water systems in an American flag bikini. Or decide to build her own 97-square-foot home.

That last experience might seem unremarkable today, when you can buy a tiny house kit on Amazon. But this was in 2011, before tiny houses became a movement and got "super fancy," says Kristie. Hers was intentionally simple, an "experiment in minimalism." Construction took about a month, with her and her mom working nights and weekends. The entire project cost $3,000 in materials, plus $300 for a used trailer to transport it. Kristie planned to live there for only a year, "but I loved the forced simplicity," she says, "and decided to buy land and make it permanent."

She found a plot of land outside Boise and planted her experiment there. At the time, Kristie was earning $12 an hour working in factories: first a potato processing plant, then a candle factory, and when she built her first house, a plastics recycling plant. She "loves factories," but this low-wage work meant that she didn't have the savings to pursue the bigger entrepreneurial projects she'd dreamed about as a teenager.

Building her tiny house, with the low cost of off-grid living, allowed Kristie to save enough for a down payment on her own plot of land. Within a few

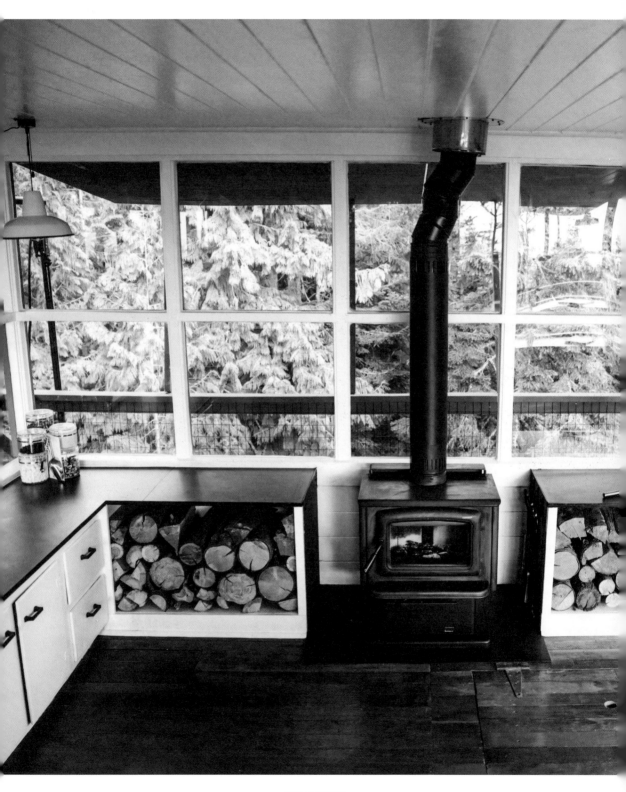

FIRE LOOKOUT

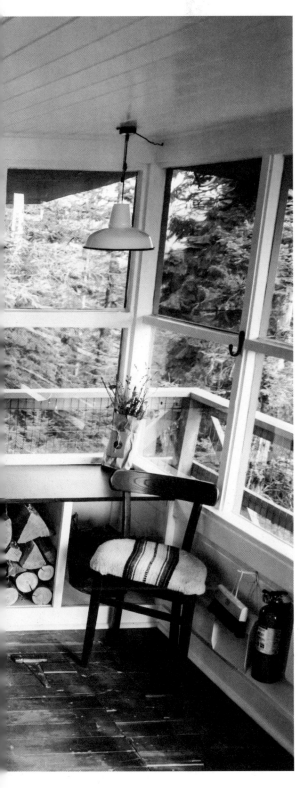

The tower's ridge beam was in the way of the
vent—a problem solved by adding a jag to the top
of the pipe.

months, the loan on her Idaho property was paid.
With that achievement, she moved on to her next
project. This time, she would build a vacation rental
business in Hawaii.

It was a big gamble. Kristie bought her Hawaiian
property for $8,000, sight unseen, off Craigslist—an
approach she "wouldn't recommend." Because she'd
just been hired by the Idaho Potato Commission, she
wasn't able to visit until eight months later. When she
and her mom finally flew to the Big Island, Kristie
had $15,000 and two months to build. The parcel was
overgrown, muddy, and littered with abandoned cars.
Kristie had envisioned a tropical treehouse where
adventurous couples could retreat into nature, but she
wasn't prepared for the challenges of a jungle land-
scape. Her build ended up taking nearly three months,
after rain delays and construction costs sometimes
triple what she would have paid on the mainland. But
when it was completed, her Airbnb took off—becom-
ing one of the most popular vacation rentals on the
site, where it's often booked months in advance.

With each project she completed, Kristie could
afford to build another, and another. Her most recent
cabin is in her home state. "A fire lookout was on
my short dream list of builds," says Kristie. While
researching online, she came upon a lookout tower
—a historic structure used by park rangers, forestry
workers, and firefighters to keep an eye out for wild-
fires in the rural western United States. It was for sale
six hours north of Boise in the rural community of
Fernwood, a 640-person logging town surrounded by
tribal land and national forest. The lookout tower cost
$67,000—a big leap from Kristie's previous projects.

But it was in her home state, and while she wasn't ready to buy, she says, "it felt meant to be."

The tower, formerly dubbed Stranger Lookout, had traveled from 13 miles southwest of Chewelah, Washington, to its current location in the Idaho Panhandle. It was built by the Washington Department of Natural Resources in 1959 and stood 40 feet tall on a wood frame. In 1983, when a new tower was built nearby, the state government put it up for sale: $1 to the person who could remove it within thirty days. Dave Kresek, the son of Ray Kresek—the curator of the Fire Lookout Museum and author of two books about fire lookouts in the Pacific Northwest—was that person.

Dave hauled the tower to a 7-acre property in Fernwood, Idaho, that he'd bought for a load of logs. To replace the old wooden frame, he bought a metal one from the Geiger Field military prison at a government auction. Then he built a log outhouse and woodshed alongside the tower.

By the time Kristie bought it in 2017, the tower had been largely abandoned for years. She purchased the property in the fall, but it was snowed in before she could finish remodeling. In the spring, she and her mom redesigned and rebuilt the tower's cab, as the cabin atop the frame is called. They built a large deck at the base and converted the existing shed into a European-style wood-fired sauna. Kristie bought a vintage 1964 Snowcat to transport guests up the property's steep driveway.

Kristie has now come full circle from her Idaho potato days. She has a short list of ten cabins she wants to build in addition to the three that are already

The roof was a challenge to access because it extends past the deck. Kristie stood on the railing and pulled herself up while balancing on a swinging pulley bar.

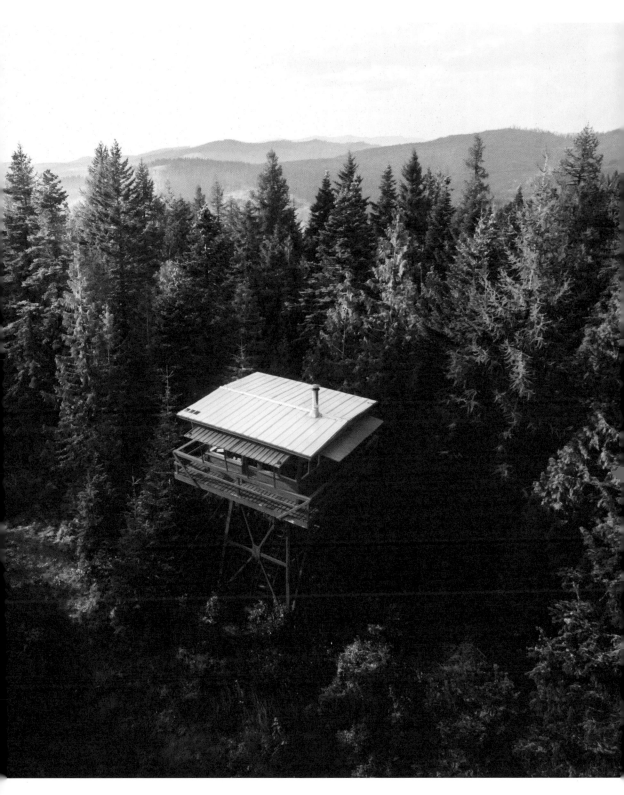

FIRE LOOKOUT

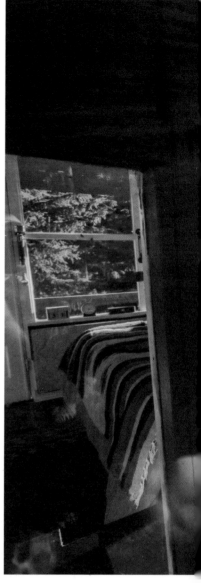

L An antique coffee grinder filled with Idaho-made coffee called Backcountry Blend.

R The deck wraps around the cab. About a third of the windows had to be replaced; some were broken when Kristie bought the lookout, others were damaged during construction.

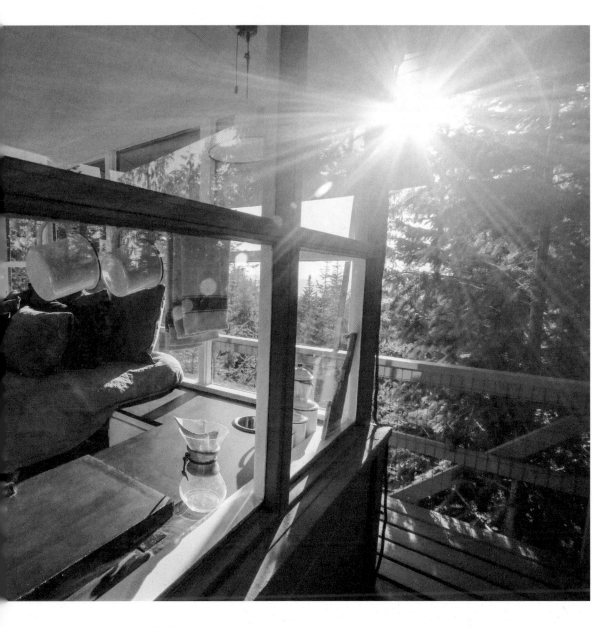

up and running. Next up: the Big Idaho Potato Hotel. The six-ton potato that she traveled around the country in has been retired—replaced by a lighter fiberglass model—so the commission gave Kristie the old spud. She's placed it on her property outside Boise, where it will become her next vacation rental.

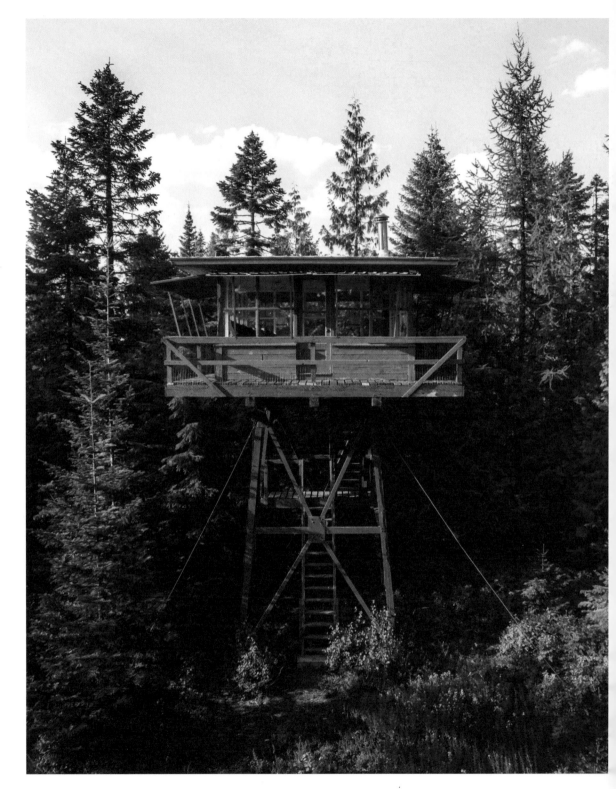

FIRE LOOKOUT

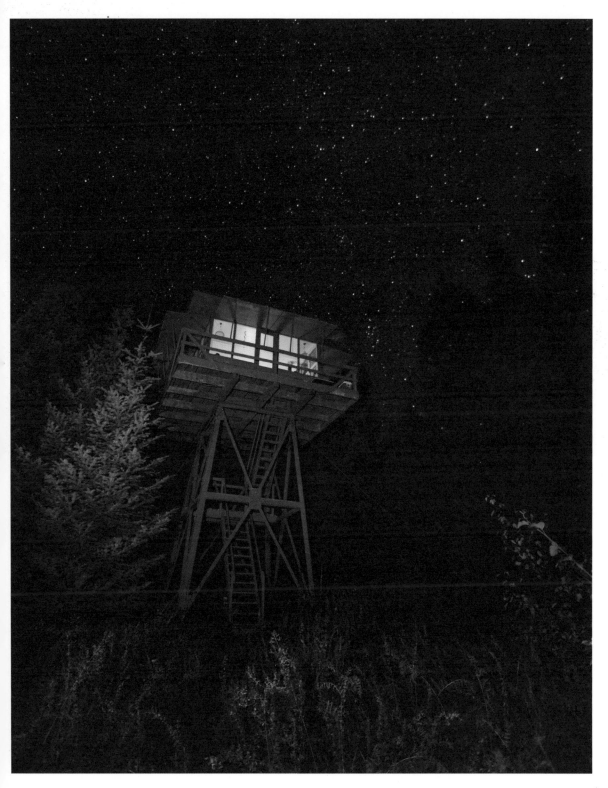

Clear, starry night in Idaho's Panhandle.

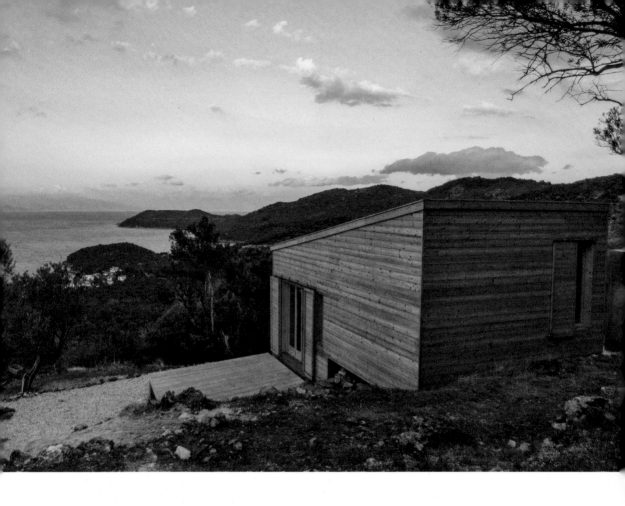

Hermitage Sykaminea
Lesbos, Greece

CONTRIBUTED BY Andreas Sell

PHOTOS BY Fotis Milionis

Located on the Greek island of Lesbos, Hermitage Sykaminea is an-off grid structure built in a mountainside olive grove. It has three floors, a woodstove, solar panels, and a well; wastewater is used as fertilizer and for the olive trees and an herb garden. On a clear day, you can see all the way to Turkey from Hermitage Sykaminea's front window.

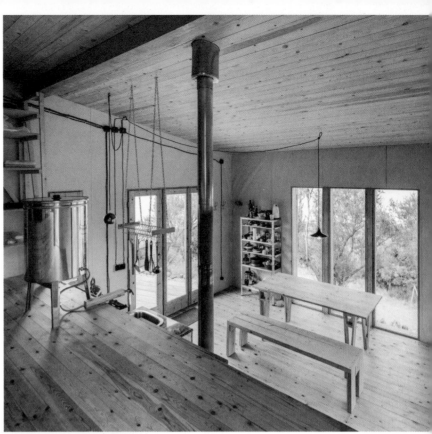

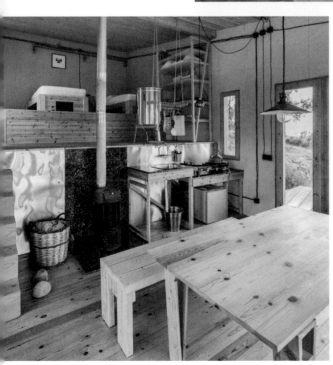

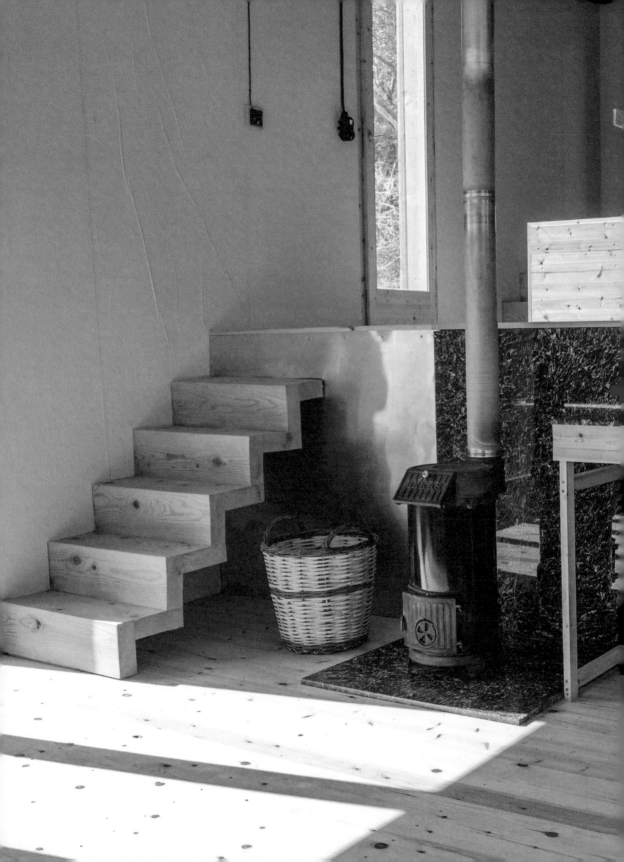

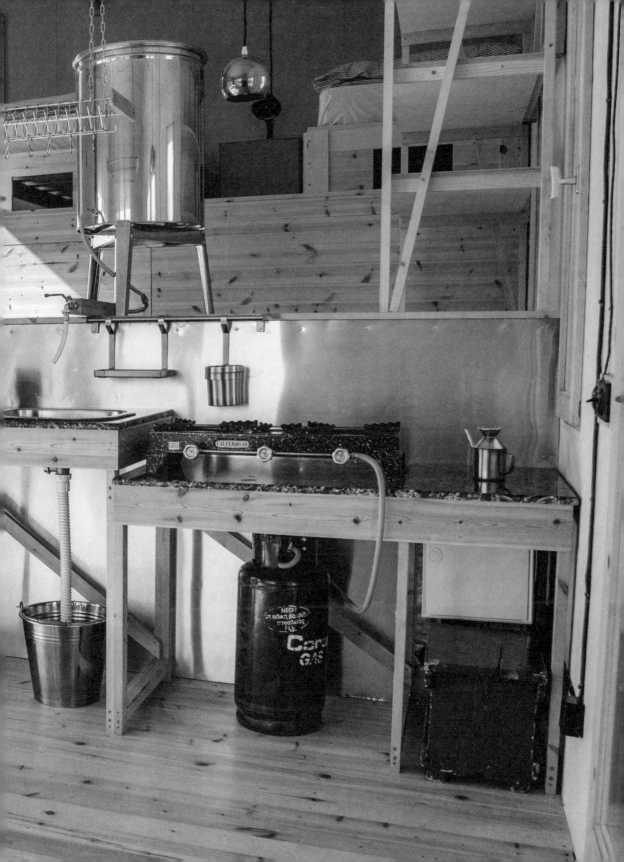

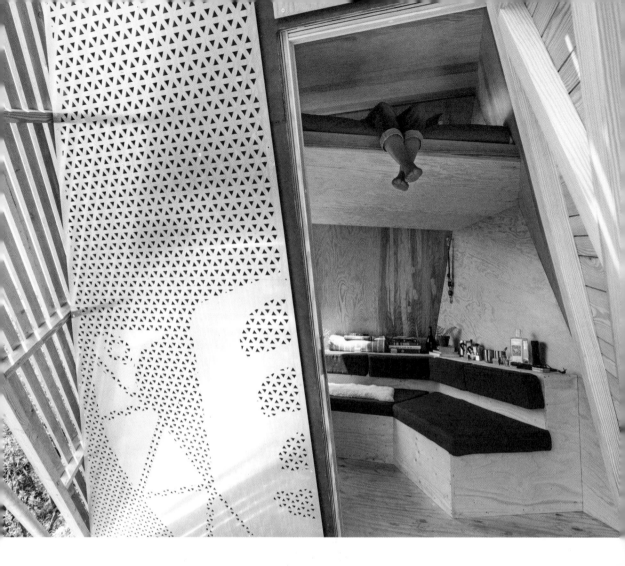

Kudhva
Cornwall, England

CONTRIBUTED BY Ben Huggins

PHOTOS BY Roy Riley

These four secluded rental cabins are perched high above Britain's North Cornwall Coast in an old slate quarry. Designed by architect-maker Ben Huggins and constructed by boat-builder-turned-furniture-maker Toby Sharp, these "kudvha" (Cornish for "hideout") aim to offer off-grid living that blends in with—and offers a unique view of—the surrounding landscape. Set atop turned pine poles, the cabins were built with insulated paged-pine panels, a synthetic rubber membrane covering, and a larch-slatted skin. Natural materials line their interiors, with built-in storage and mezzanine beds. The site also offers a temporary scaffolding reception with a canteen, toilets, and showers.

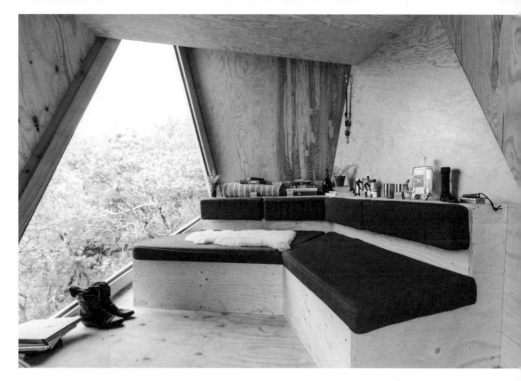

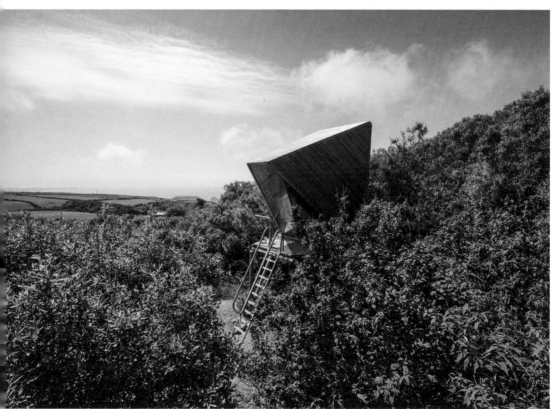

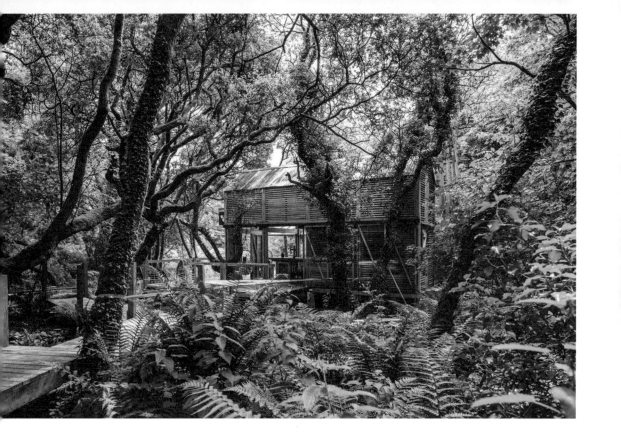

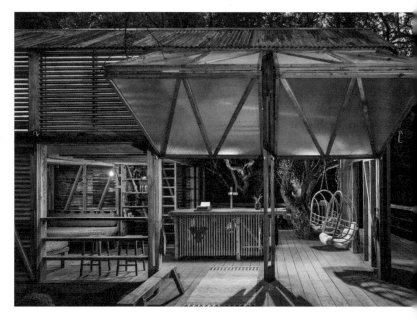

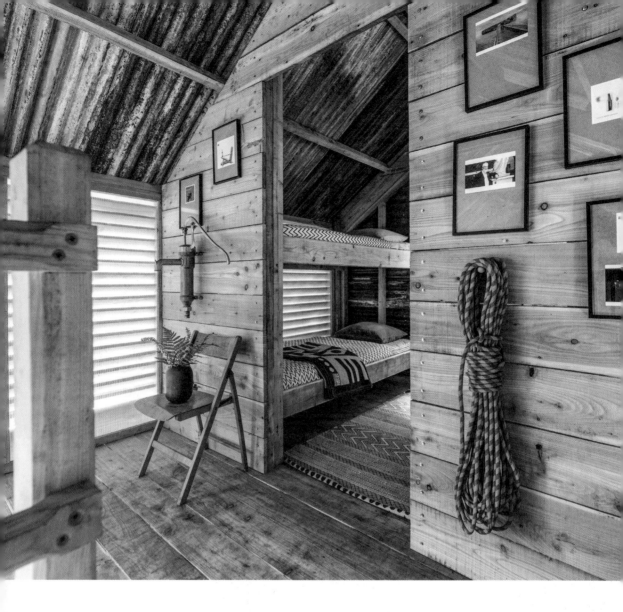

The Danish Cabin
Cornwall, England

CONTRIBUTED BY
Louise Middleton

PHOTOS BY George Fielding

Located on Britain's southwest coast, this structure was created as an off-grid bar and cabin. After a long day's adventure, guests can relax with a drink while taking advantage of the cabin's ingenious engineering: slide the foldable walls up and let the outdoors in, or bring them down to shelter the two single sofa beds in the downstairs sleeping area. Bunks upstairs in the mezzanine make up the other four berths, so guests can enjoy arguing over who gets to crawl up the ladder to bed. The cabin was designed by New British Design and Kudhva, and created in partnership with Carlsberg.

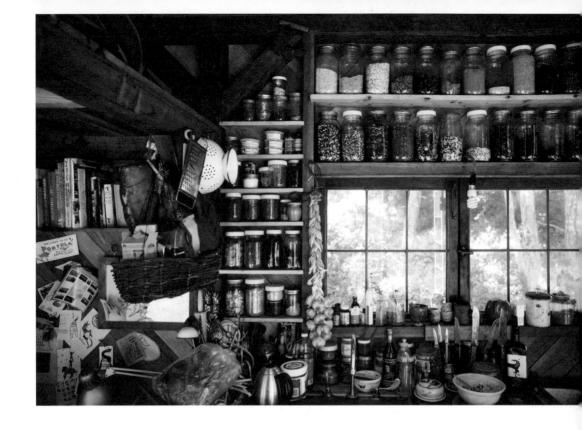

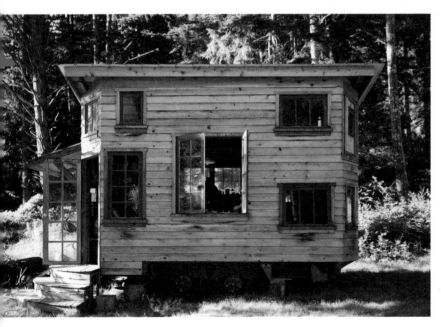

Brooke and Emmett's Tiny House
Orcas Island, Washington

CONTRIBUTED BY Brooke Budner and Emmett Adam

PHOTOS BY Molly DeCoudreaux

Brooke Budner and Emmett Adam built their tiny timber-framed house in 2013. It was their solution to Orcas Island's affordable housing problem—they became homeowners for less than $2,000—but it was also mobile: the cabin fit onto an 8.5' x 18' flatbed trailer. Built with scavenged wood, windows, and roof metal, it contains no nails, screws, plywood, or drywall; the frame is joined entirely with wood pegs. It has an open floor plan with a few different levels, lofts, storage areas accessed through hatches, and living room bench seats that open like chests.

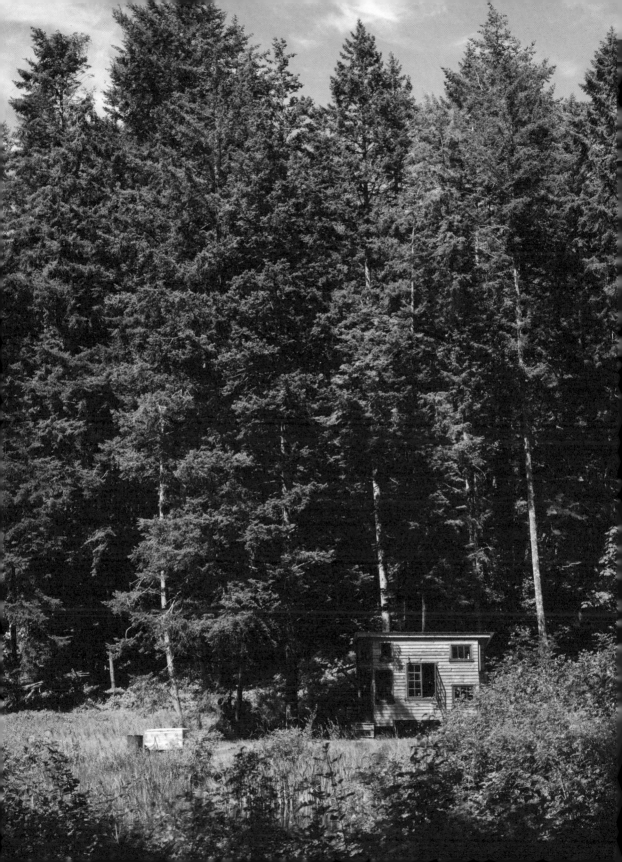

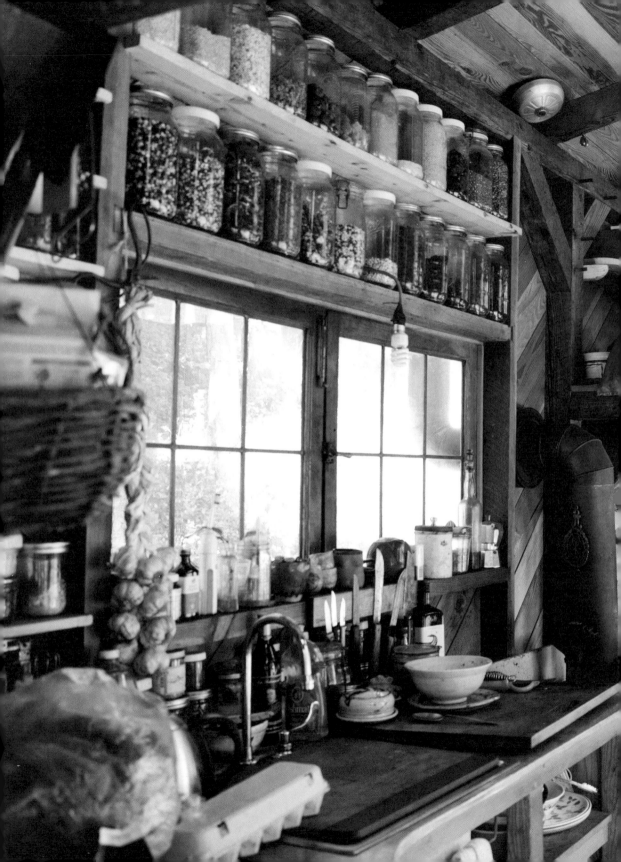

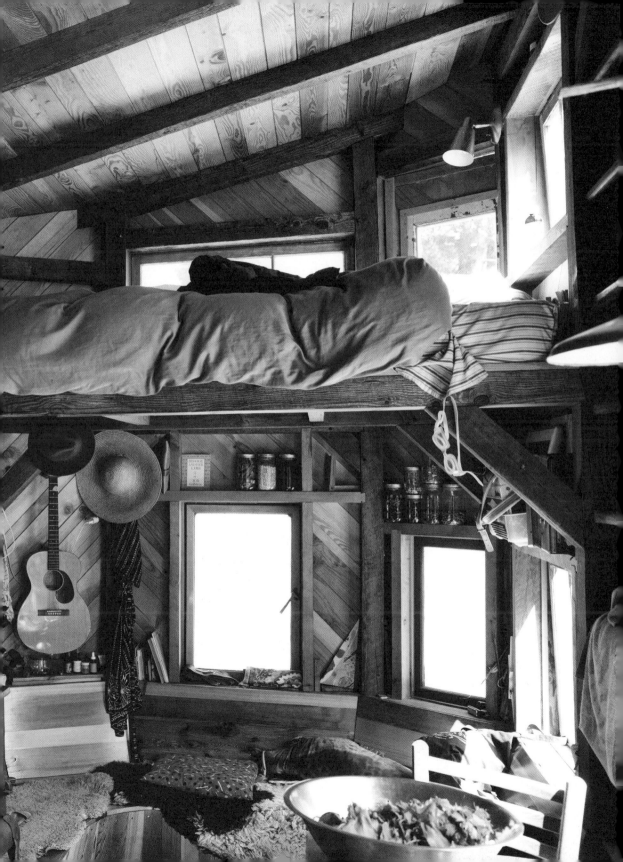

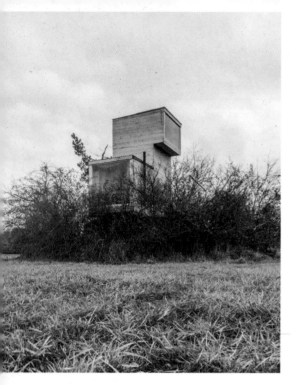

Útulna,
Fortress Extension
Vratenín, Czech Republic

CONTRIBUTED BY Jan Tyrpekl

PHOTOS BY Antonín Matějovský

Thousands of small fortresses were built ahead of World War II in order to defend the Czechoslovakian border from the Nazis. Though they were never used, what to do with them remains a sensitive subject in Czech and Slovak society. So this experimental cabin—built atop one of these former concrete bunkers—was designed as a light wooden structure that could be easily removed.

Just 129 square feet, the cabin has two large windows: one faces east, toward the Austrian border, while the other offers a view of the nearby village and its church. The principle of the construction was to minimize the material, cost, and time needed for completion. The building is simple; it can be built with common tools. The project was not financed with donations or grants, but with the help of friends, family, and students of architecture who wanted to help. The shelter is available to anyone who wants to stay.

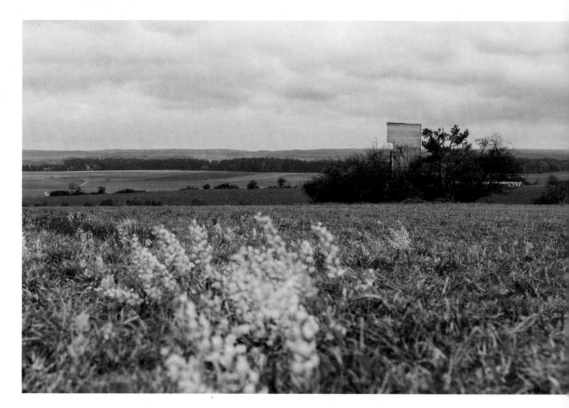

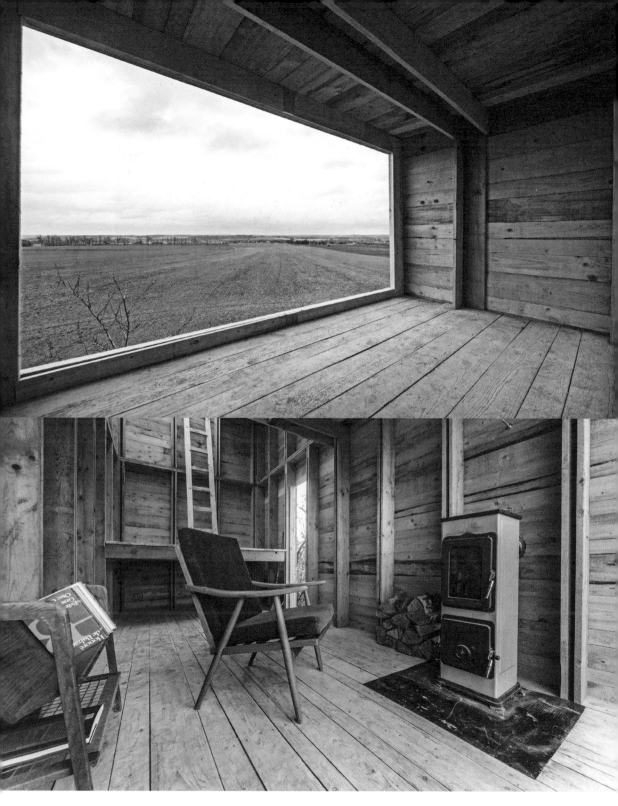

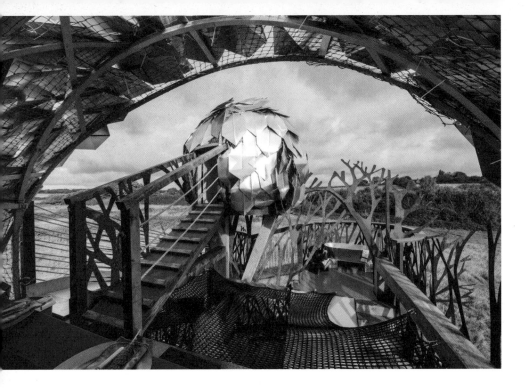

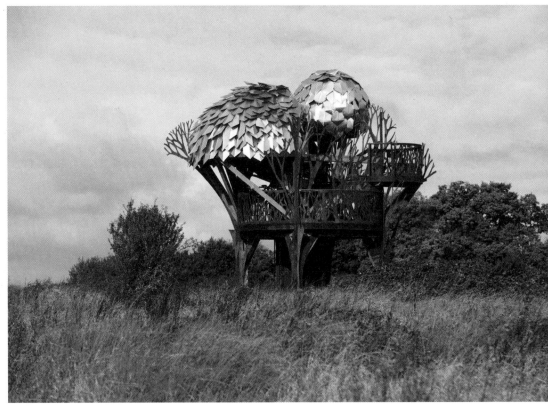

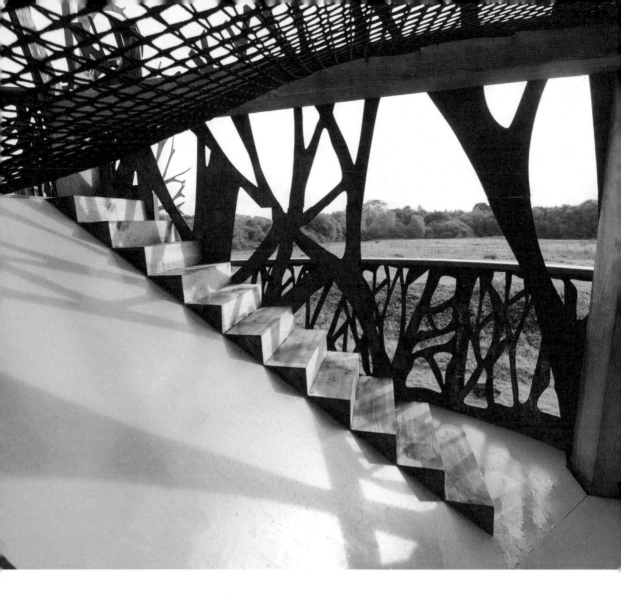

Pop Top Tree House
Lewes, England

CONTRIBUTED BY Studio Hardie

PHOTOS BY Leigh Simpson

Located in a campground in East Sussex, England, this treehouse looks like it could be in Neverland: the entrance is through a trunk, a slide connects the first and second levels, and one of its sleeping spaces is made from a cargo net. With a timber frame, glulam sandwich platforms, and pine canopies, it was designed to be temporary, so there's no foundation— a challenge its builders, Studio Hardie, handled by creating large cantilevers for balance. The treehouse was commissioned for the British television program *George Clarke's Amazing Spaces*.

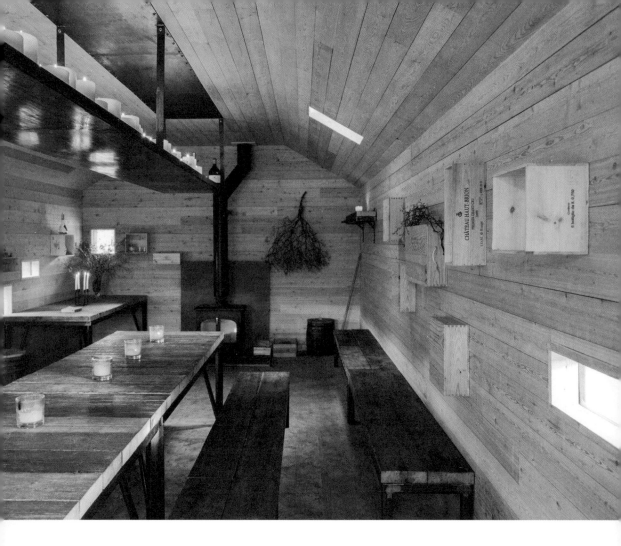

Culardoch Shieling
Aberdeenshire, Scotland

CONTRIBUTED BY
Moxon Architects

PHOTOS BY Ben Addy

The shieling sits alone in the vast, rugged, and windswept landscape of the Cairngorms, in the Scottish Highlands. Clad entirely in wood, with a cruck frame roof draped in heather, moss, and stone, the cabin is meant to recall farmers' shielings, summer huts that were used in Scotland and northern England for centuries. Though the cabin's windows appear haphazardly placed, with different sizes and orientations, everything about them was carefully selected: they allow in the right amount of light while offering a sense of seclusion and beautiful views of the River Gairn, the massive granite tors, and the water of Allt Bad a'Mhonaich tumbling down the side of Ben Avon.

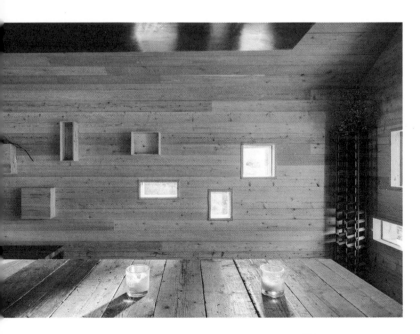

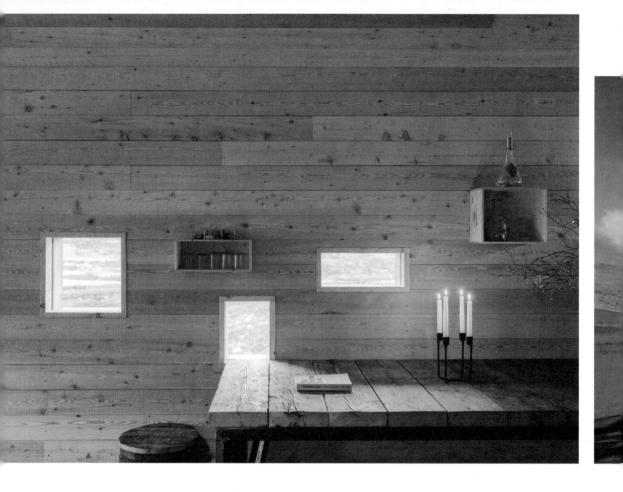

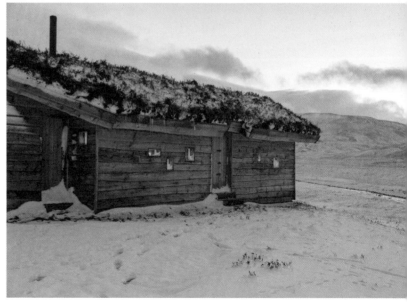

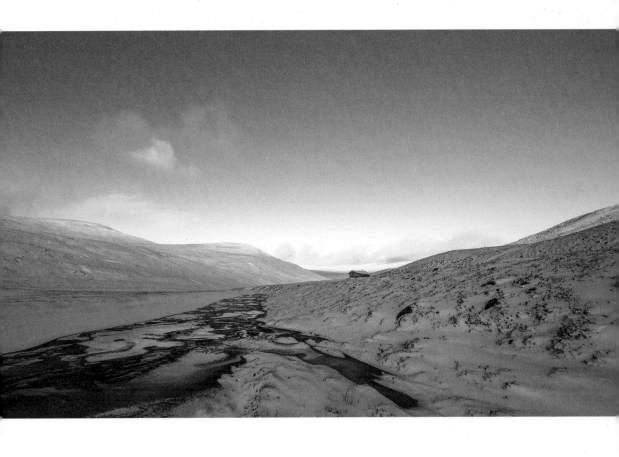

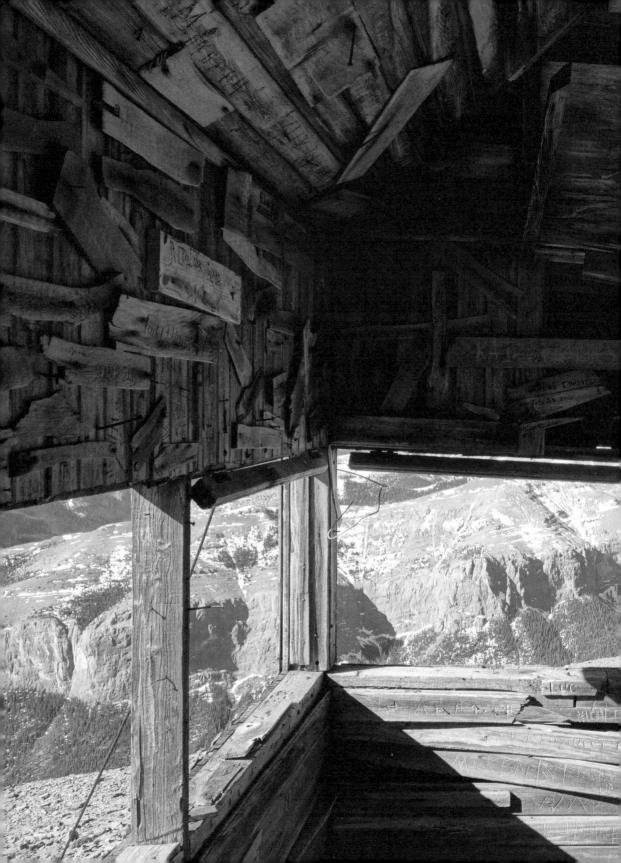

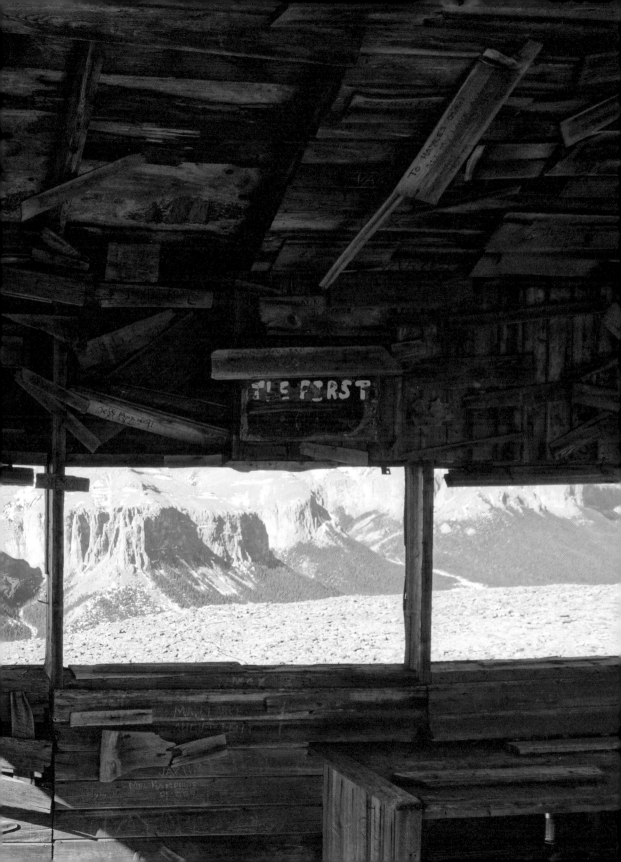

PHOTO POST-PRODUCTION
Zach Vitale

ILLUSTRATIONS
Daren Rabinovitch

COVER PHOTOGRAPHY
Noah Kalina

RESEARCH
Jane C. Hu

Special Thanks

Richard Pine
Michael Szczerban

Firewood brigade at Beaver Brook.
PHOTO BY Wesley Verhoeve

PREVIOUS
Black Rock Fire Lookout
Ghost River Wilderness Area, Alberta
PHOTO BY Keil Wretham

Visit
cabinporn.com/submit
to share your home with
the community.

Find a directory for each
home and photographer
featured in this book at
cabinporn.com/inside.

View our archive, featuring
thousands of cabins:
cabinporn.com

Follow Cabin Porn:
instagram.com/cabinporn
facebook.com/cabinporn
twitter.com/cabinporn